If you find this journal
please return it as soon as possible to:

+ Élian Black'Mor

3, impasse de l'Oubli

Paris (4e) île de la Cité

Reward :

BLACK'MOR CHRONICLES

From the *Lands of the West* to the Gate of the Automatons

EXPEDITION N°0001

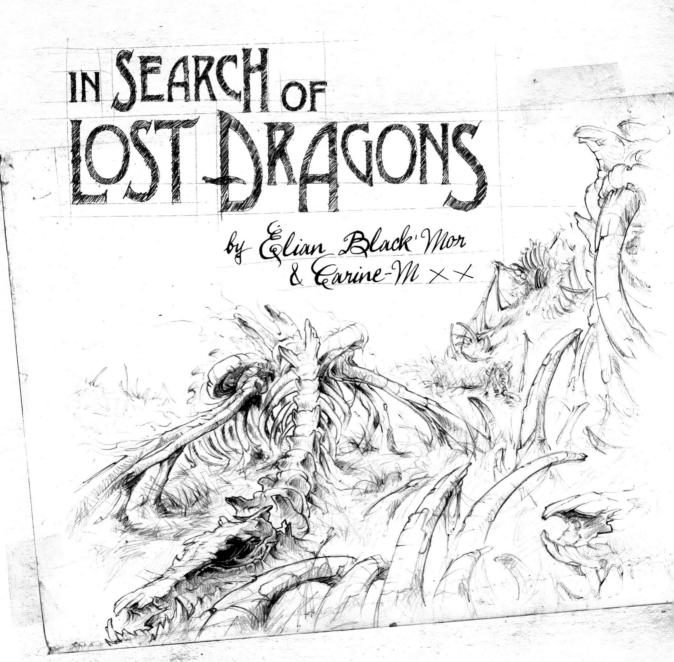

IN SEARCH OF LOST DRAGONS

by Elian Black'Mor
& Carine-M ××

«He who fights too long against Dragons
becomes a dragon himself.»

- Friedrich Nietzsche -

Brittany
the disappearance

THE BEAST OF THE BOGS

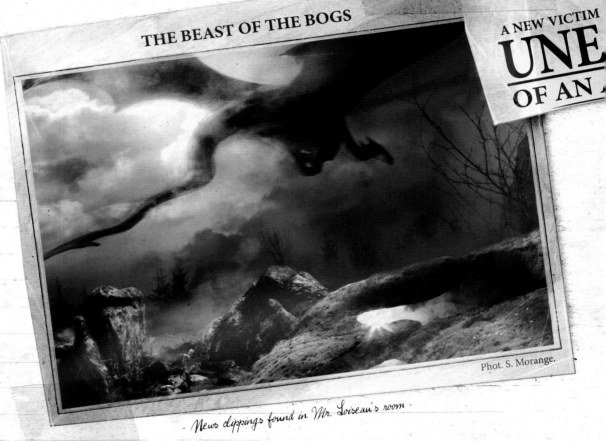

Phot. S. Morange.

- News clippings found in Mr. Loiseau's room -

X I've just arrived at a small Inn in the heart of
Armorica. A strange and desolate place, deep in the shadow
of the Arrée Mountains. The old locals say the marshes that
abound here are the very doors to Hell itself.

I've also heard that here one can easily find Ankou, the Grim
Reaper, out on his rounds, collecting souls upon his chariot at the
moment of their passing...

I think I shall pass a few days in this foggy, dank,
and charming little corner of paradise!
Especially since the most surprising things happen here.

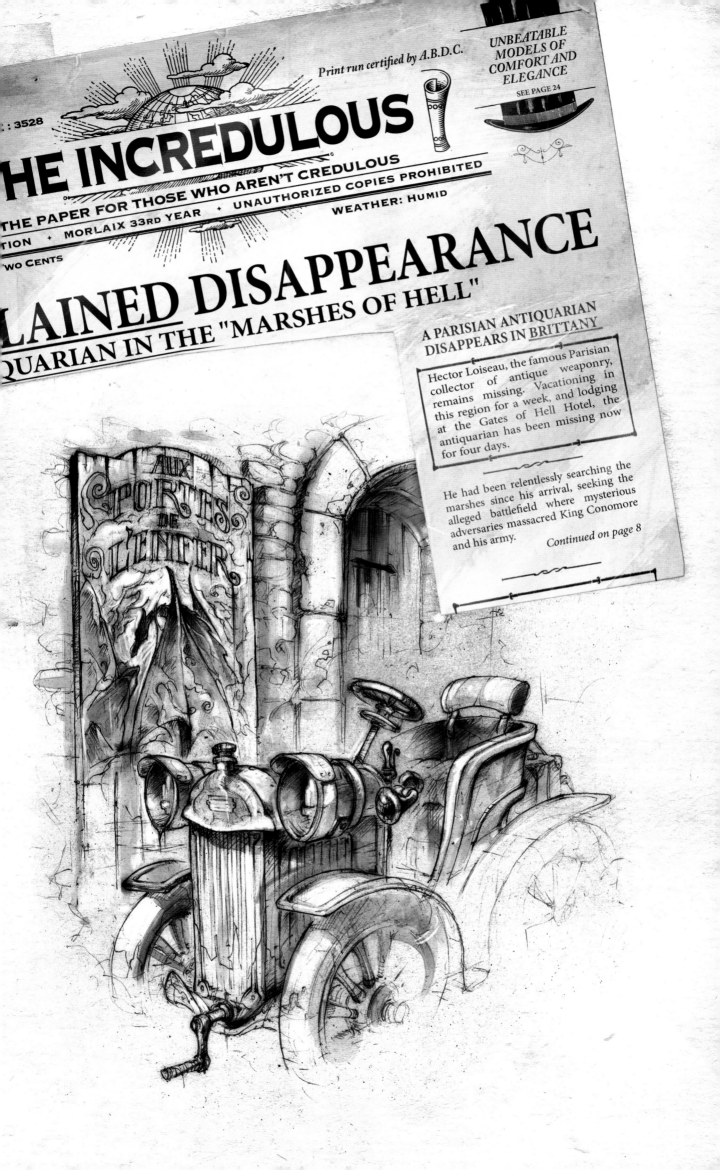

: 3528

Print run certified by A.B.D.C.

UNBEATABLE
MODELS OF
COMFORT AND
ELEGANCE
SEE PAGE 24

HE INCREDULOUS

THE PAPER FOR THOSE WHO AREN'T CREDULOUS

TION • MORLAIX 33rd YEAR • UNAUTHORIZED COPIES PROHIBITED

WEATHER: Humid

wo Cents

LAINED DISAPPEARANCE
QUARIAN IN THE "MARSHES OF HELL"

A PARISIAN ANTIQUARIAN DISAPPEARS IN BRITTANY

Hector Loiseau, the famous Parisian collector of antique weaponry, remains missing. Vacationing in this region for a week, and lodging at the Gates of Hell Hotel, the antiquarian has been missing now for four days.

He had been relentlessly searching the marshes since his arrival, seeking the alleged battlefield where mysterious adversaries massacred King Conomore and his army.

Continued on page 8

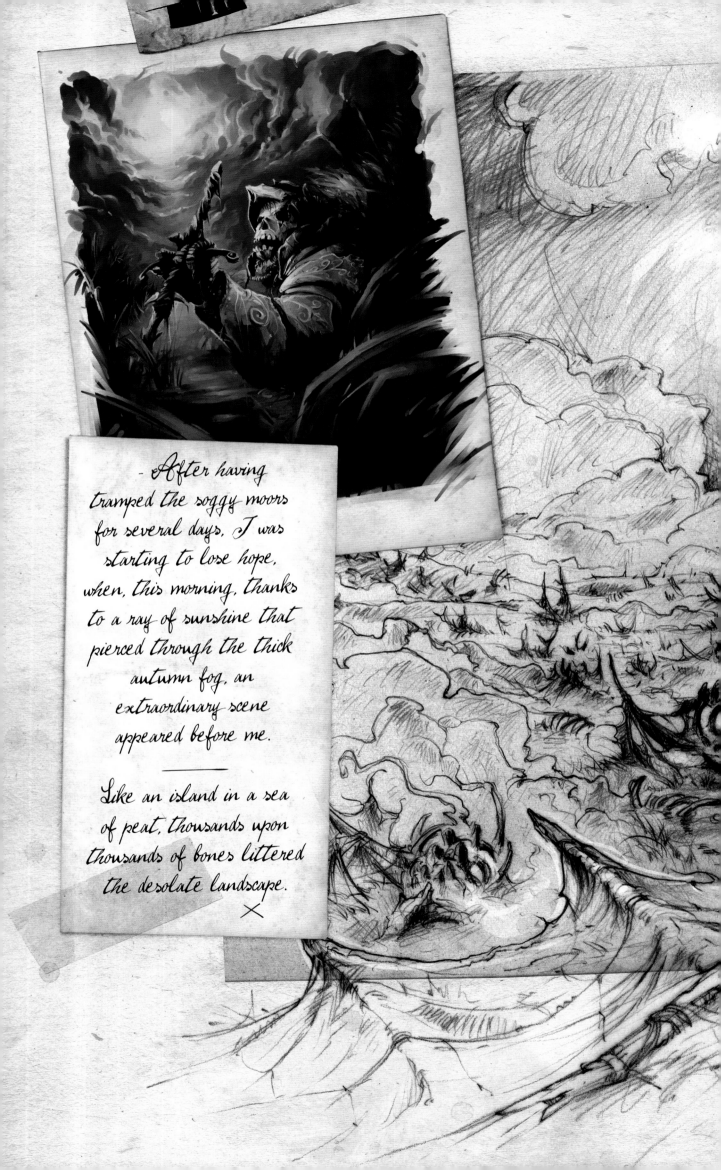

- After having tramped the soggy moors for several days, I was starting to lose hope, when, this morning, thanks to a ray of sunshine that pierced through the thick autumn fog, an extraordinary scene appeared before me.

———

Like an island in a sea of peat, thousands upon thousands of bones littered the desolate landscape.

X

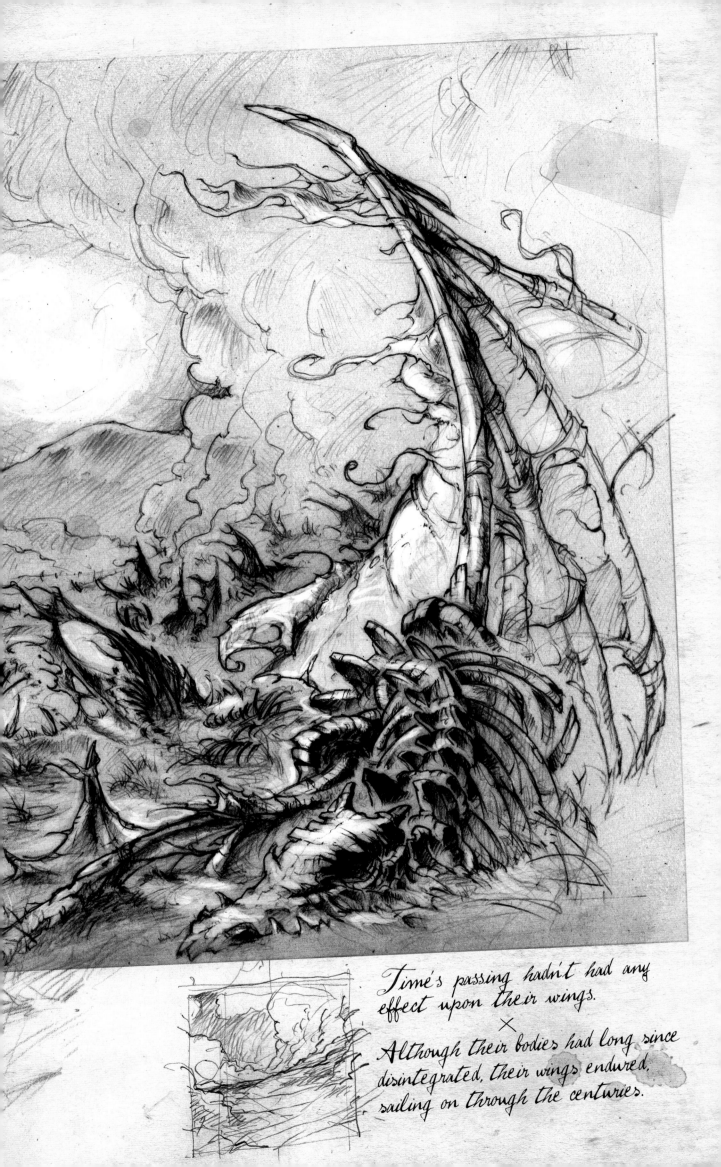

Time's passing hadn't had any effect upon their wings.

✕

Although their bodies had long since disintegrated, their wings endured, sailing on through the centuries.

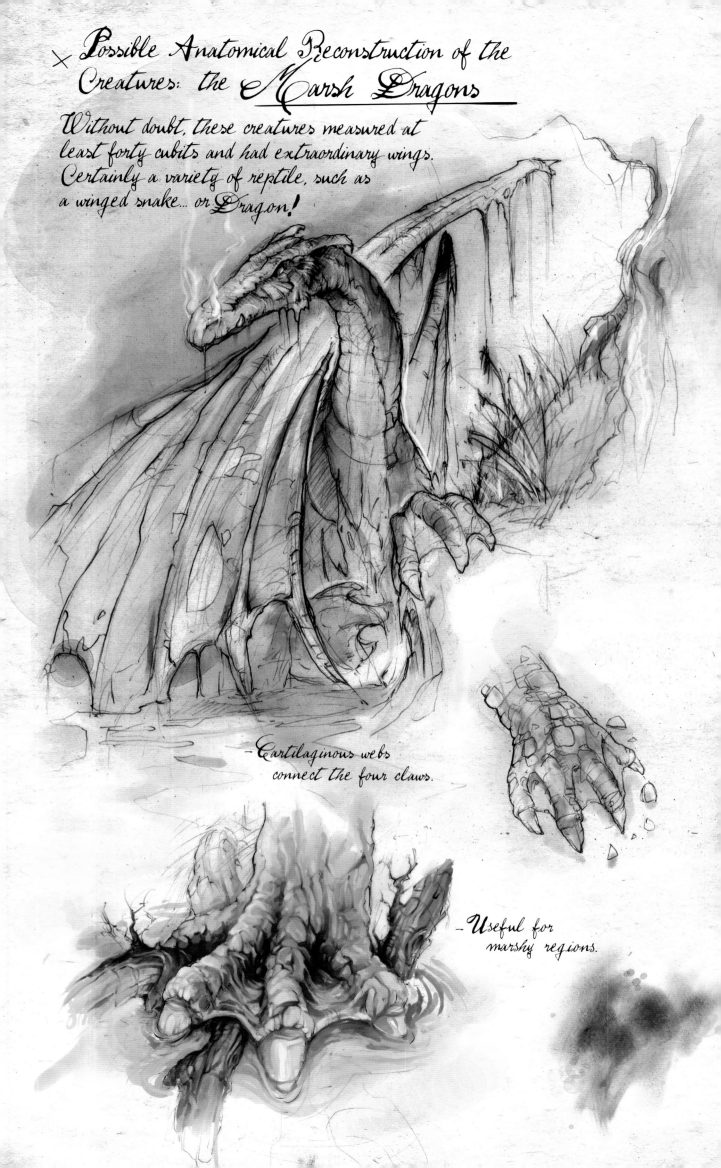

Possible Anatomical Reconstruction of the Creatures: the Marsh Dragons

Without doubt, these creatures measured at
least forty cubits and had extraordinary wings.
Certainly a variety of reptile, such as
a winged snake... or Dragon!

-Cartilaginous webs
connect the four claws.

-Useful for
marshy regions.

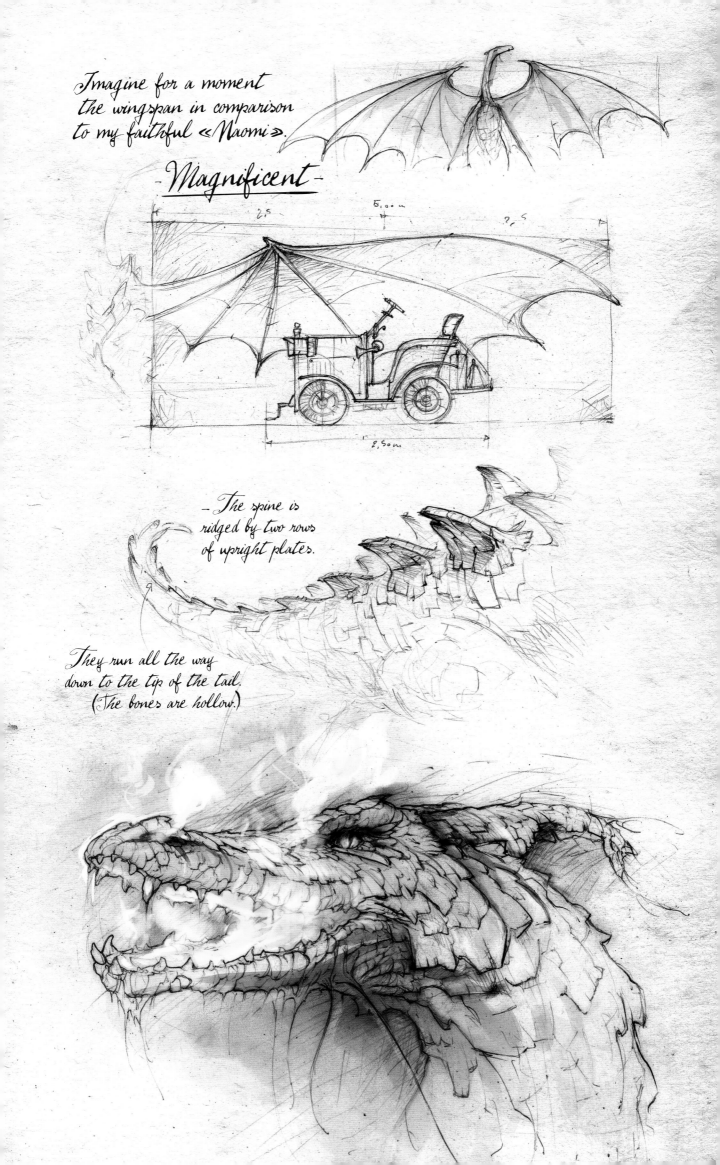

Imagine for a moment
the wingspan in comparison
to my faithful «Naomi».

Magnificent

- The spine is
ridged by two rows
of upright plates.

They run all the way
down to the tip of the tail.
(The bones are hollow.)

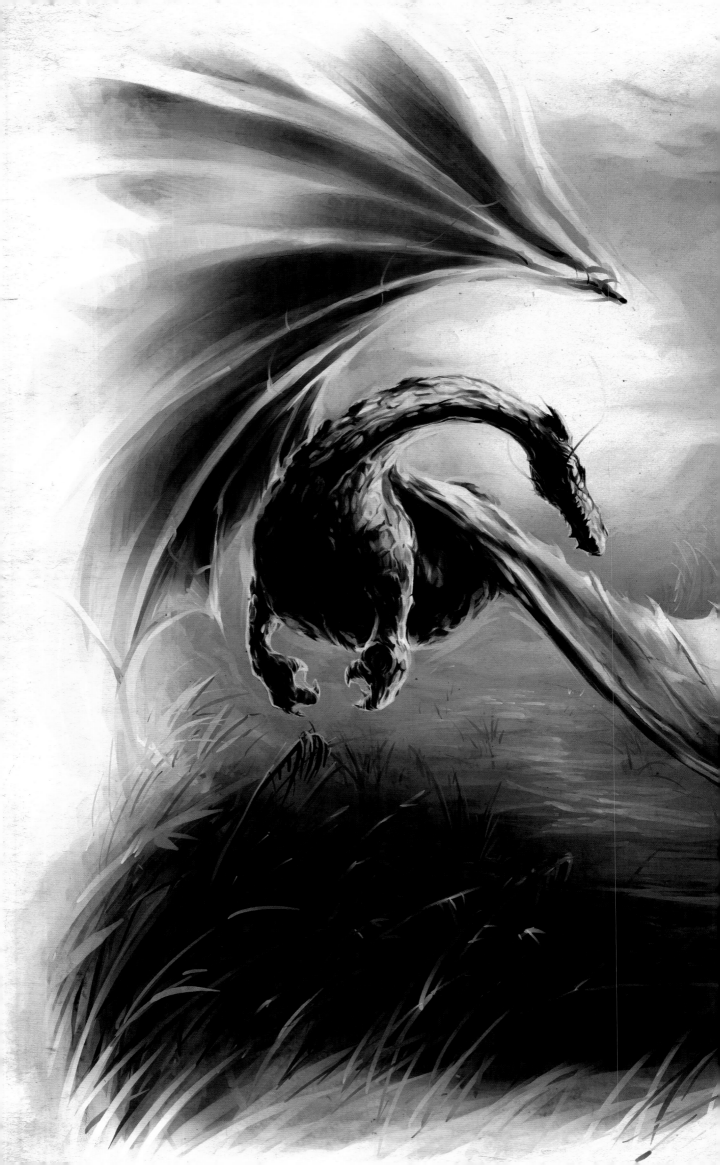

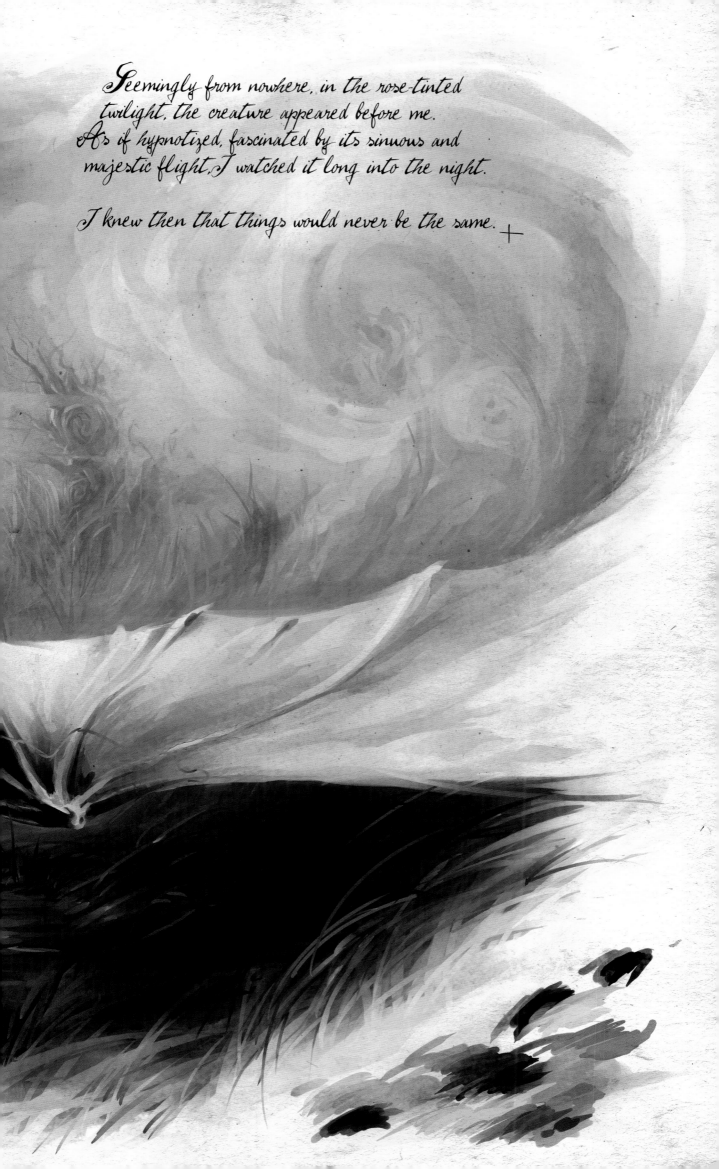

Seemingly from nowhere, in the rose-tinted
twilight, the creature appeared before me.
As if hypnotized, fascinated by its sinuous and
majestic flight, I watched it long into the night.

I knew then that things would never be the same. +

the Shadow Dragons

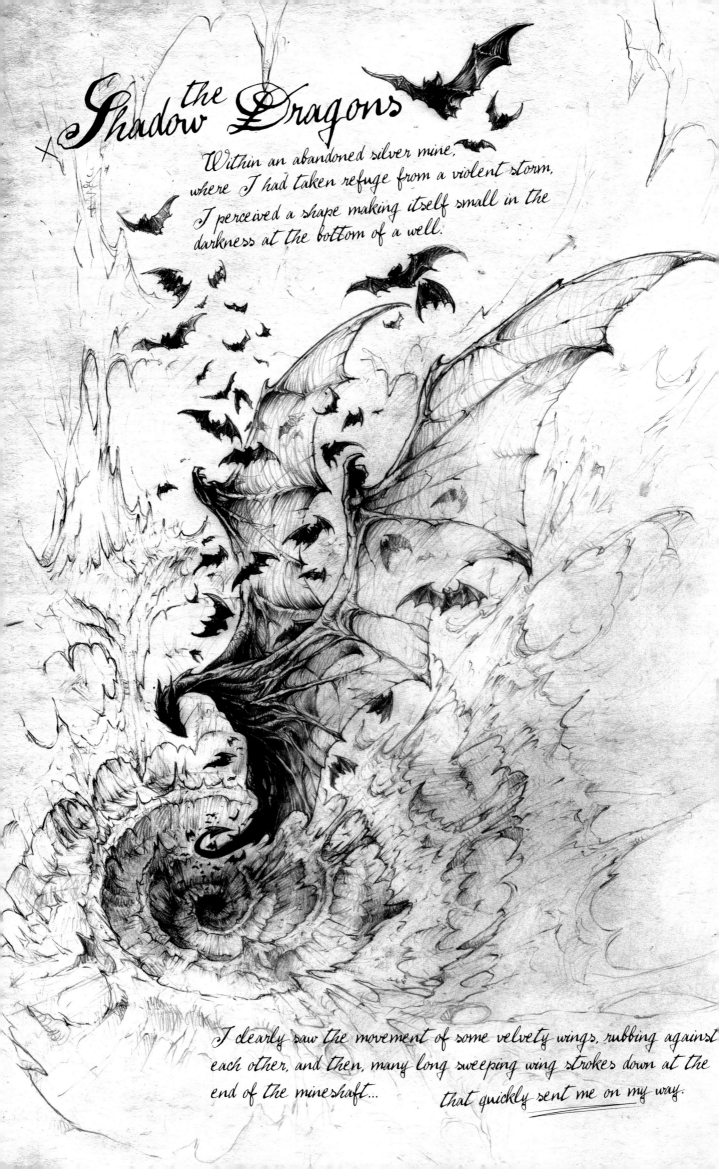

*Within an abandoned silver mine,
where I had taken refuge from a violent storm,
I perceived a shape making itself small in the
darkness at the bottom of a well.*

*I clearly saw the movement of some velvety wings, rubbing against
each other, and then, many long sweeping wing strokes down at the
end of the mineshaft... that quickly sent me on my way.*

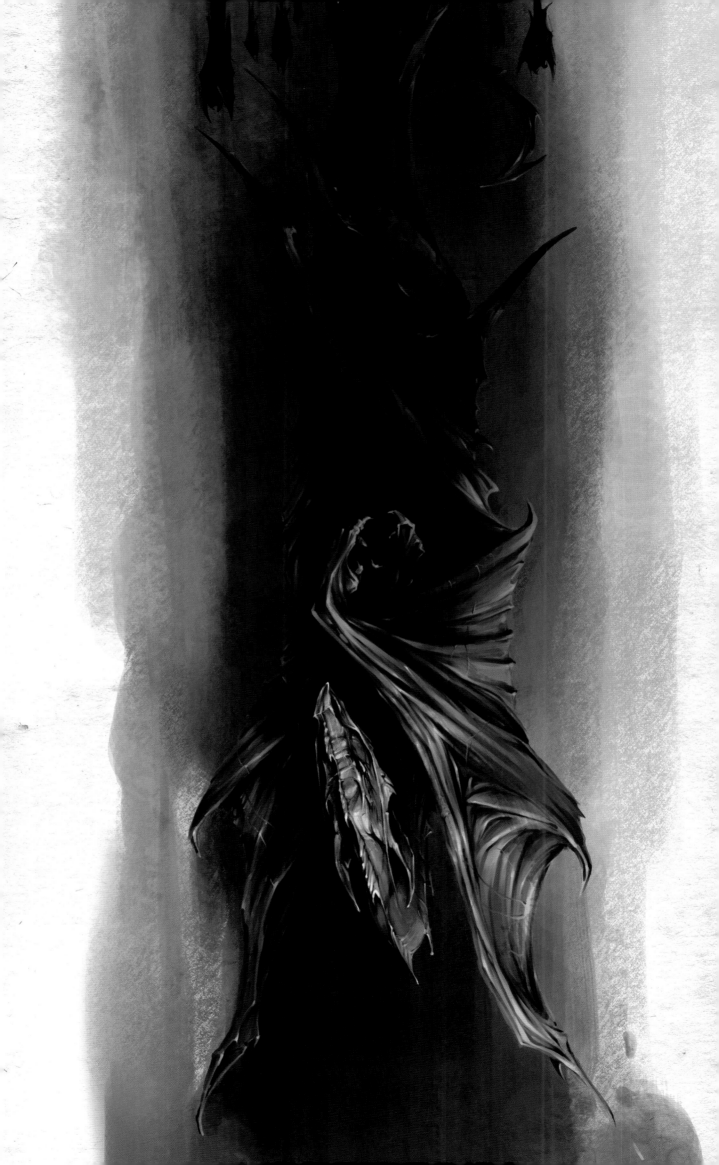

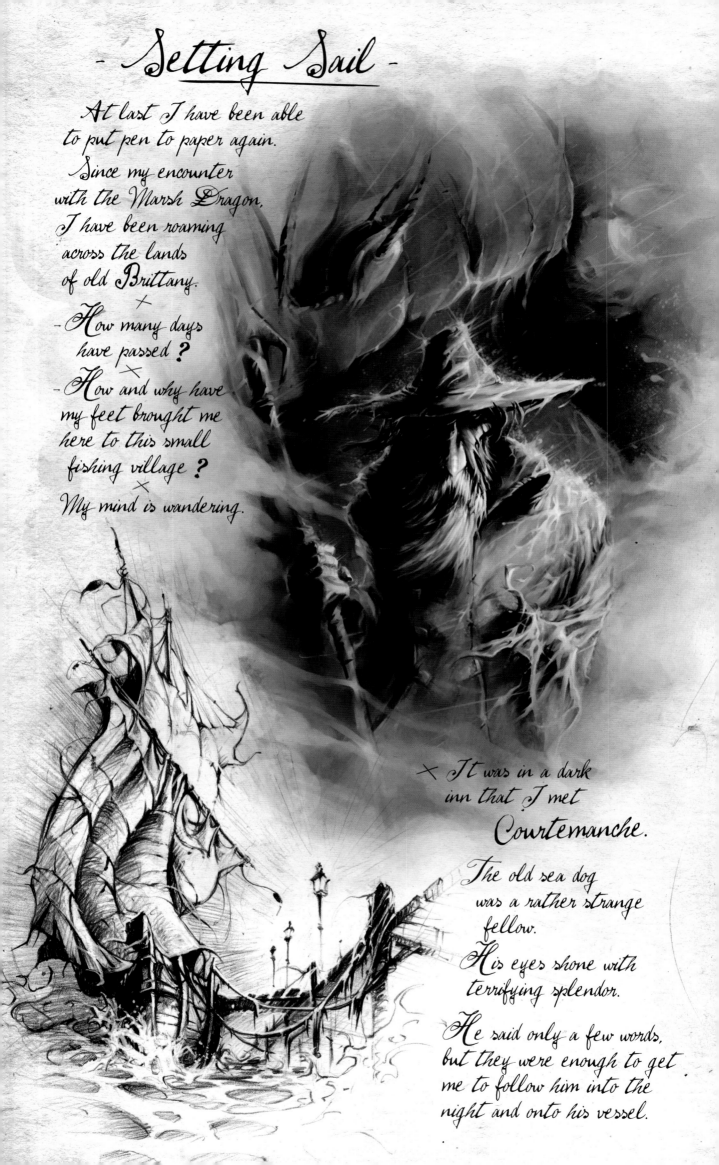

- Setting Sail -

At last I have been able
to put pen to paper again.
Since my encounter
with the Marsh Dragon,
I have been roaming
across the lands
of old Brittany.

— How many days
have passed?

— How and why have
my feet brought me
here to this small
fishing village?

My mind is wandering.

It was in a dark
inn that I met
Courtemanche.

The old sea dog
was a rather strange
fellow.
His eyes shone with
terrifying splendor.

He said only a few words,
but they were enough to get
me to follow him into the
night and onto his vessel.

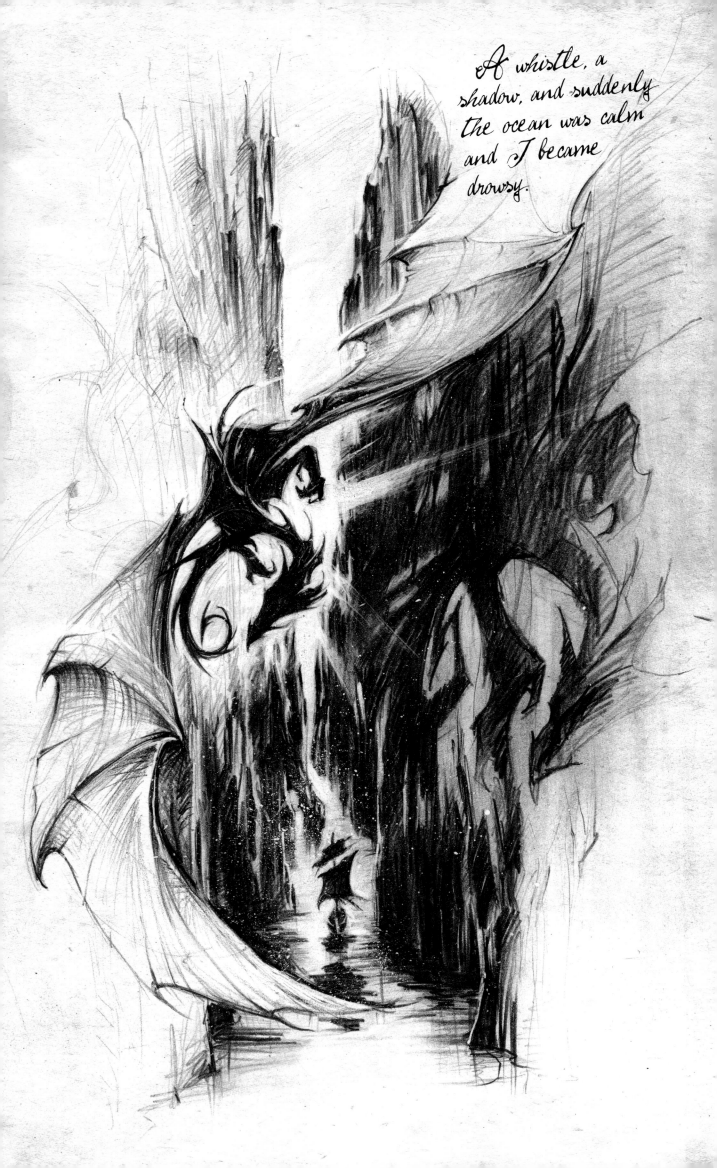

A whistle, a
shadow, and suddenly
the ocean was calm
and I became
drowsy.

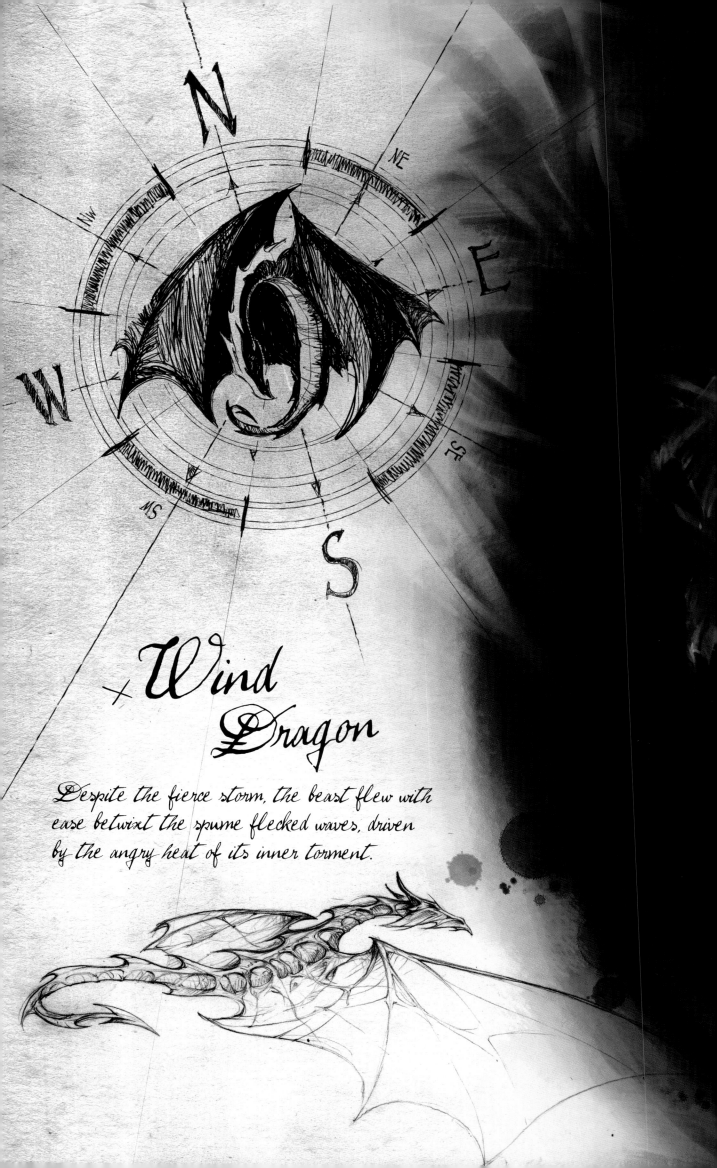

Wind Dragon

Despite the fierce storm, the beast flew with ease betwixt the spume flecked waves, driven by the angry heat of its inner torment.

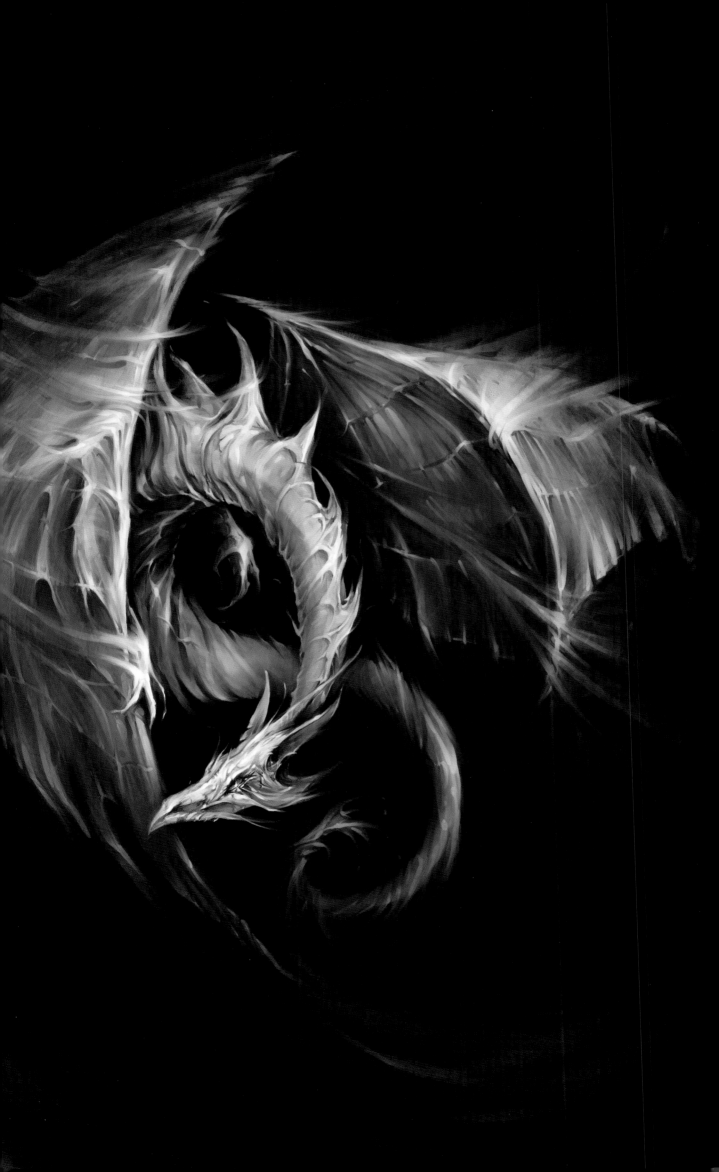

When I awoke, the storm had moved on.
A gentle calm had settled upon the
surface of the ocean.
As the silhouette of a rocky shore rose up in the distance,
a ring of colossal stones emerged from the morning mist.
In its center, a long winged creature flew, swooping
around the jagged rocks.

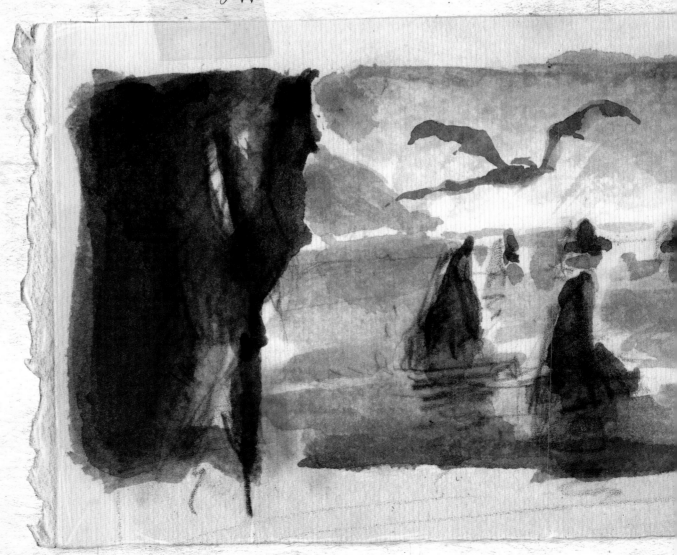

✗ As our vessel slowly approached __Cromlech.__

the Wind Dragon let loose a long, shrill cry and disappeared
suddenly behind one of the standing stones.

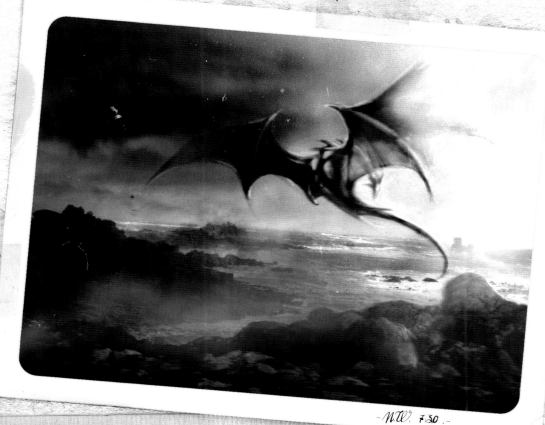

— N.W. 7.30 —

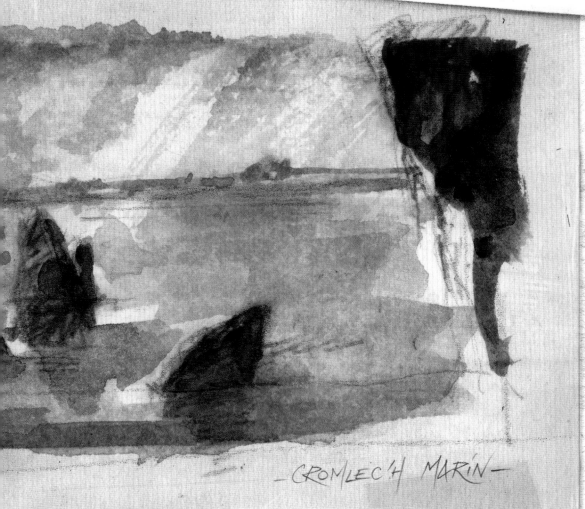

— CROMLEC'H MARIN —

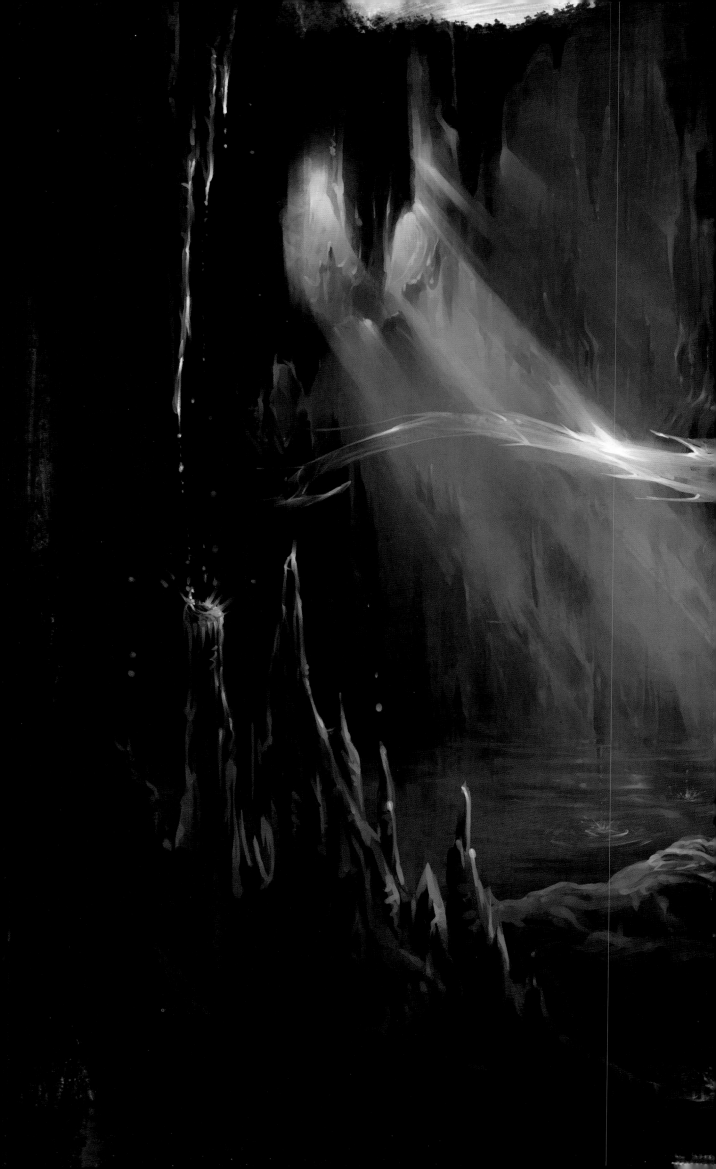

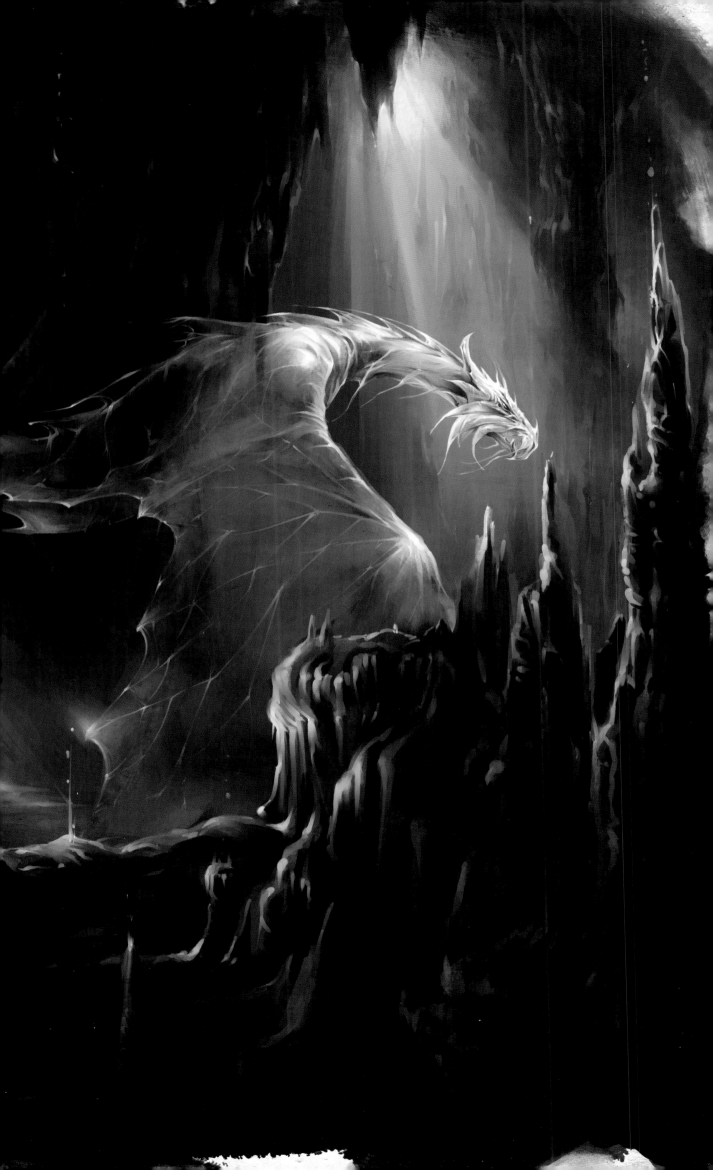

Atlantic Ocean

Scotland

Stranraer

Irish Sea

Ireland

Trouble at sea

England

St. George's Channel

English Channel

Departure for Scotland

Cromlech

Cave

Brittany

4 wind gap

Marshes

N
North

56°

53°

50°

47°

9°

6°

3°

✕ Side Notes

- The Dragon Cemetery -

There were at least five hundred car
casses that littered the marsh. What
special chemistry did this peat bog hold
that allowed for their preservation in
the open air?

The day following my discovery, I
searched in vain for the cemetery again.
The endless fog that shrouded the marsh
has long guarded, and guards still, that
extraordinary sanctuary.

✕

- The Wind Dragon -

Setting up my camera on the bridge of the creaking
old ship was not an easy task, thus I am rather proud
of the image I managed to capture of the amazing
flight of that magnificent creature.

✕

- The Marsh Dragon -

I'm a pretty poor naturalist, and being so
moved by what I saw, I was unable to note
precisely the details of this magnificent animal.
However, my drawing is quite ~~real~~ true-to-life.

+

- The Shadow Dragon -

I hardly believe that it really exists. Why,
suddenly, are all the Dragons of this world
showing themselves to me? What I think
I saw appears to be more fantasy than reality.

However......

- The Abbey -

For several hours we sailed up a long estuary, deep into the heart of the Lowlands. A man of few words, the ship's pilot landed the vessel, and with a nod of his head, indicated I should disembark...

As he came about, I headed up a deep forest valley where soon I came upon the ruins of a once vast Abbey.

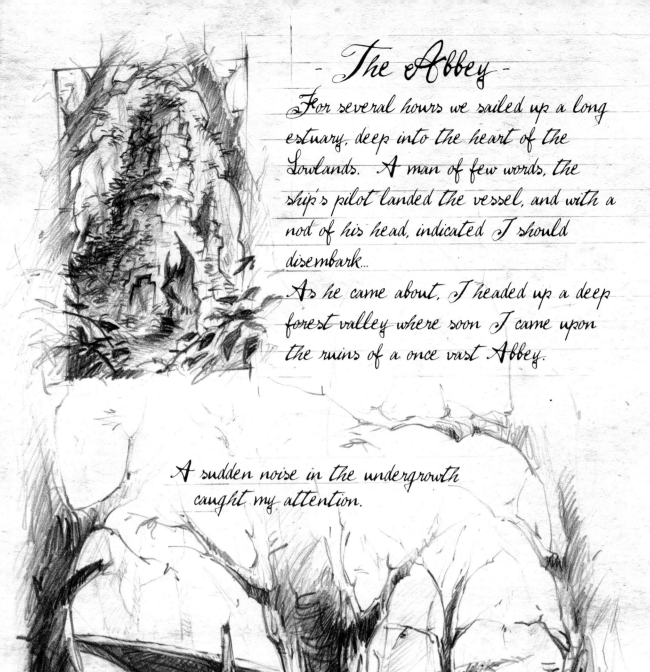

A sudden noise in the undergrowth caught my attention.

✕ A large winged shadow moved slowly through the thick, dark forest and then disappeared as suddenly as it had appeared.

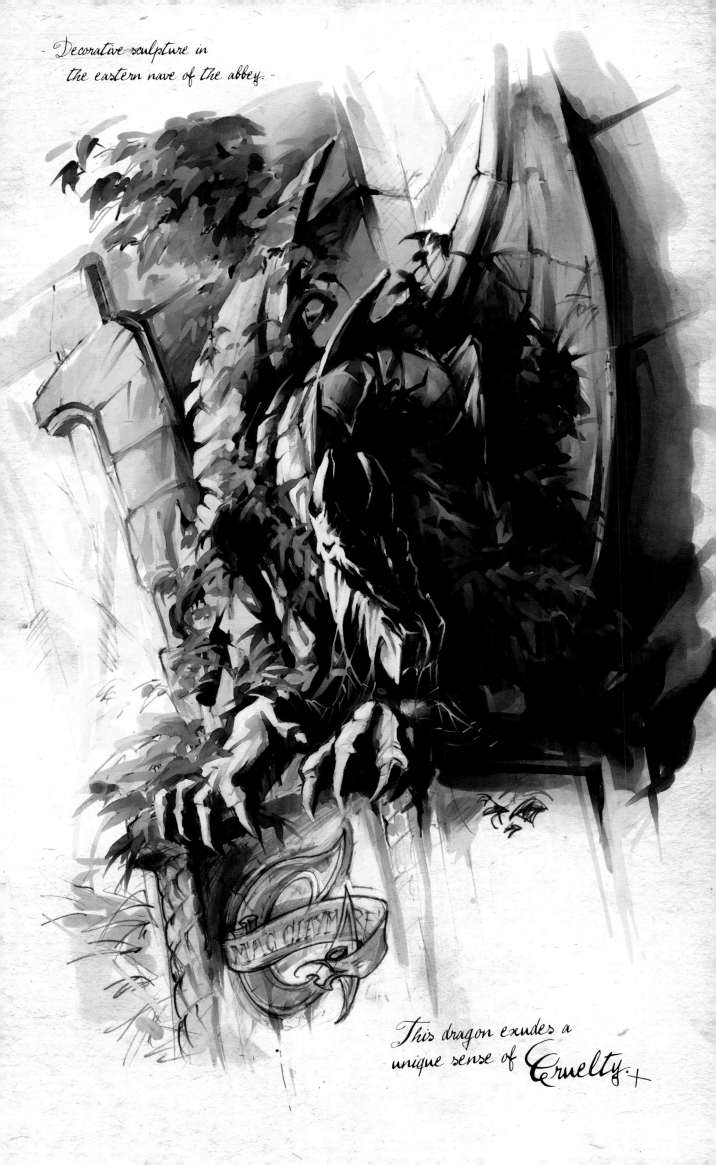

- Decorative sculpture in
 the eastern nave of the abbey. -

This dragon exudes a
unique sense of Cruelty. +

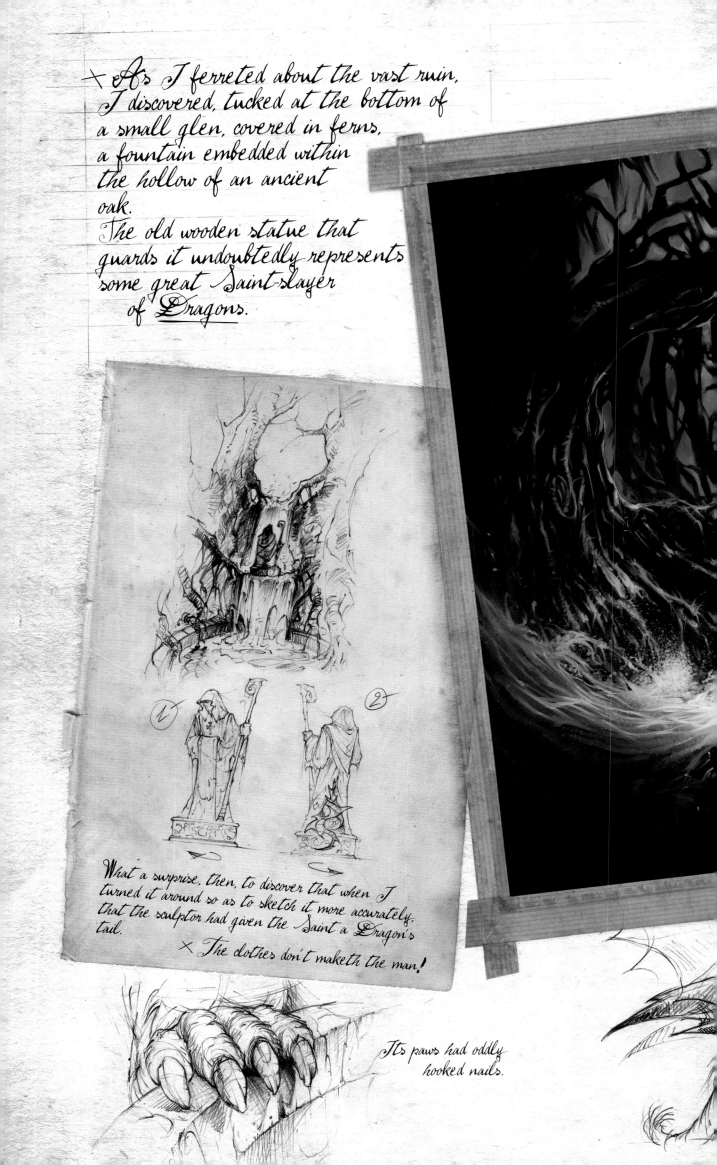

✗ As I ferreted about the vast ruin, I discovered, tucked at the bottom of a small glen, covered in ferns, a fountain embedded within the hollow of an ancient oak.
The old wooden statue that guards it undoubtedly represents some great Saint-slayer of Dragons.

What a surprise, then, to discover that when I turned it around so as to sketch it more accurately, that the sculptor had given the Saint a Dragon's tail.
✗ The clothes don't maketh the man!

Its paws had oddly hooked nails.

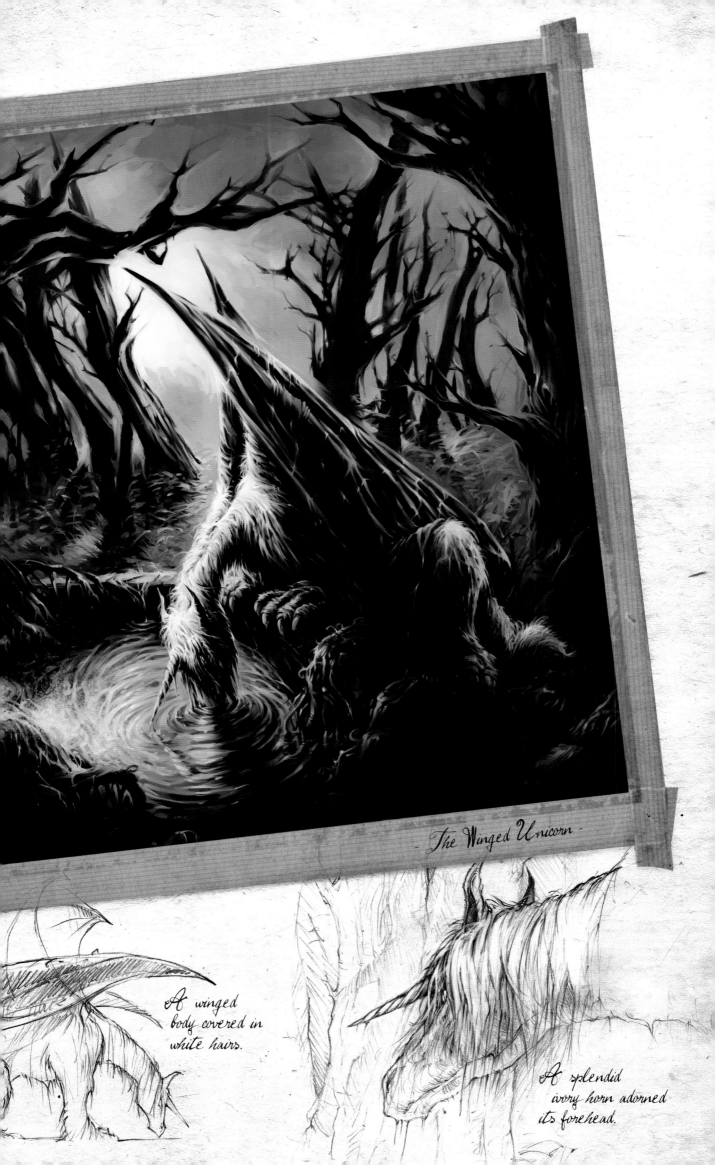

- The Winged Unicorn -

A winged
body covered in
white hairs.

A splendid
ivory horn adorned
its forehead.

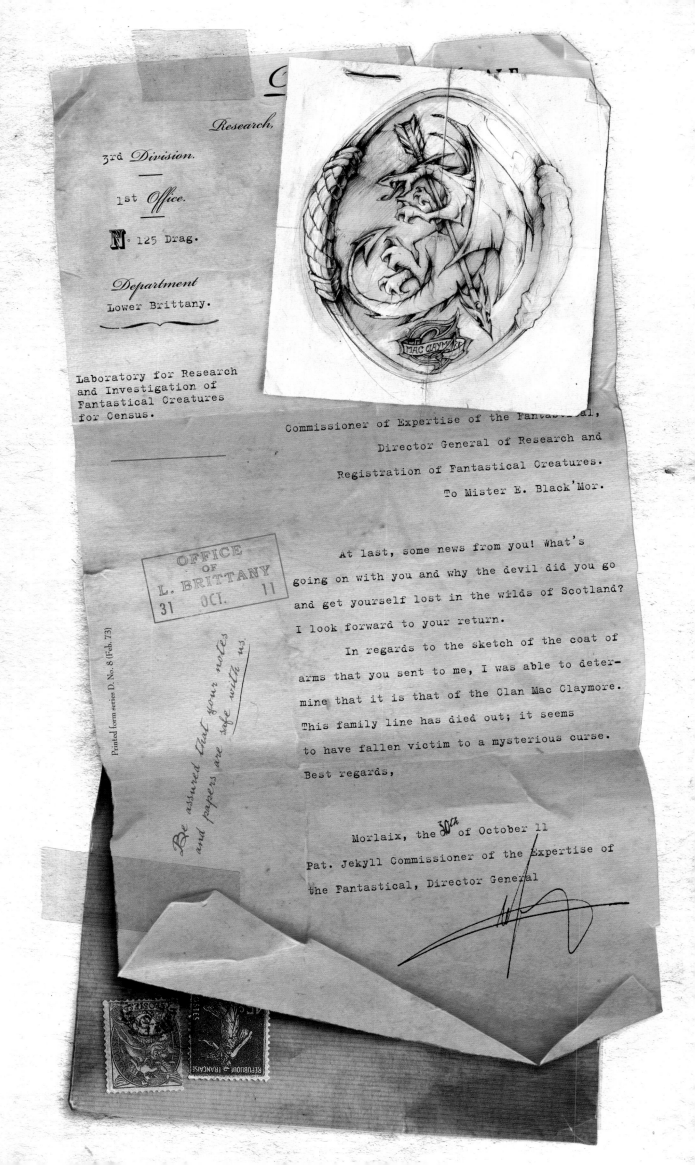

Research,

3rd *Division.*

1st *Office.*

N° 125 Drag.

Department
Lower Brittany.

Laboratory for Research
and Investigation of
Fantastical Creatures
for Census.

*Be assured that your notes
and papers are safe with us.*

Commissioner of Expertise of the Fantastical,

Director General of Research and

Registration of Fantastical Creatures.

To Mister E. Black'Mor.

At last, some news from you! What's
going on with you and why the devil did you go
and get yourself lost in the wilds of Scotland?
I look forward to your return.

In regards to the sketch of the coat of
arms that you sent to me, I was able to deter-
mine that it is that of the Clan Mac Claymore.
This family line has died out; it seems
to have fallen victim to a mysterious curse.
Best regards,

Morlaix, the 30th of October 11
Pat. Jekyll Commissioner of the Expertise of
the Fantastical, Director General

MAC CLAYMORE

REPUBLIQUE FRANÇAISE

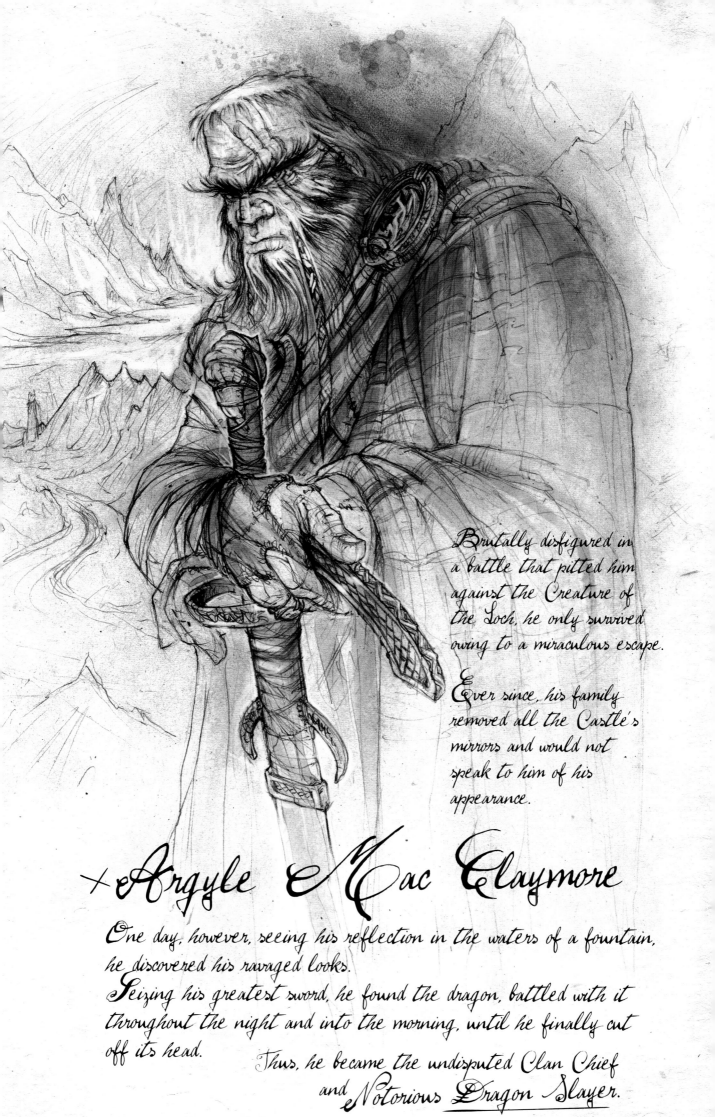

Brutally disfigured in a battle that pitted him against the Creature of the Loch, he only survived owing to a miraculous escape.

Ever since, his family removed all the Castle's mirrors and would not speak to him of his appearance.

Argyle Mac Claymore

One day, however, seeing his reflection in the waters of a fountain, he discovered his ravaged looks.
Seizing his greatest sword, he found the dragon, battled with it throughout the night and into the morning, until he finally cut off its head.
Thus, he became the undisputed Clan Chief and Notorious Dragon Slayer.

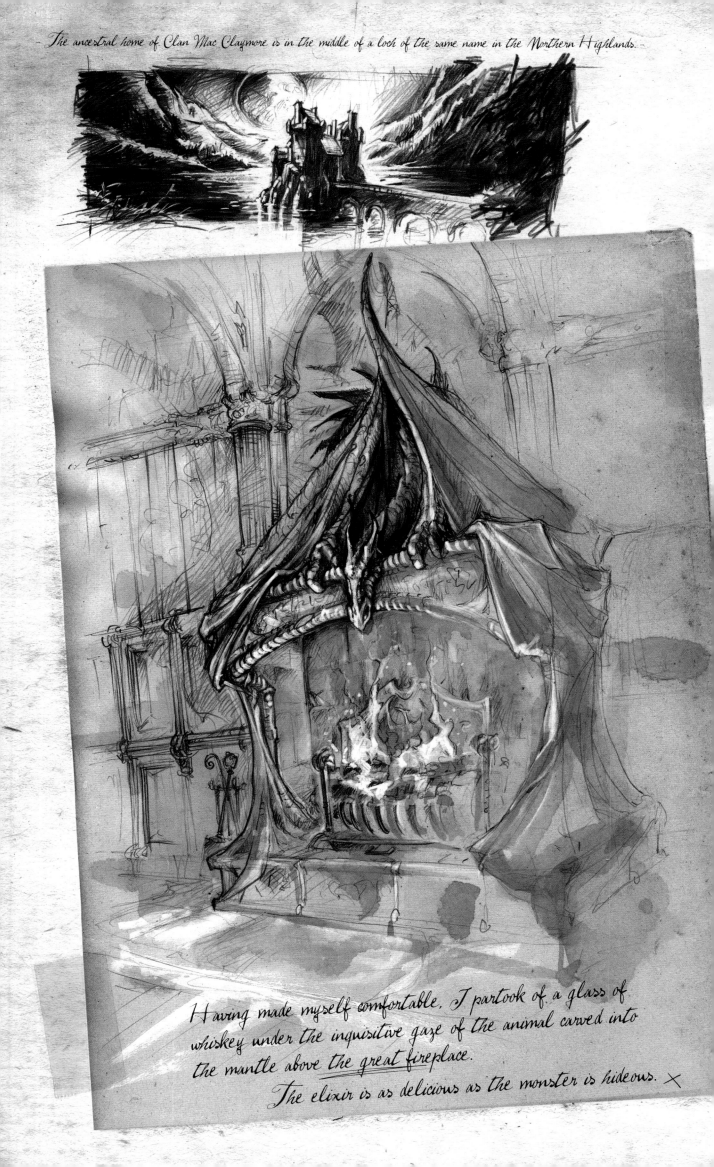

Having made myself comfortable, I partook of a glass of whiskey under the inquisitive gaze of the animal carved into the mantle above the great fireplace.

The elixir is as delicious as the monster is hideous. X

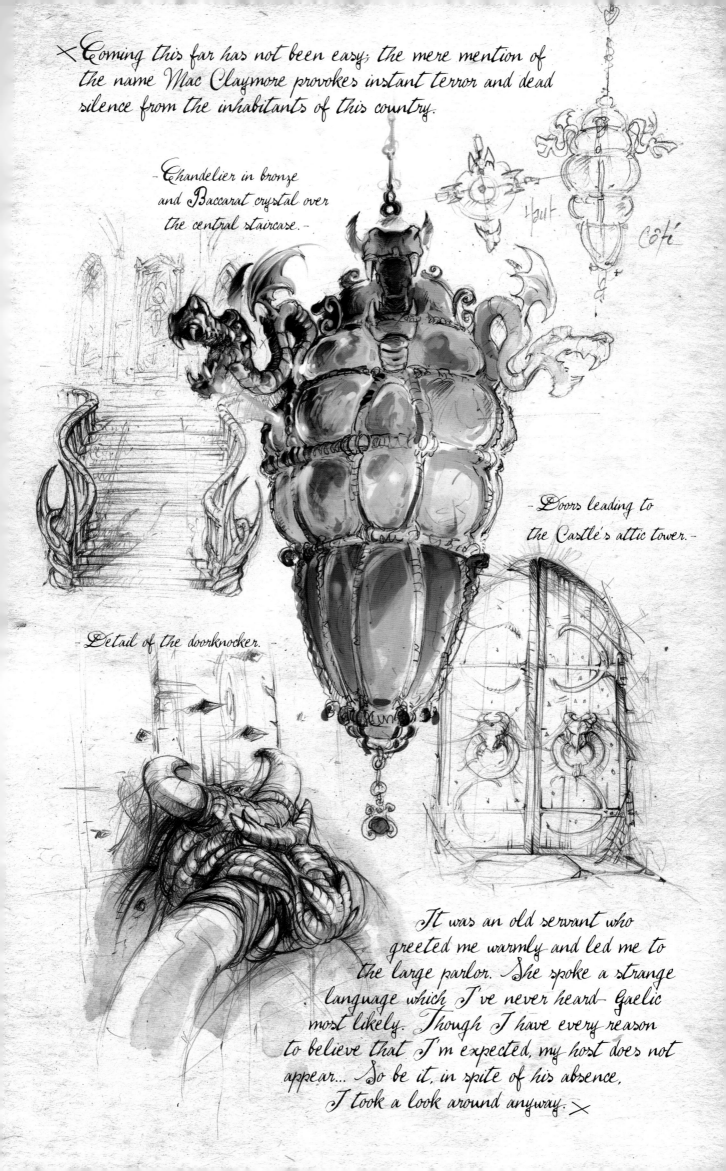

Coming this far has not been easy; the mere mention of the name Mac Claymore provokes instant terror and dead silence from the inhabitants of this country.

- Chandelier in bronze and Baccarat crystal over the central staircase. -

Haut

côté

- Doors leading to the Castle's attic tower. -

- Detail of the doorknocker. -

It was an old servant who greeted me warmly and led me to the large parlor. She spoke a strange language which I've never heard— Gaelic most likely. Though I have every reason to believe that I'm expected, my host does not appear... So be it, in spite of his absence, I took a look around anyway.

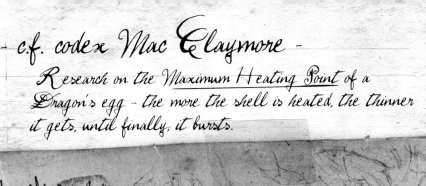

c.f. codex Mac Claymore -

Research on the Maximum Heating Point of a
Dragon's egg - the more the shell is heated, the thinner
it gets, until finally, it bursts.

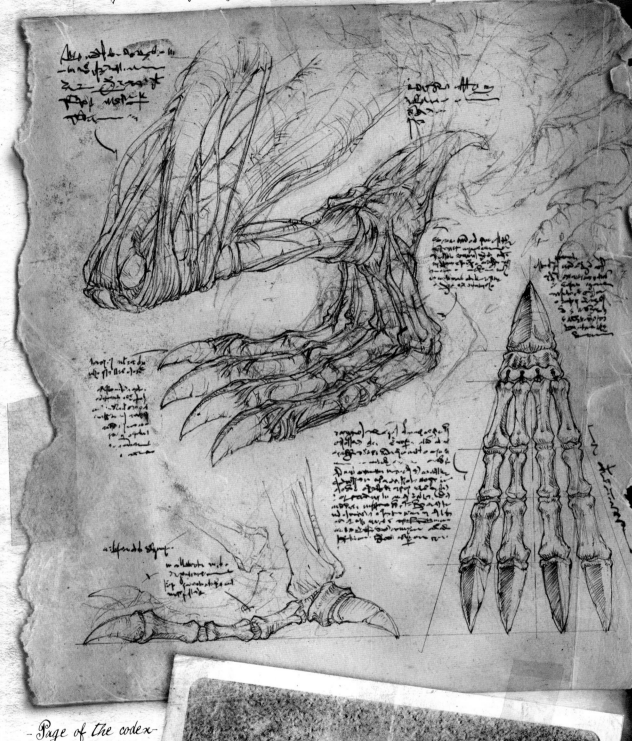

- Page of the codex-

- Footprint
photographed
on the banks
of the Loch -

X

(The similarities
to the studies
in the codex
are unsettling)

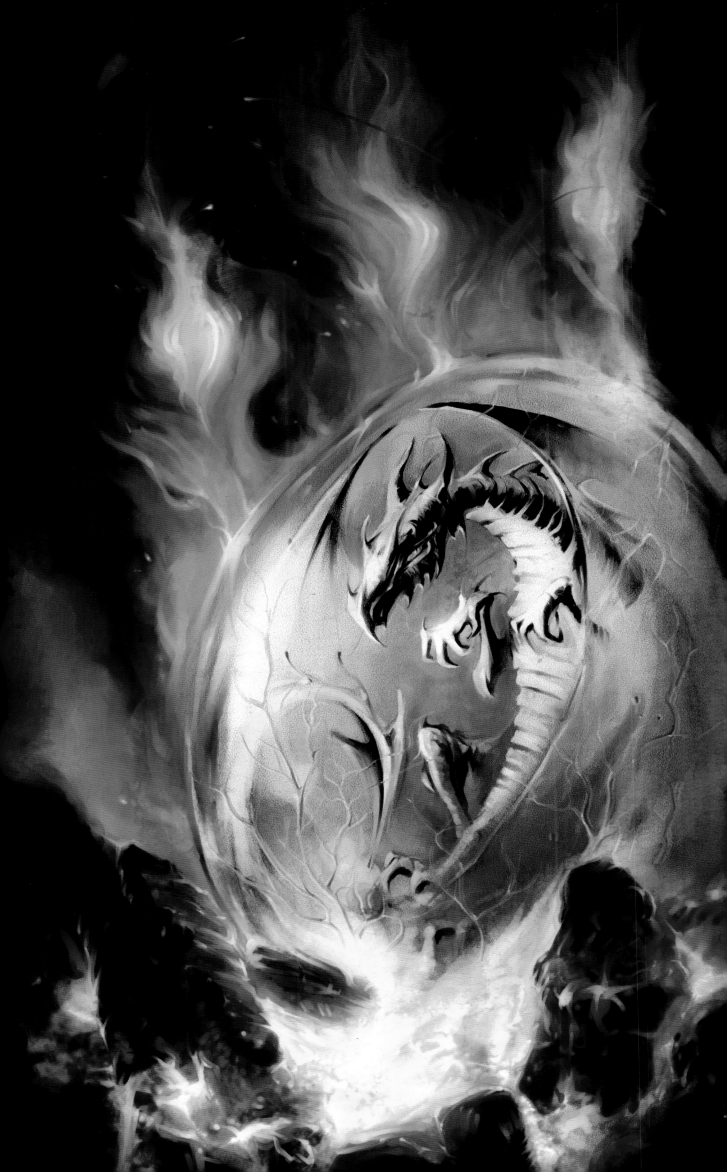

✕ The Attic

A nightmarish place wherein I discovered a strange arsenal.

Without a doubt, this is the lair where Argyle Mac Claymore imprisoned his victims and caused them to suffer the worst *Torments.*

The willow and steel cage mercilessly imprisoned the captured animal.

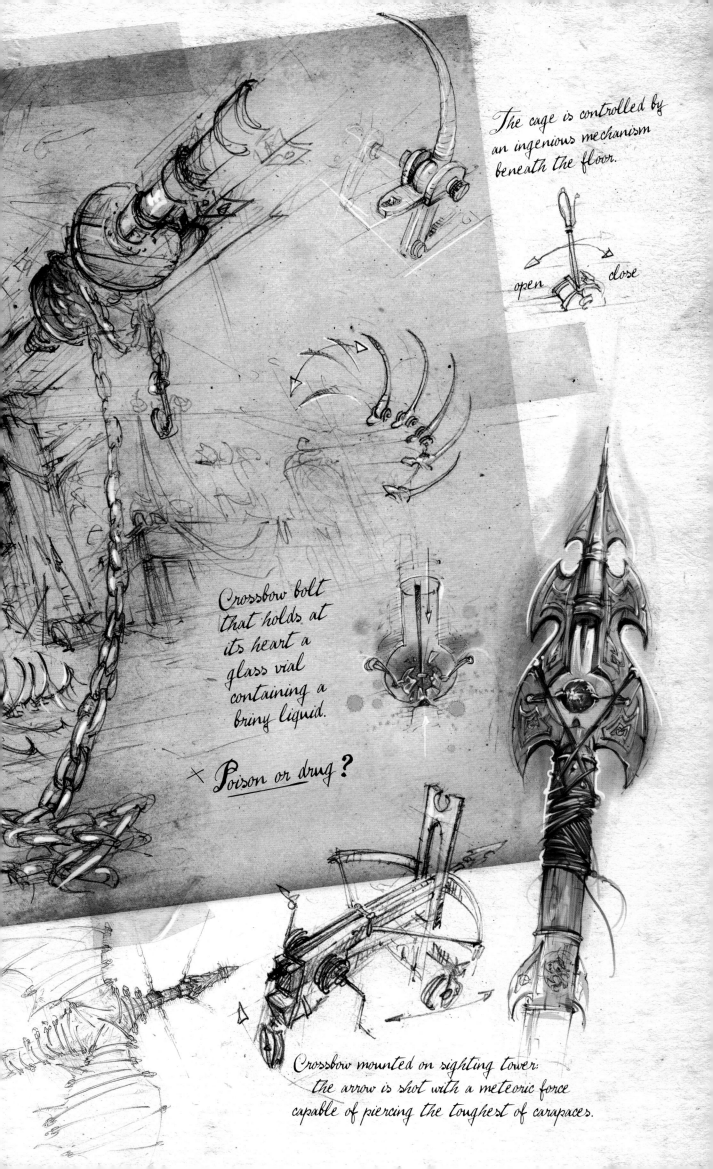

The cage is controlled by an ingenious mechanism beneath the floor.

open close

Crossbow bolt that holds at its heart a glass vial containing a briny liquid.

✗ Poison or drug?

Crossbow mounted on sighting tower: the arrow is shot with a meteoric force capable of piercing the toughest of carapaces.

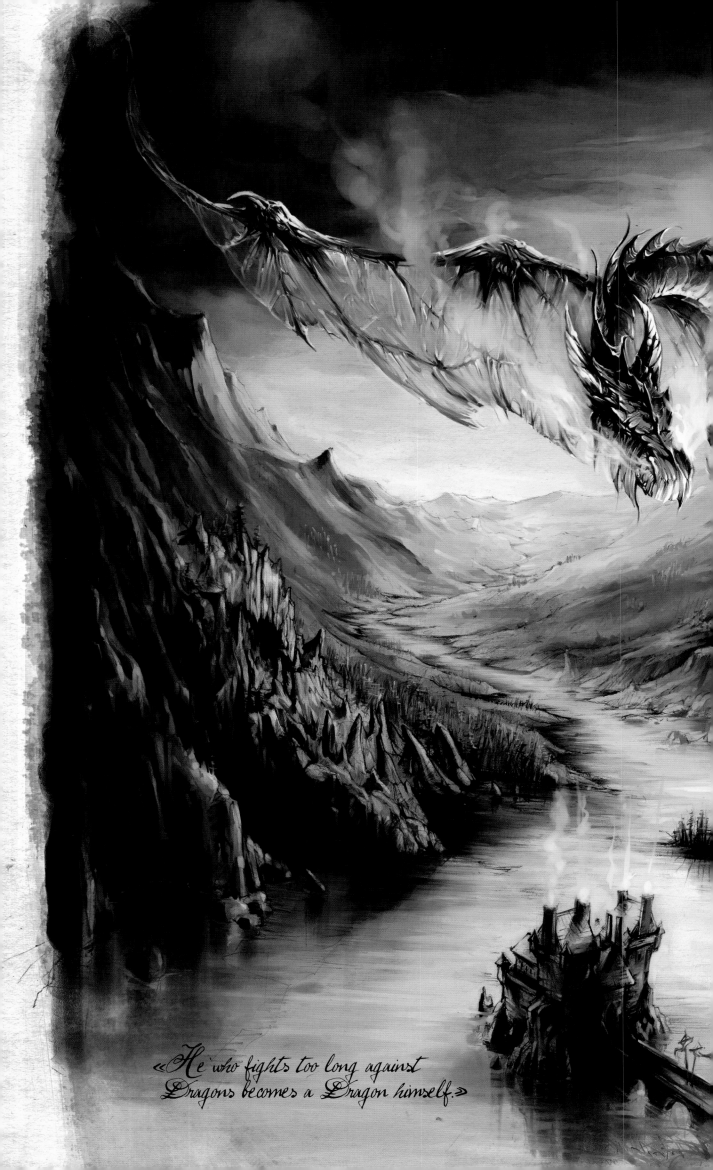

«He who fights too long against Dragons becomes a Dragon himself.»

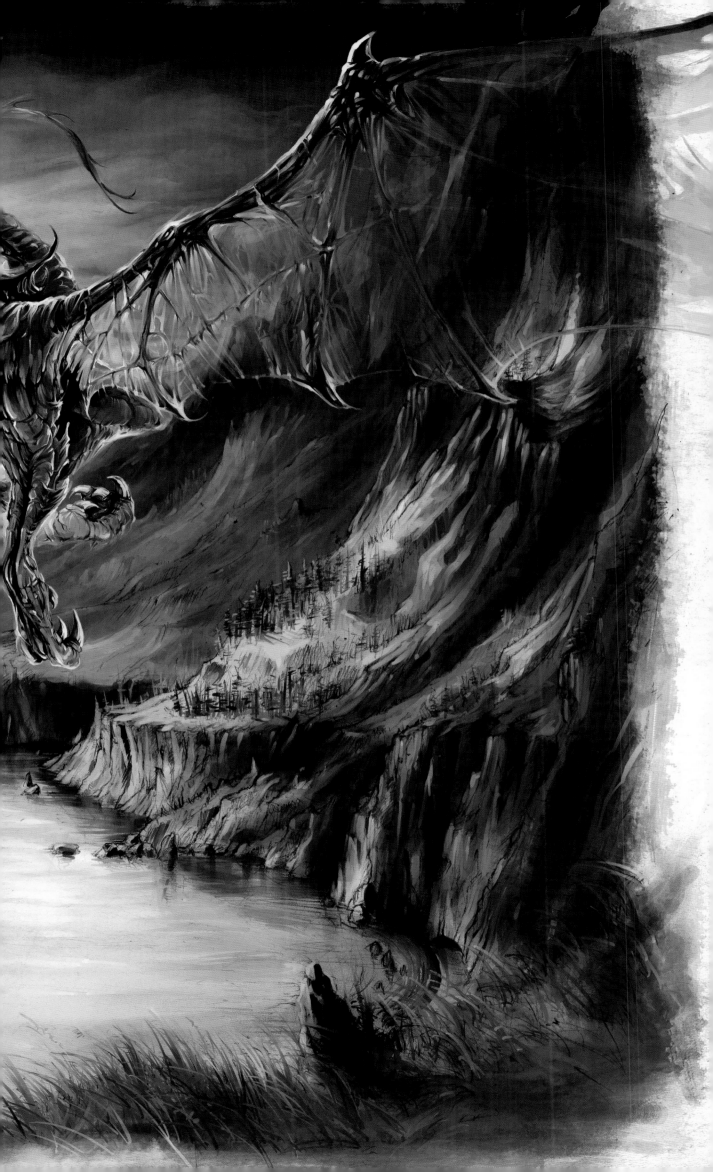

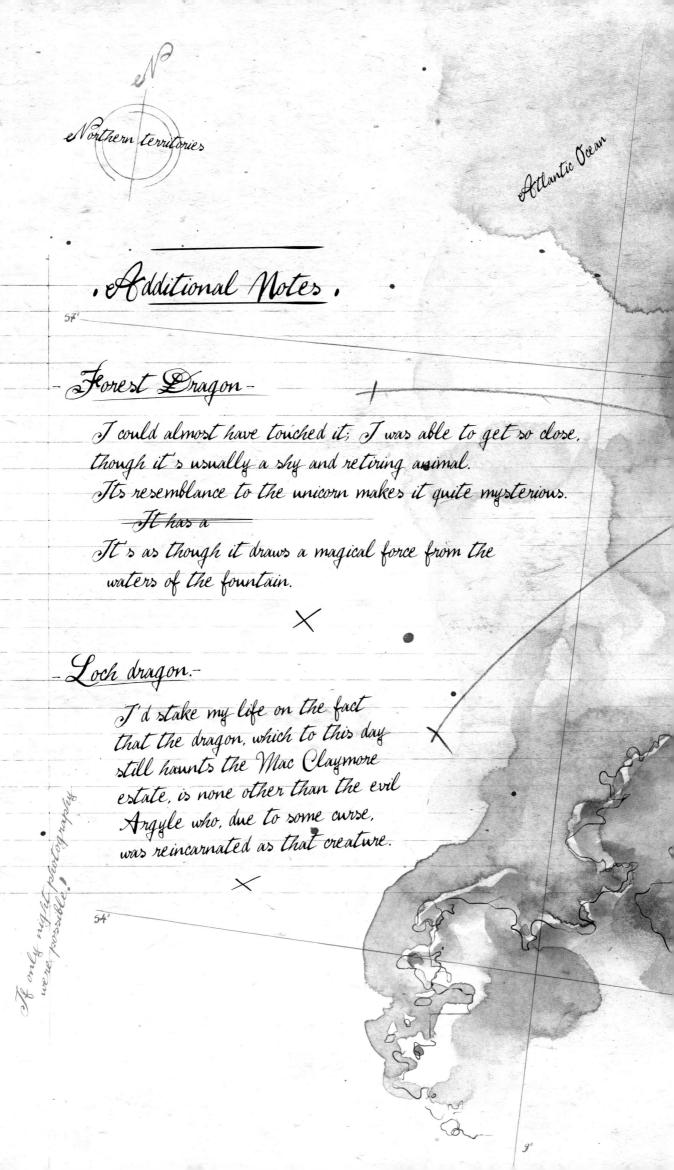

Atlantic Ocean

. Additional Notes .

57°

- Forest Dragon -

I could almost have touched it; I was able to get so close,
though it's usually a shy and retiring animal.
Its resemblance to the unicorn makes it quite mysterious.
~~It has a~~
It's as though it draws a magical force from the
waters of the fountain.

X

- Loch dragon -

I'd stake my life on the fact
that the dragon, which to this day
still haunts the Mac Claymore
estate, is none other than the evil
Argyle who, due to some curse,
was reincarnated as that creature.

X

If only night photography
were possible!

54°

9°

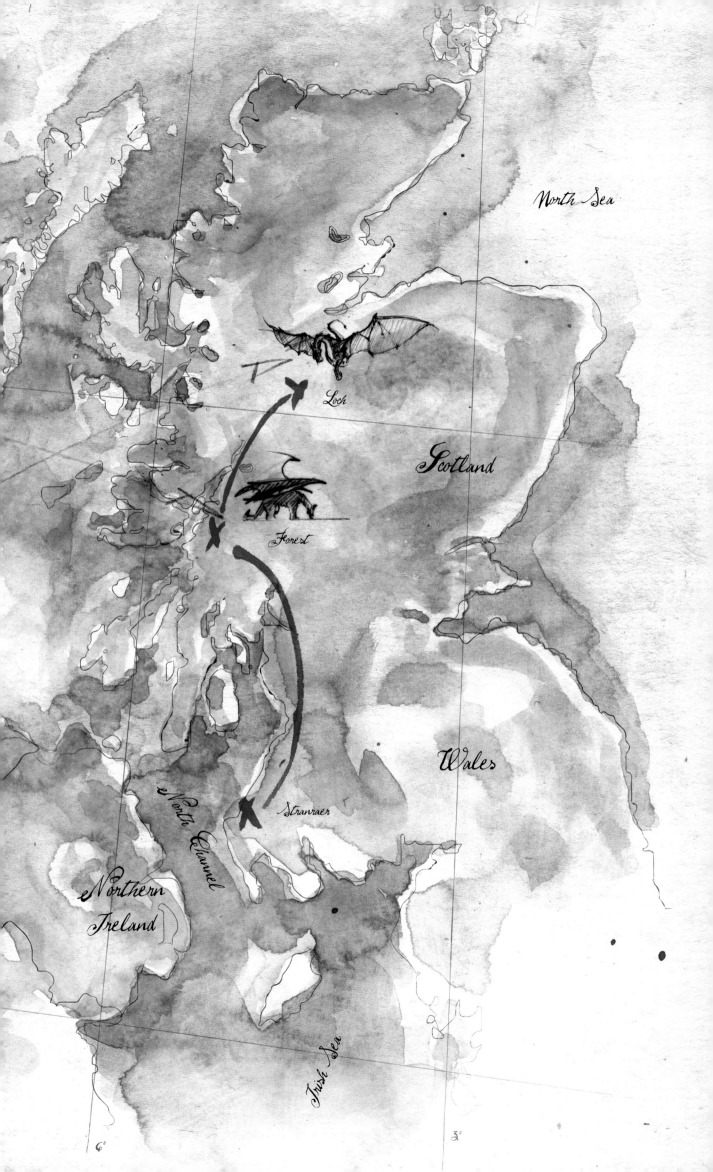

North Sea

Loch

Scotland

Forest

Wales

North Channel

Stranraer

Northern
Ireland

Irish Sea

×I finally caught up with Courtemanche!
As churlish as ever, my guide had been
waiting for me for the last few weeks in
a pub in Mallaig.
We sailed off towards the Irish Isles
at the break of dawn.
Sensing that my companion was tense and
worried, I kept my eye on the surface of
the sea, which suddenly started to roil, then
bubble vigorously as though we were inside
some sort of infernal caldron.

The Muirdris

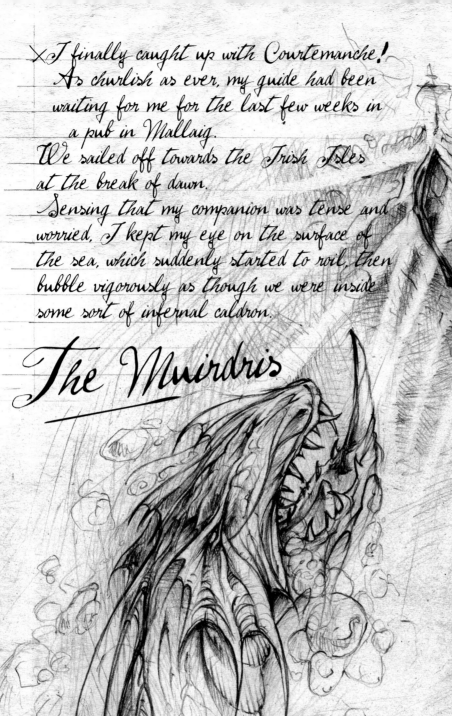

The Muirdris, a sea serpent of terrifying proportions,
rose from out of the middle of the turbulence and
roiling vapors.
The whirlpools and eddies that it generated nearly
overturned our ship.
However, his intentions did not seem belligerent.
He accompanied us for the next few miles before
diving back into the dark depths of the Irish Sea.

This weird creature being part serpent, part salmon has a mouth in the shape of a fish. It is able to breathe fire underwater.

Siren Dragon

We came across a shipwreck drifting with the currents.

The sails seemed to have been fire-damaged, though there was no trace of fire on the bridge, or below.

The deserted ship.

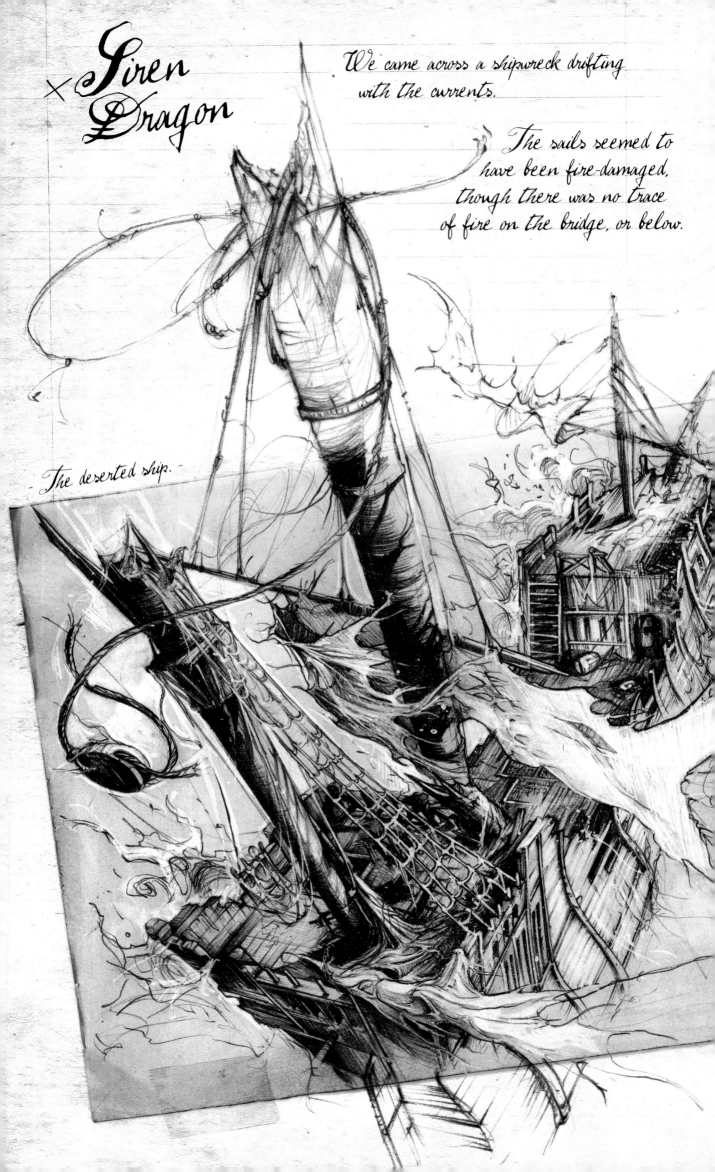

- WANTED -

REWARD

WARNING !

IT IS RECOMMENDED
THAT ANY ATTEMPTS TO
APPREHEND THE BEAST
BE DONE WITH NO LESS
THAN 100 STRONG
ARMED MEN.

4.000 PIASTRES !

NAME : SIREN DRAGON.................................

CHARACTERISTICS : WRECKS SHIPS.................................

PECULIARITY : SIMULATES BENGAL LIGHTS.................................

CONTACT THE CONFIDENTIAL MISSIONARY WITH ANY INFORMATION

-Plate affixed to the officer's mess wall.-

This creature, able to conjure up storms, haunts the coast of Ireland and, in the way of all Sirens, draws ships upon the reefs in the dark of night, with its breath of fire.

×

It has a predilection for the old shores from whence the missionary monks set out upon their stone vessels

Probably settling an old score!

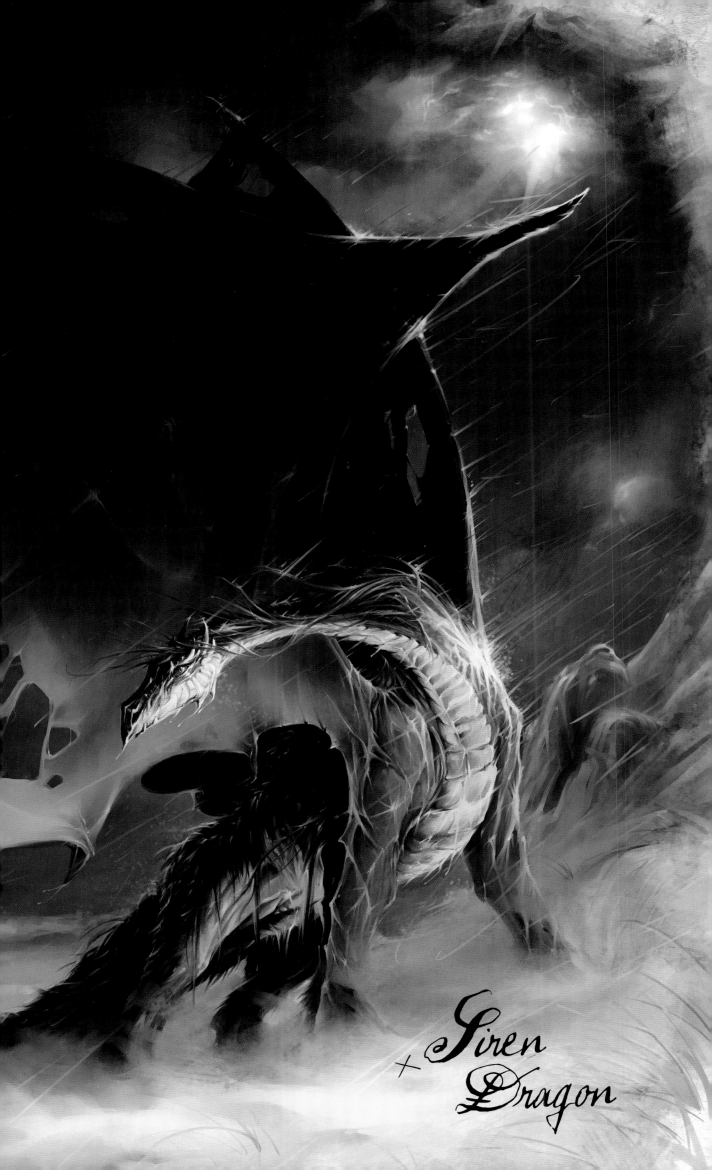

Siren
+ Dragon

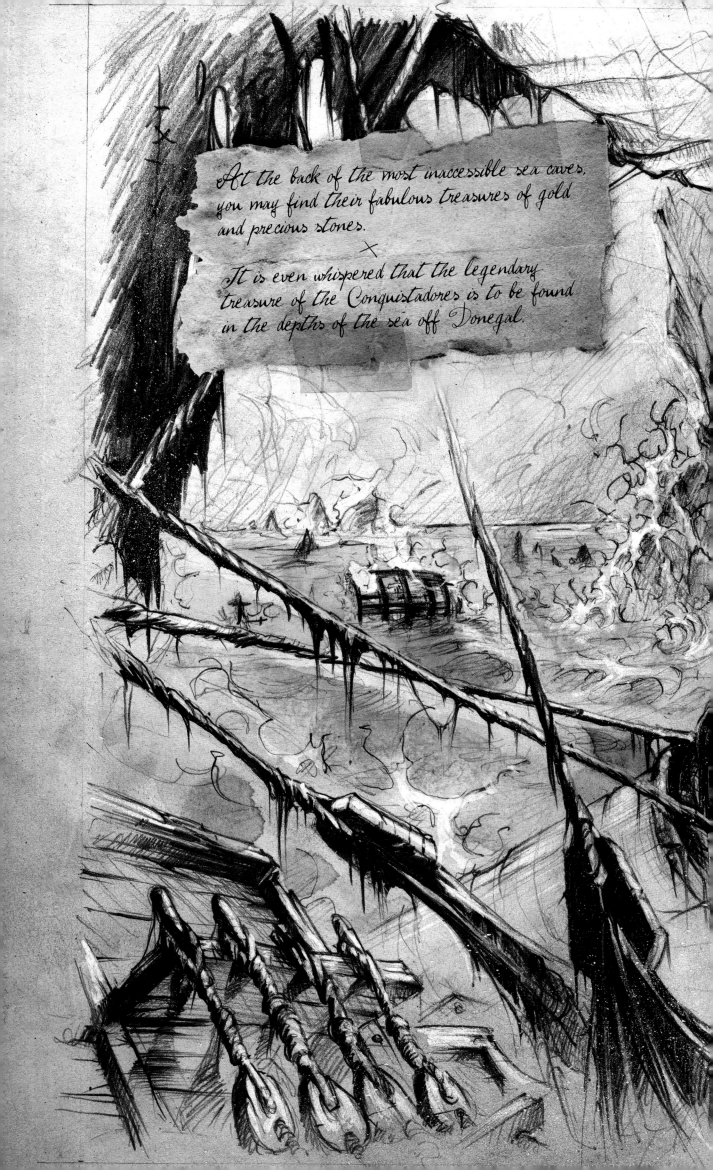

At the back of the most inaccessible sea caves, you may find their fabulous treasures of gold and precious stones.

It is even whispered that the legendary treasure of the Conquistadores is to be found in the depths of the sea off Donegal.

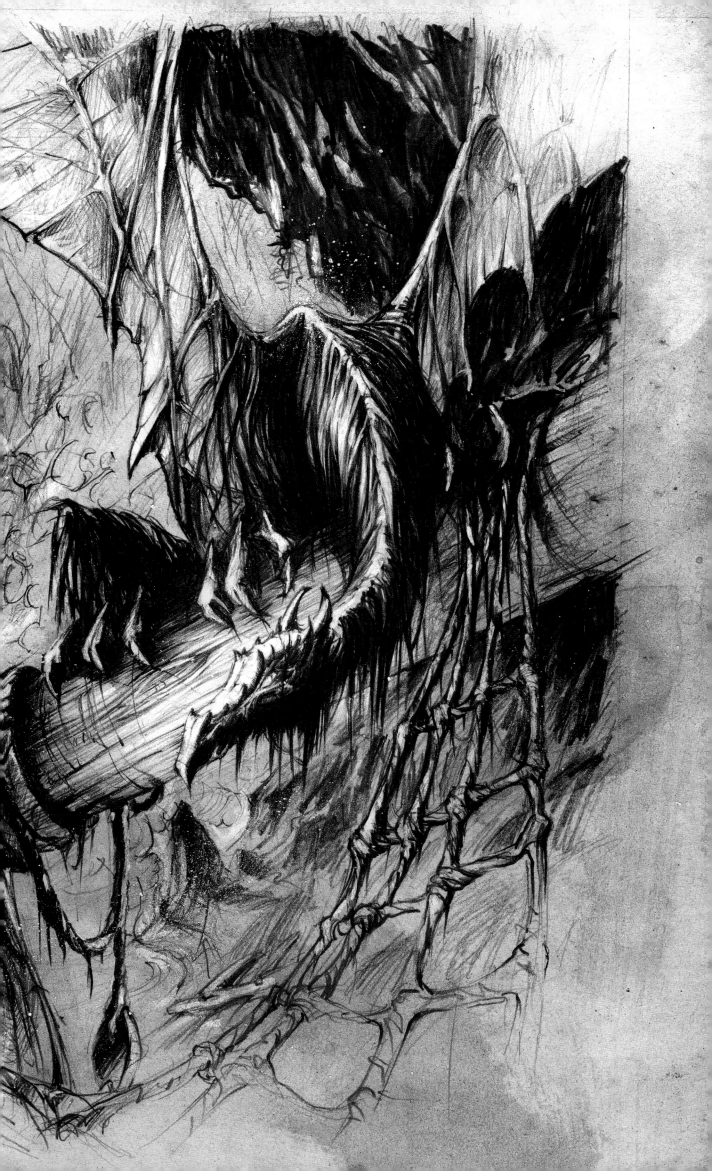

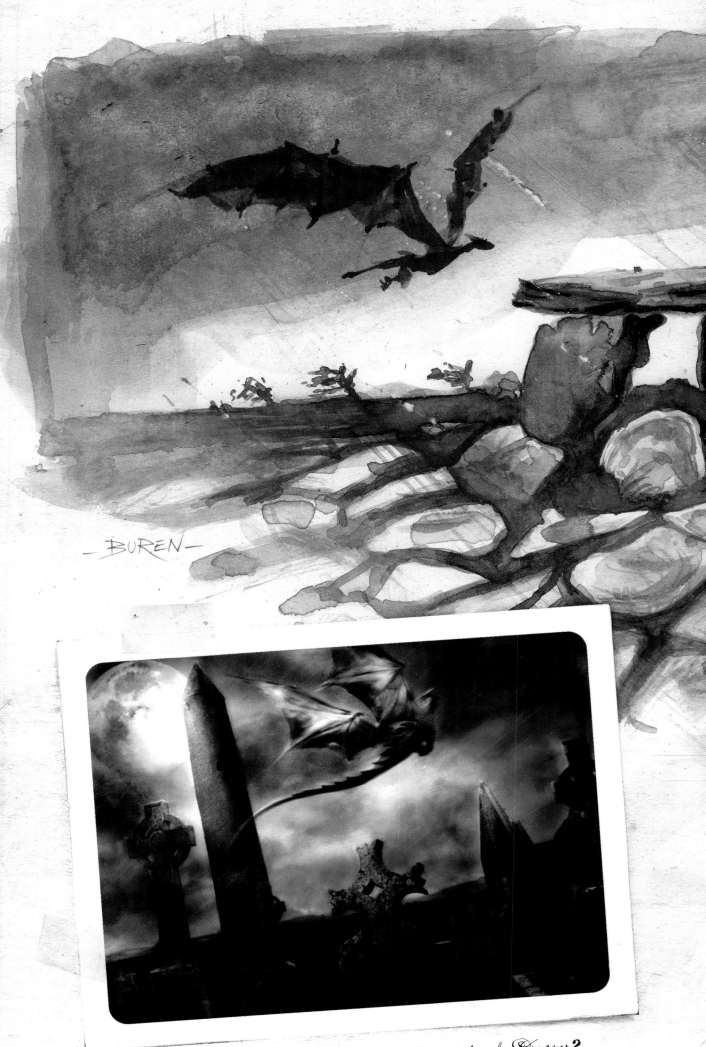

—BUREN—

Has Christianity really supplanted the worship of Dragons?

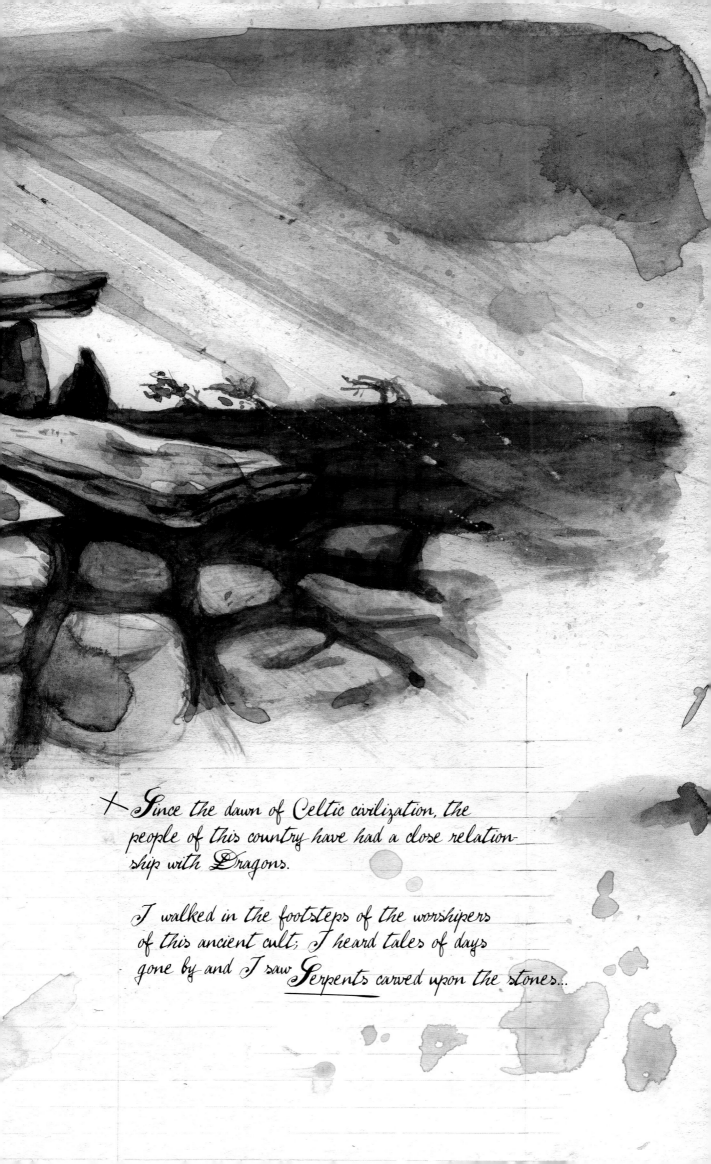

✝ Since the dawn of Celtic civilization, the people of this country have had a close relationship with Dragons.

I walked in the footsteps of the worshipers of this ancient cult; I heard tales of days gone by and I saw Serpents carved upon the stones...

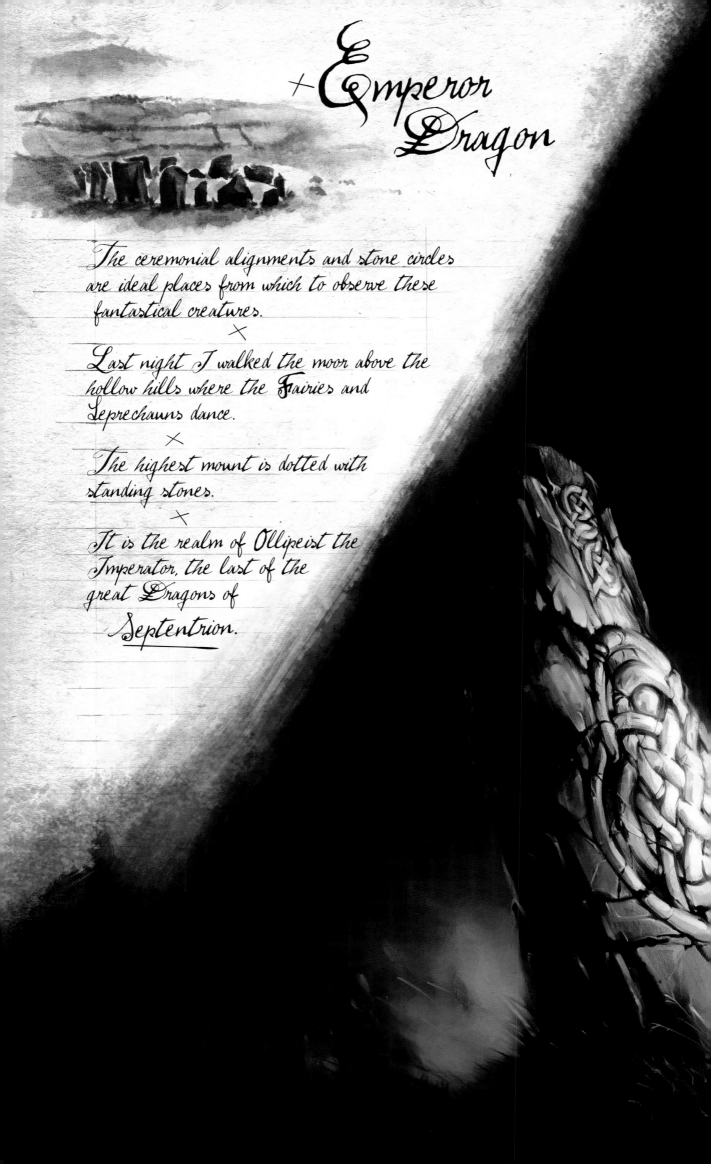

Emperor Dragon

The ceremonial alignments and stone circles are ideal places from which to observe these fantastical creatures.

✕

Last night I walked the moor above the hollow hills where the Fairies and Leprechauns dance.

✕

The highest mount is dotted with standing stones.

✕

It is the realm of Ollipeist the Imperator, the last of the great Dragons of Septentrion.

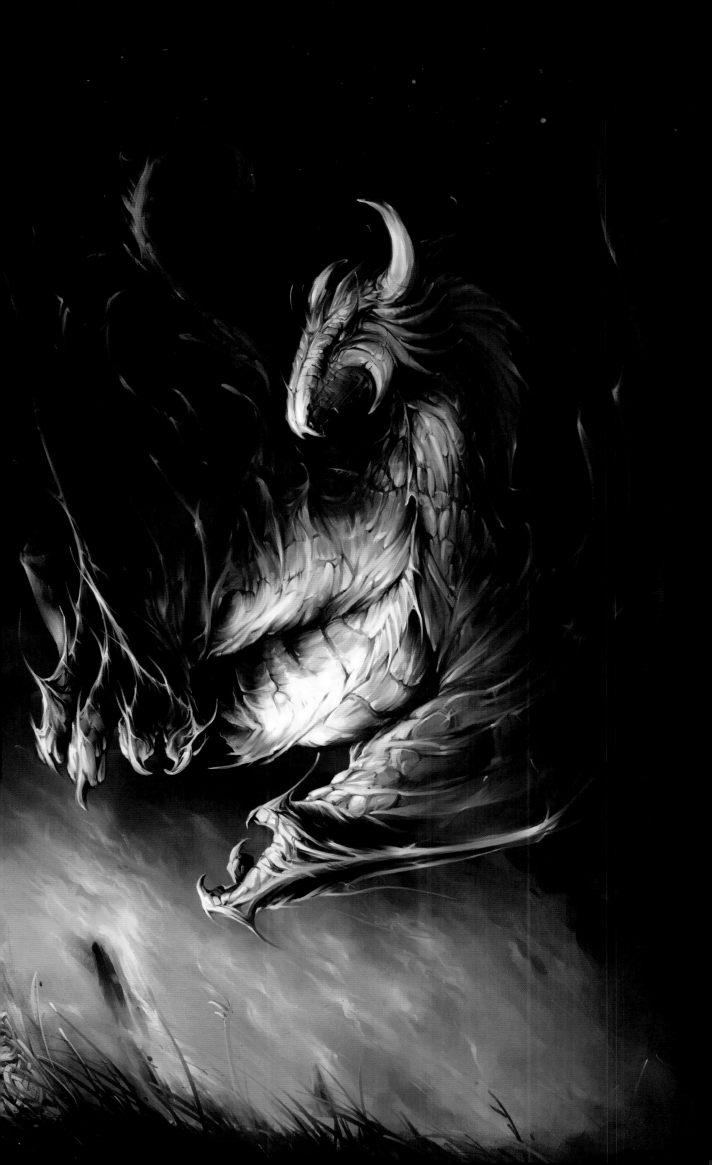

Journey Notes

- The Sea Serpent -

Also known as Muirdris or Sinach.
I read, in the incredible Bestiaries
from the Middle Ages at the
Dublin Fairy Institute,
that its mouth was the gateway to hell
and I don't find that difficult to believe!
(I'm still shaking.)

It is undoubtedly one of the monsters
that haunts mariners' legends.

+

- Siren Dragon -

Despite what Courtemanche says,
this magnificent animal impresses
with its great nobility.
It seemed to me its behavior was less
one of cruelty than one of a kind
of Desperate Bravery.

Burren

Emperor

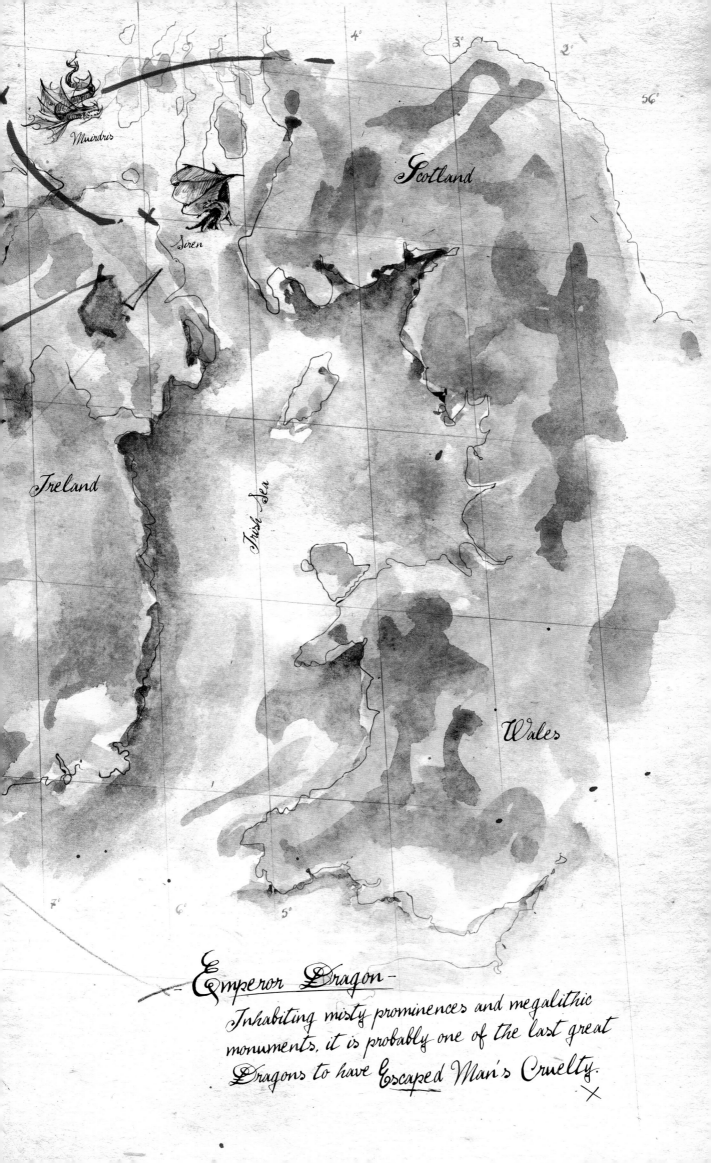

Muirdris

Siren

Scotland

Ireland

Irish Sea

Wales

4° 3° 2° 56°

7° 6° 5°

Emperor Dragon —

Inhabiting misty prominences and megalithic
monuments, it is probably one of the last great
Dragons to have Escaped Man's Cruelty.

✗

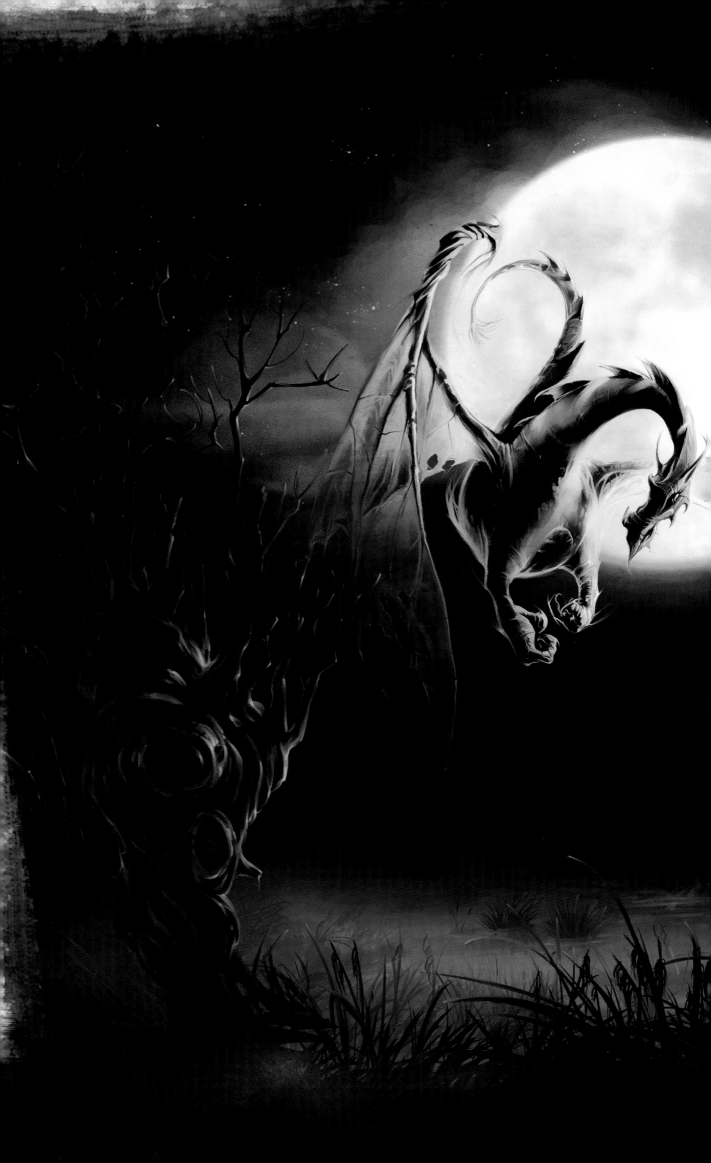

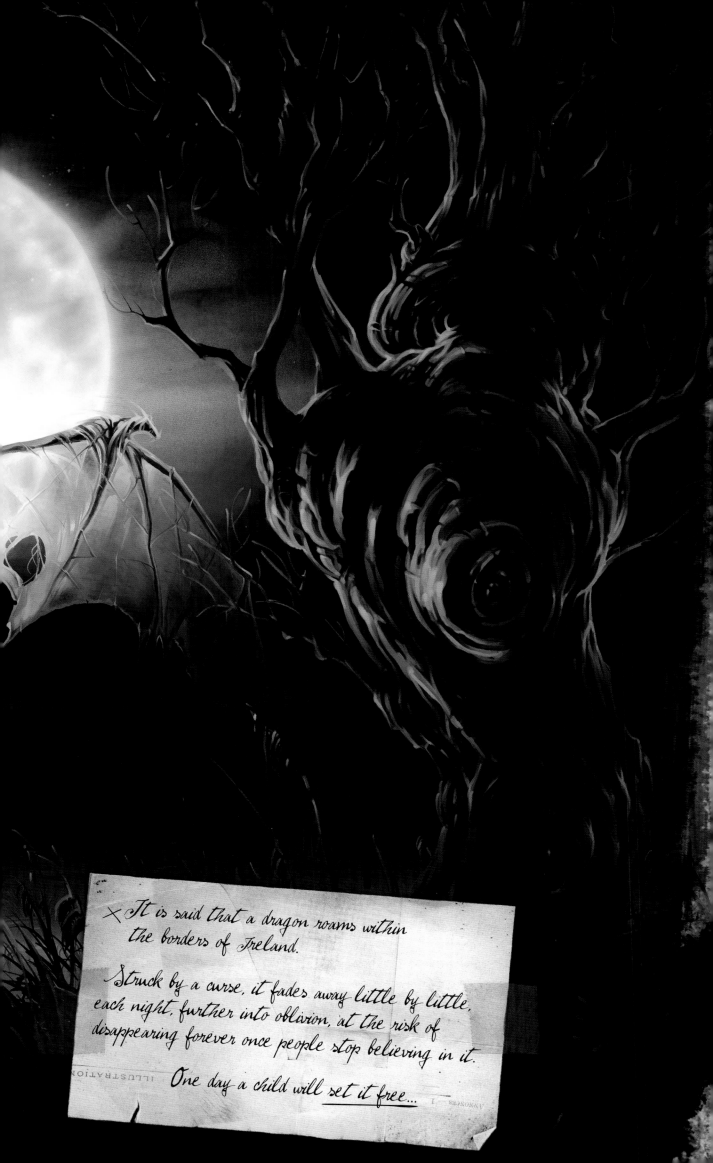

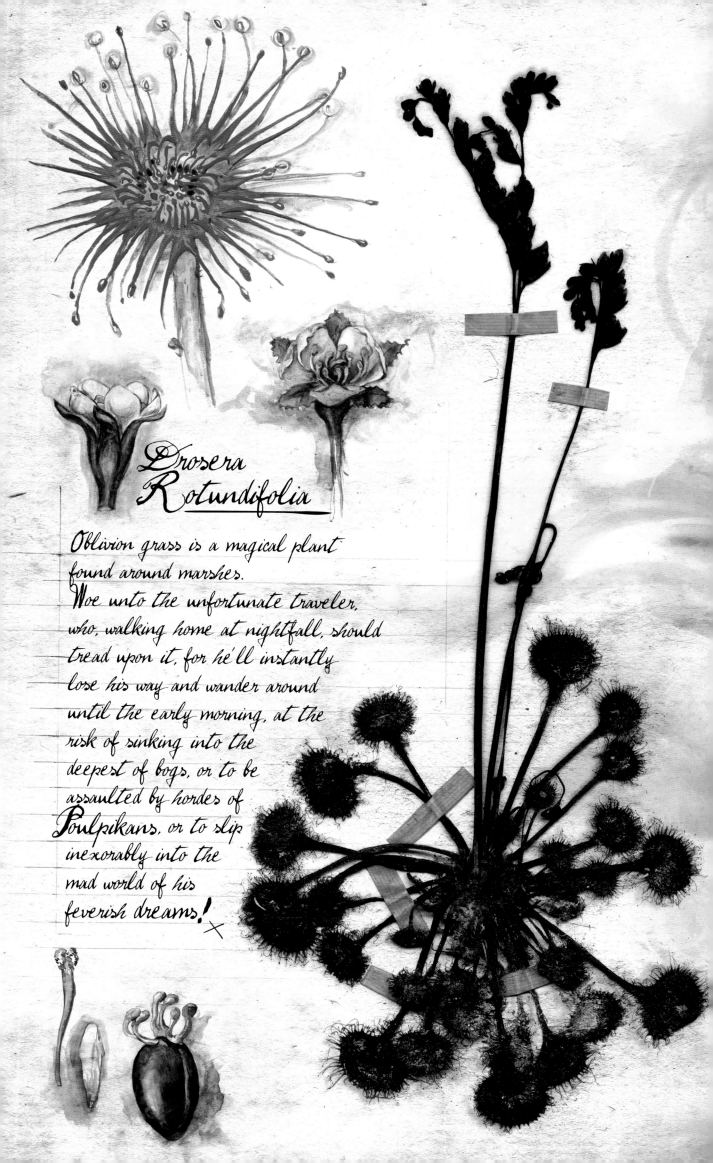

Drosera Rotundifolia

Oblivion grass is a magical plant
found around marshes.
Woe unto the unfortunate traveler,
who, walking home at nightfall, should
tread upon it, for he'll instantly
lose his way and wander around
until the early morning, at the
risk of sinking into the
deepest of bogs, or to be
assaulted by hordes of
Poulpikans, or to slip
inexorably into the
mad world of his
feverish dreams!

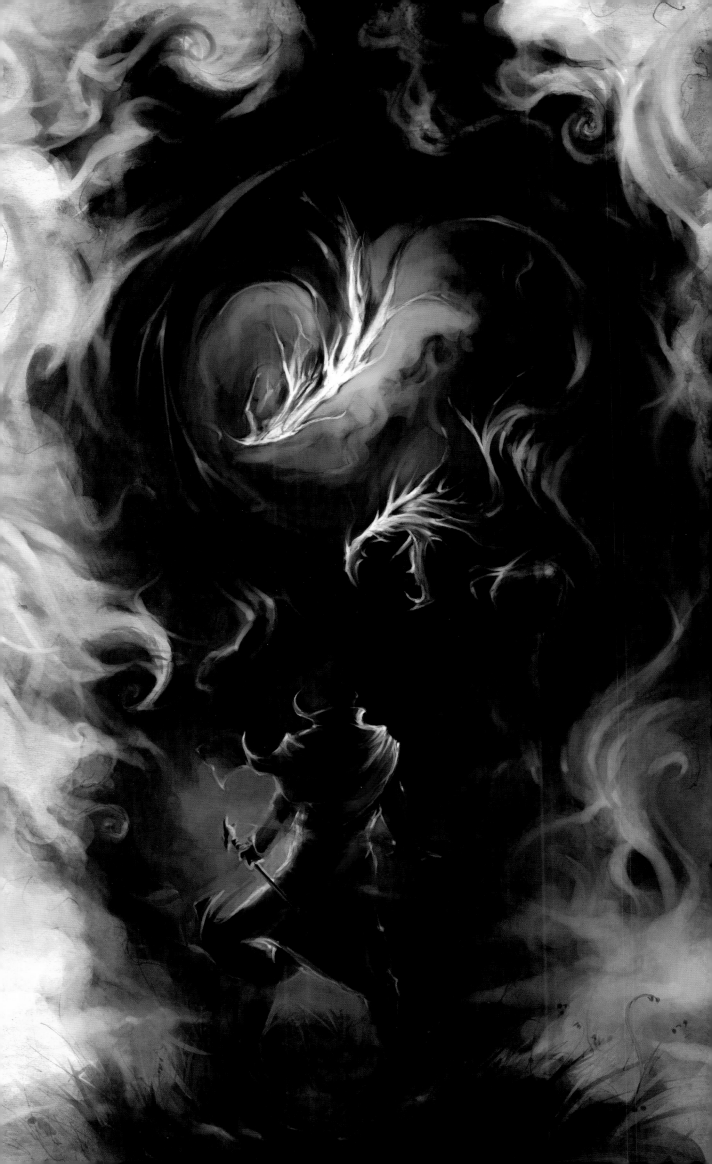

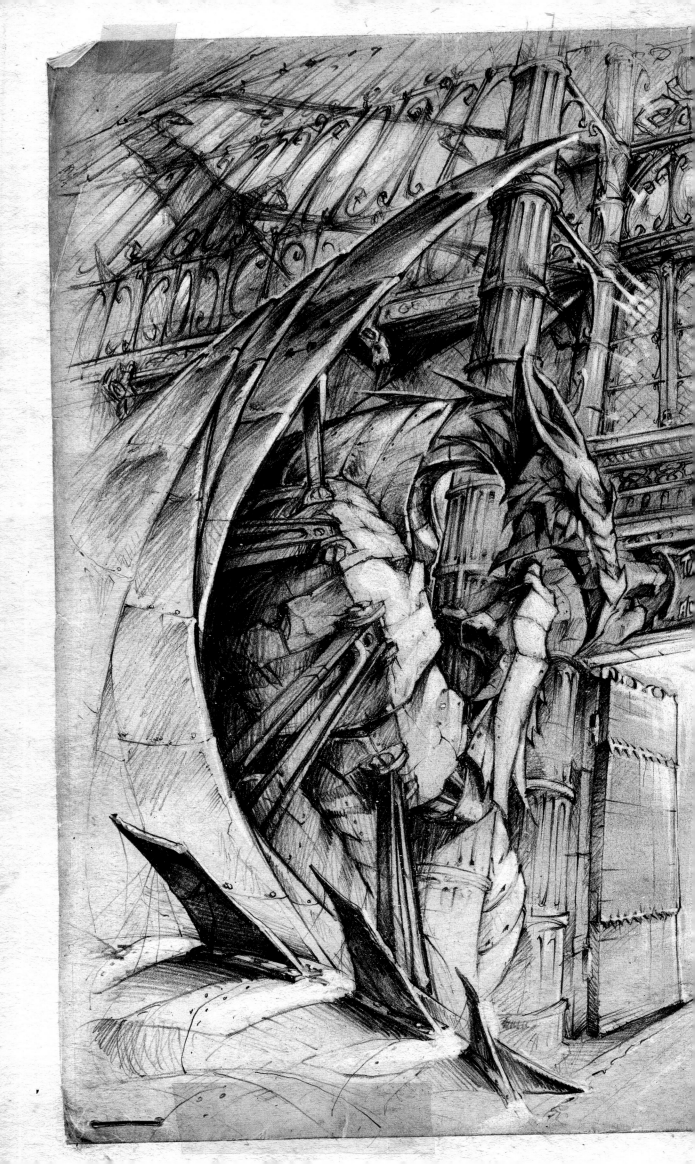

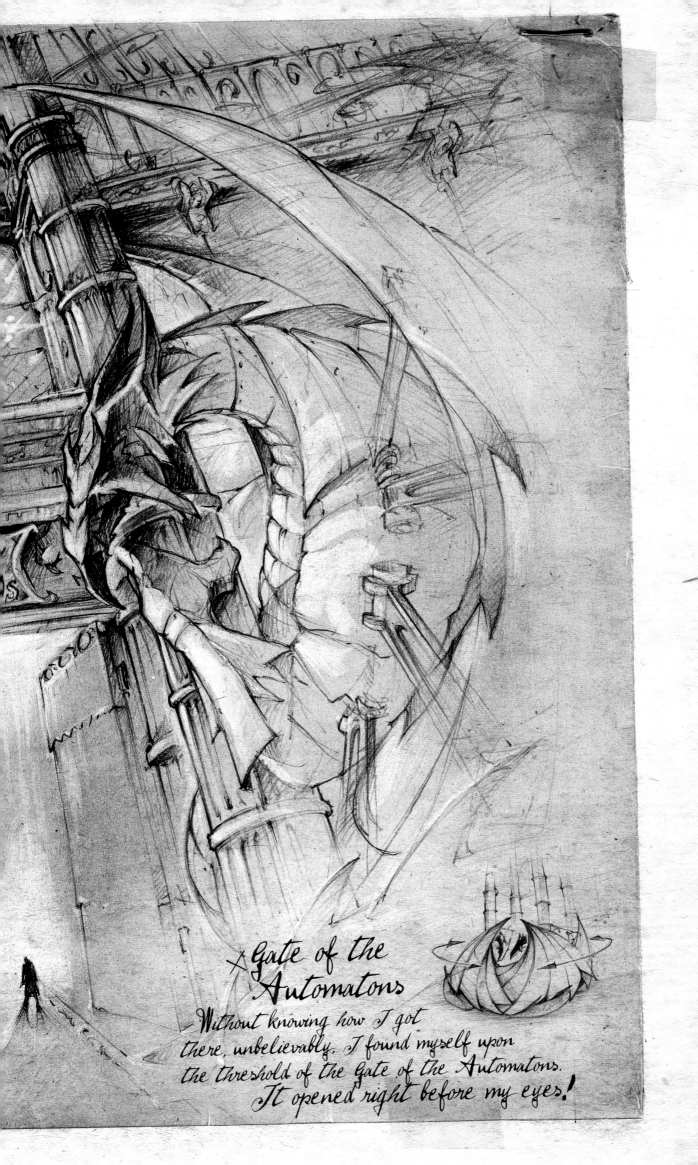

Gate of the
Automatons

Without knowing how I got
there, unbelievably, I found myself upon
the threshold of the Gate of the Automatons.
It opened right before my eyes!

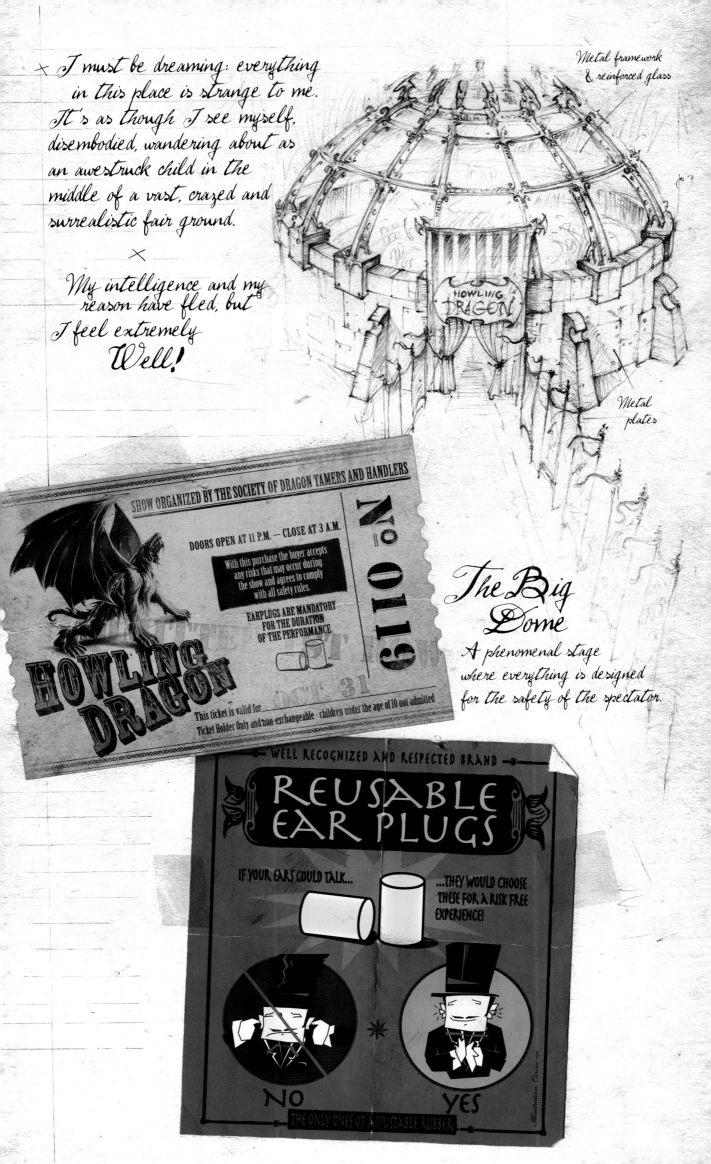

I must be dreaming: everything in this place is strange to me. It's as though I see myself, disembodied, wandering about as an awestruck child in the middle of a vast, crazed and surrealistic fair ground.

My intelligence and my reason have fled, but I feel extremely *Well!*

Metal framework & reinforced glass

HOWLING DRAGON

Metal plates

SHOW ORGANIZED BY THE SOCIETY OF DRAGON TAMERS AND HANDLERS

N° 0119

DOORS OPEN AT 11 P.M. — CLOSE AT 3 A.M.

With this purchase the buyer accepts any risks that may occur during the show and agrees to comply with all safety rules.

EARPLUGS ARE MANDATORY FOR THE DURATION OF THE PERFORMANCE.

HOWLING DRAGON

This ticket is valid for _____
Ticket Holder Only and non-exchangeable - children under the age of 10 not admitted

OCT. 31

The Big Dome
A phenomenal stage where everything is designed for the safety of the spectator.

— WELL RECOGNIZED AND RESPECTED BRAND —

REUSABLE EAR PLUGS

IF YOUR EARS COULD TALK...

...THEY WOULD CHOOSE THESE FOR A RISK FREE EXPERIENCE!

NO YES

THE ONLY ONES OF ADJUSTABLE RUBBER

An unforgettable experience that
makes you break out in a cold sweat...

FIRE
DRAGON

✕ Fire
Dragon

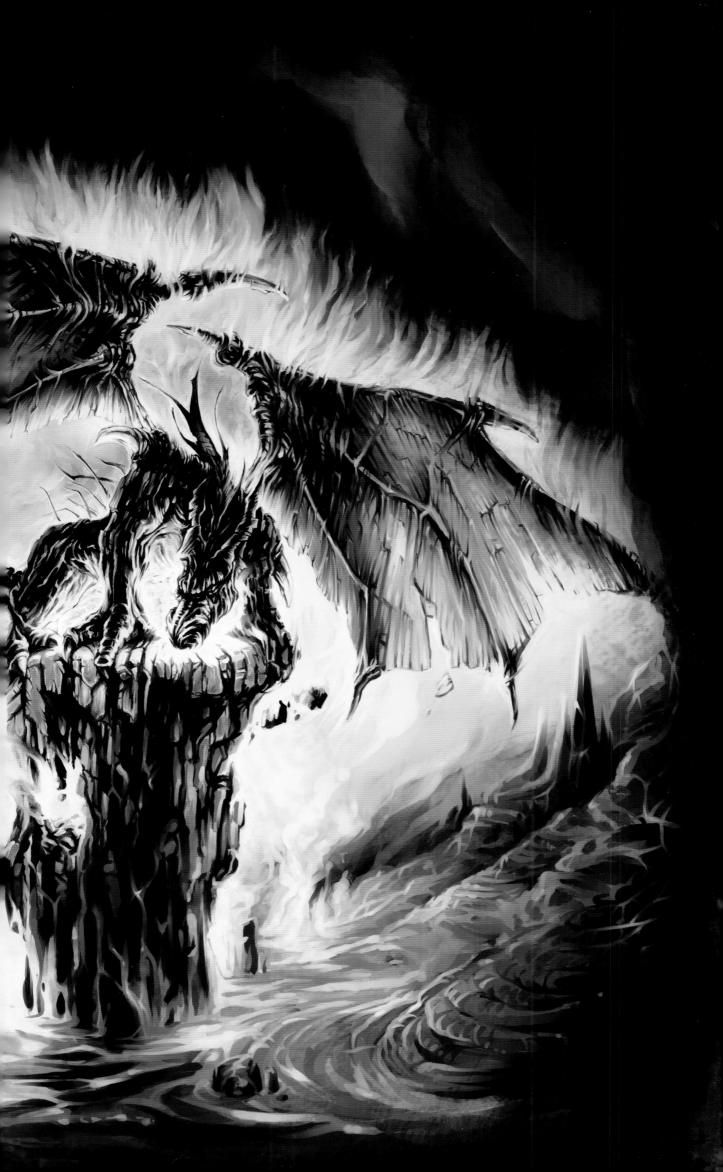

THE SONG OF THE ABYSS

THE ONLY SONAR IMAGE KNOWN TO DATE

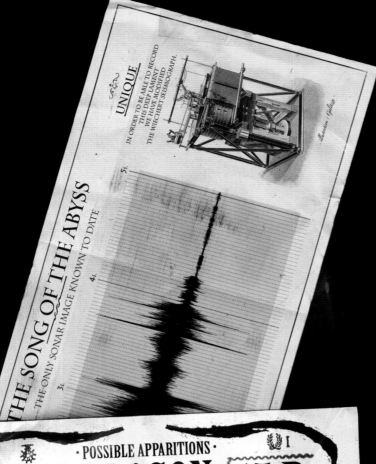

Illustration Galileo

UNIQUE

IN ORDER TO BE ABLE TO RECORD
THIS DEEP LAMENT
WE HAVE MODIFIED
THE WIECHERT SEISMOGRAPH.

· POSSIBLE APPARITIONS ·

DRAGON
OF THE ABYSS

TOTAL
IMMERSION
SUNDAYS
& HOLIDAYS

15 P.
FOR THIS AQUATIC
DAYDREAM

MAGIC AT GREAT DEPTHS

Voyage
deep into
the Abyss

THE BEAST OF THE ABYSS
WILL OPEN THE GATES TO THE DEPTHS

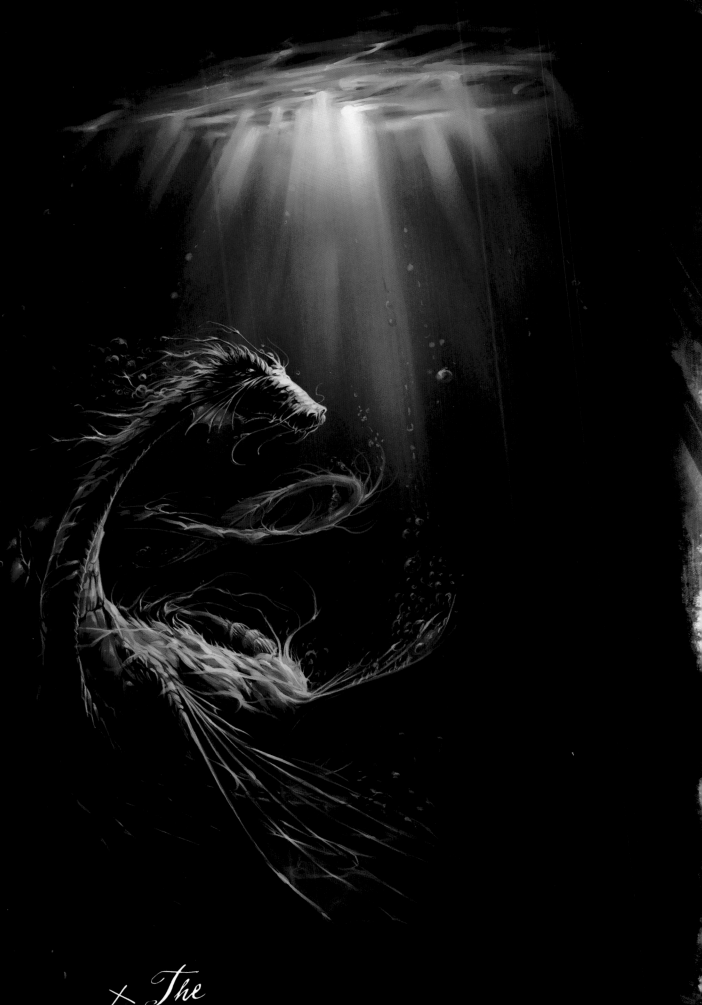

× The
Dragon
of the Abyss

This animal is the only
Dragon ever to have been
raised in captivity!

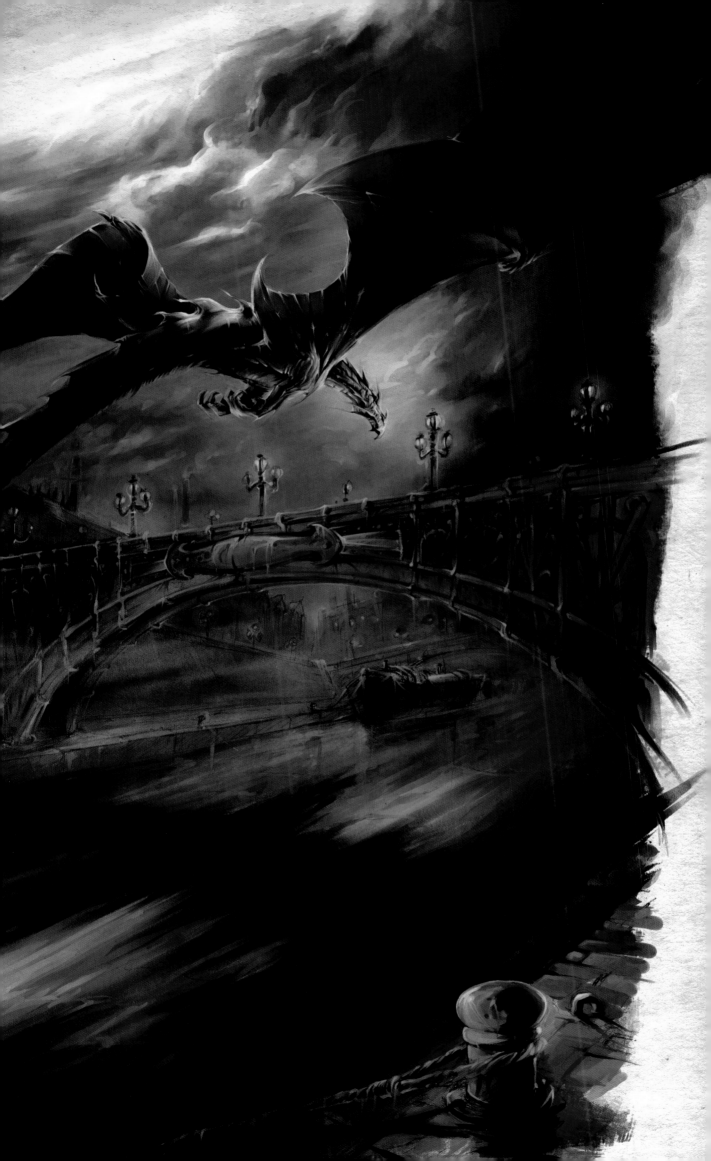

BLACK'MOR CHRONICLES

From the *Sewers of Paris* to the Top of the World

EXPEDITION N°0002

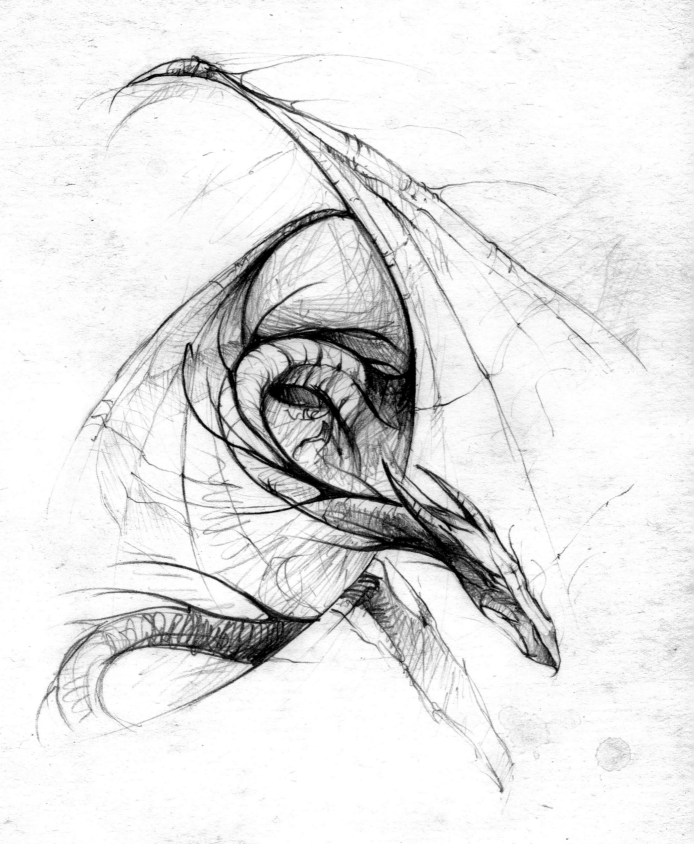

« So comes snow after fire, and even Dragons have their ending. »

— J.R.R. Tolkien —

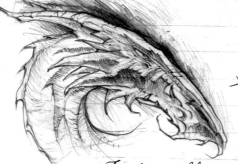

Paris, 31st of October

Is it possible that so much time has come to pass since
my return; my return from a journey to the
edge of reason ?

It is impossible to describe.
Alone in my Paris studio, I look back
with wonder at each episode of the trip.
As surprising as it may seem, having passed
through a short period of melancholy, my emotions
are settled and I am enjoying a quite
unfamiliar sense of calm and serenity.

During my next trip to Vienna I will take
the opportunity to consult with an old acquaintance.

Perhaps the good Sigmund can make
some sense of my recent adventures ?

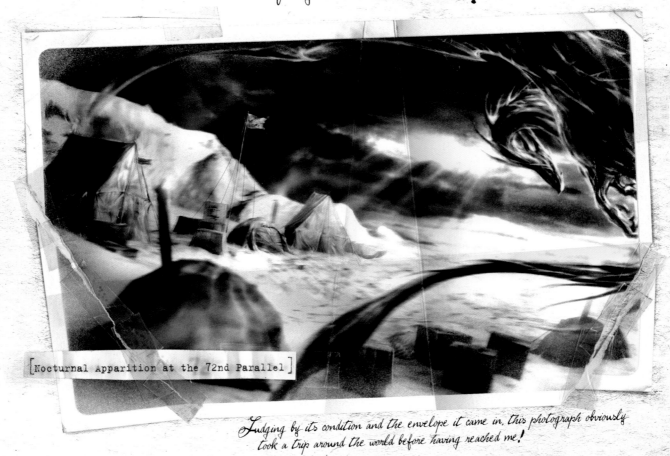

[Nocturnal Apparition at the 72nd Parallel]

Judging by its condition and the envelope it came in, this photograph obviously
took a trip around the world before having reached me !

DIRECTOR GENERAL
Of Research and Registration of Fantastical Creatures

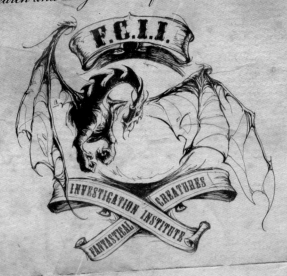

3rd _Division._

1st _Office._

N°125 Drag.

Department
Lower Brittany.

Laboratory for Research
and Investigation of
Fantastical Creatures
for Census.

Dear Elian,

 Your recent letter has filled me with
joy. I am very happy to find that you are in
such good health, and in all honesty, I've been
waiting for the right moment to draw your
attention to this photograph that I have been
holding in my drawer for several weeks now.
 Edifying, is it not?
 Your latest adventures have confirmed
your incredible talents and the time has come
for you to be informed of the existence of the
FCII, a learned society with multifaceted
goals, whose mission is to investigate the
existence of fantastical creatures. I ask that
you please urgently contact our Paris
representative.

 Keep well.

Printed form series D. No. 9 (Feb. 73)

Mr. de la Mole's address
is on the back of this letter.

OFFICE
OF
L. BRITTANY
27 SEPT. 12

Morlaix, the 27th of September 12
Pat. Jekyll Commissioner of Expertise
of the Fantastical,
Director General

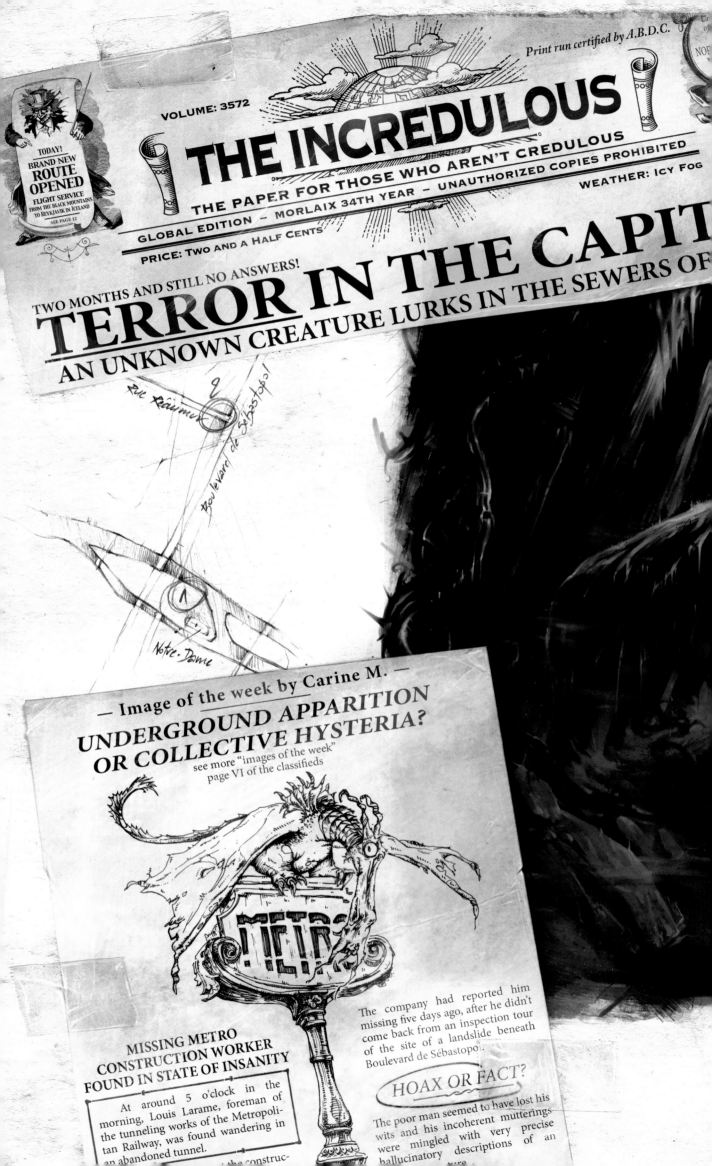

Print run certified by A.B.D.C.

VOLUME: 3572

THE INCREDULOUS

THE PAPER FOR THOSE WHO AREN'T CREDULOUS

GLOBAL EDITION — MORLAIX 34TH YEAR — UNAUTHORIZED COPIES PROHIBITED

PRICE: TWO AND A HALF CENTS

WEATHER: ICY FOG

TWO MONTHS AND STILL NO ANSWERS!

TERROR IN THE CAPIT

AN UNKNOWN CREATURE LURKS IN THE SEWERS OF

Rue Réaumur
Boulevard de Sébastopol
Notre-Dame

— Image of the week by Carine M. —

UNDERGROUND APPARITION
OR COLLECTIVE HYSTERIA?

see more "images of the week"
page VI of the classifieds

MISSING METRO
CONSTRUCTION WORKER
FOUND IN STATE OF INSANITY

At around 5 o'clock in the morning, Louis Larame, foreman of the tunneling works of the Metropolitan Railway, was found wandering in an abandoned tunnel.

the construc-

The company had reported him missing five days ago, after he didn't come back from an inspection tour of the site of a landslide beneath Boulevard de Sébastopol.

HOAX OR FACT?

The poor man seemed to have lost his wits and his incoherent mutterings were mingled with very precise hallucinatory descriptions of an

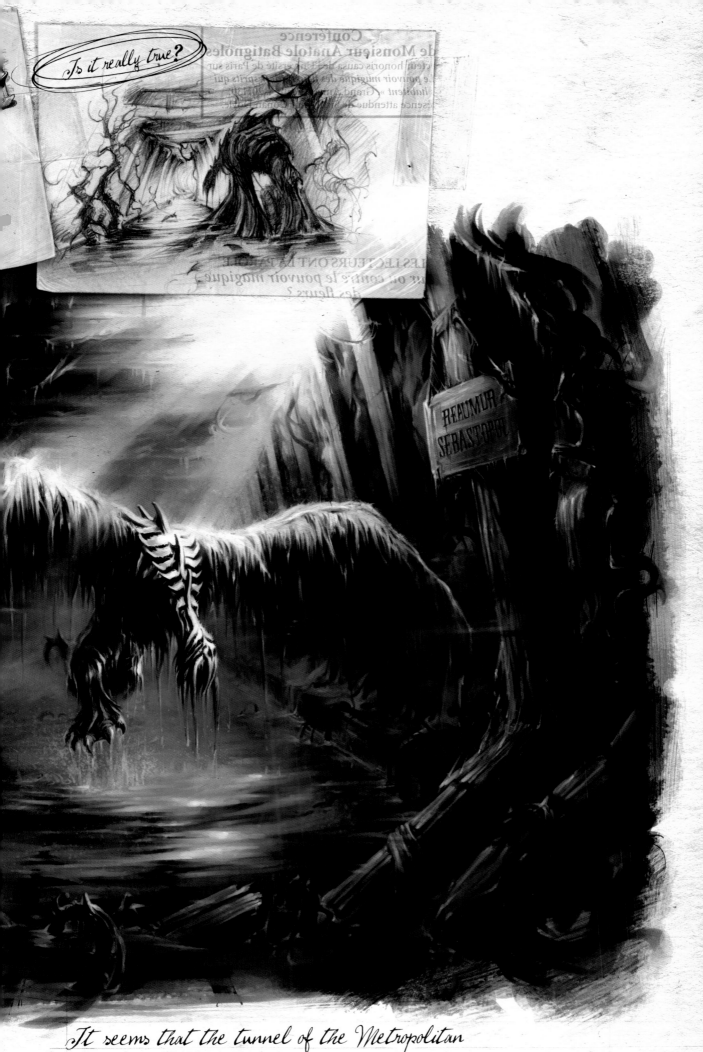

It seems that the tunnel of the Metropolitan
has pierced the ceiling of one of the vast subterra-
nean caverns that riddle the area beneath the capital.

What monster has escaped from the bowels of Paris?

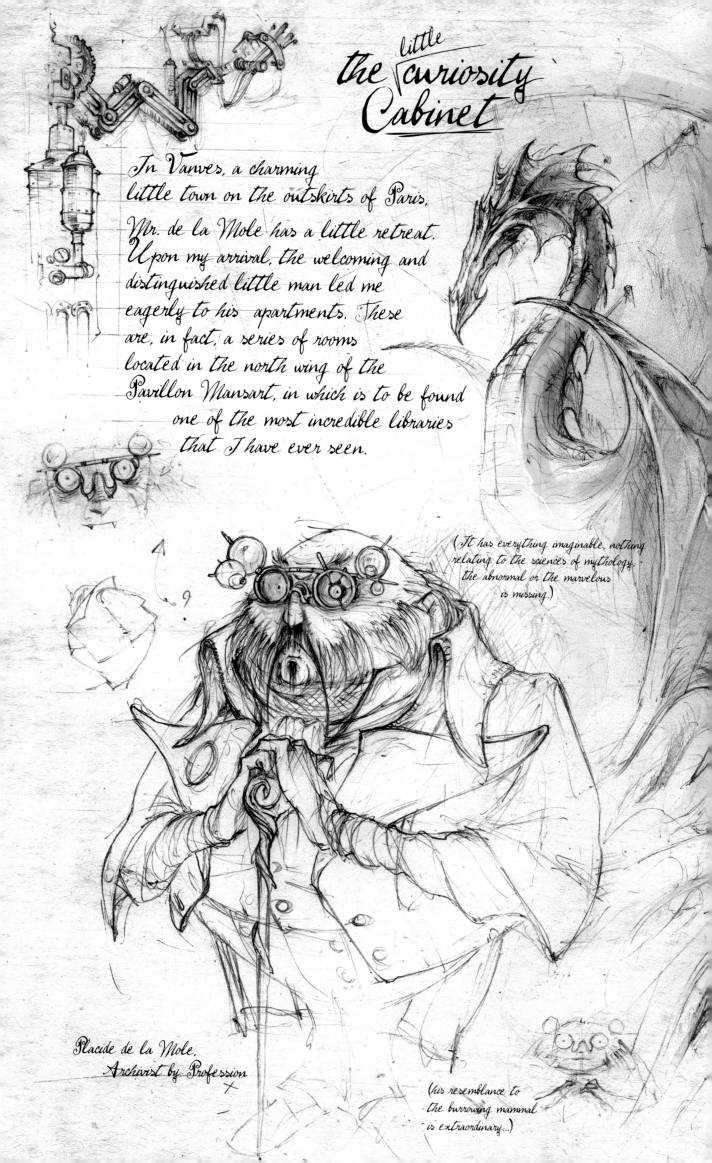

the little curiosity Cabinet

In Vanves, a charming little town on the outskirts of Paris, Mr. de la Mole has a little retreat. Upon my arrival, the welcoming and distinguished little man led me eagerly to his apartments. These are, in fact, a series of rooms located in the north wing of the Pavillon Mansart, in which is to be found one of the most incredible libraries that I have ever seen.

(It has everything imaginable, nothing relating to the sciences of mythology, the abnormal or the marvelous is missing.)

Placide de la Mole,
Archivist by Profession

(his resemblance to the burrowing mammal is extraordinary...)

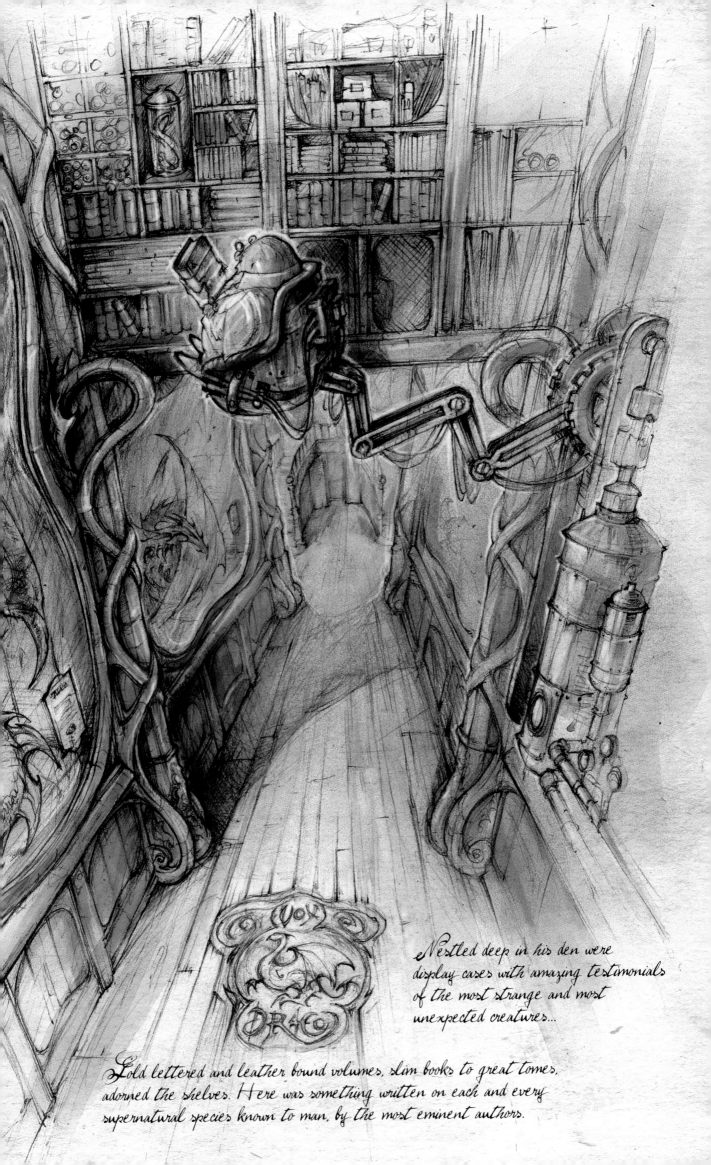

Nestled deep in his den were display cases with amazing testimonials of the most strange and most unexpected creatures...

Gold lettered and leather bound volumes, slim books to great tomes, adorned the shelves. Here was something written on each and every supernatural species known to man, by the most eminent authors.

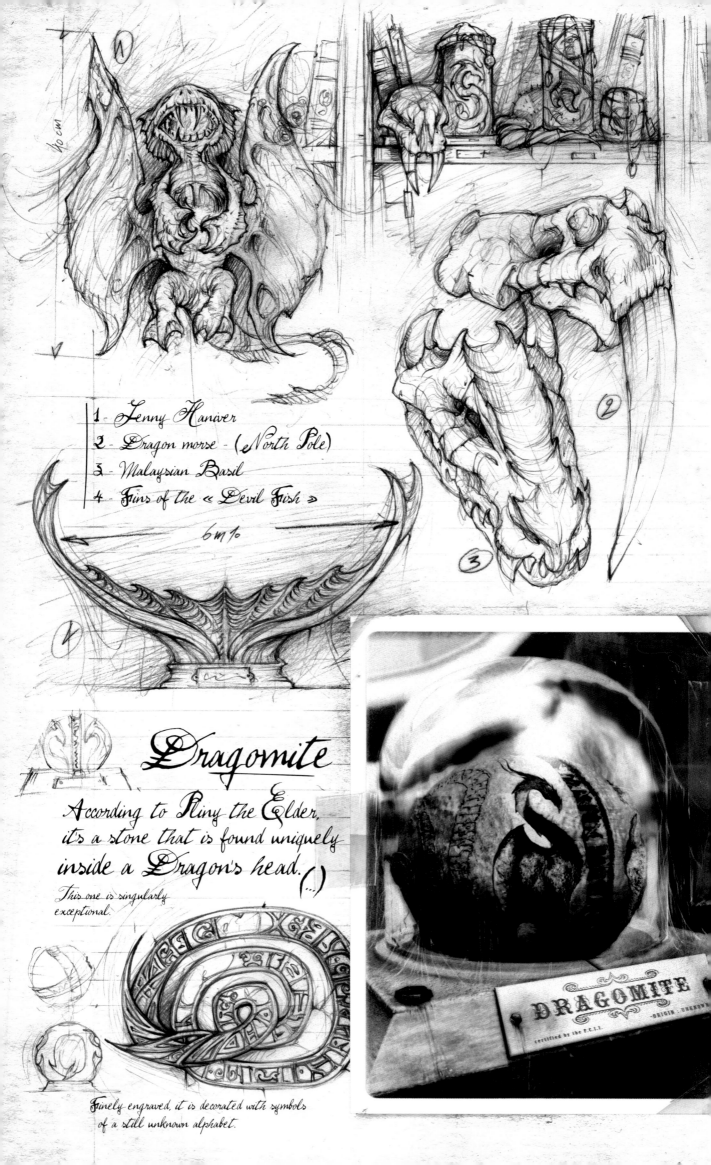

1 - *Jenny Haniver*
2 - *Dragon morse* - *(North Pole)*
3 - *Malaysian Basil*
4 - *Fins of the « Devil Fish »*

6 m ⁰/₀

Dragomite

According to Pliny the Elder, it's a stone that is found uniquely inside a Dragon's head. (...)

This one is singularly exceptional.

Finely engraved, it is decorated with symbols of a still unknown alphabet.

DRAGOMITE

-ORIGIN: UNKNOWN-

certified by the F.C.I.I.

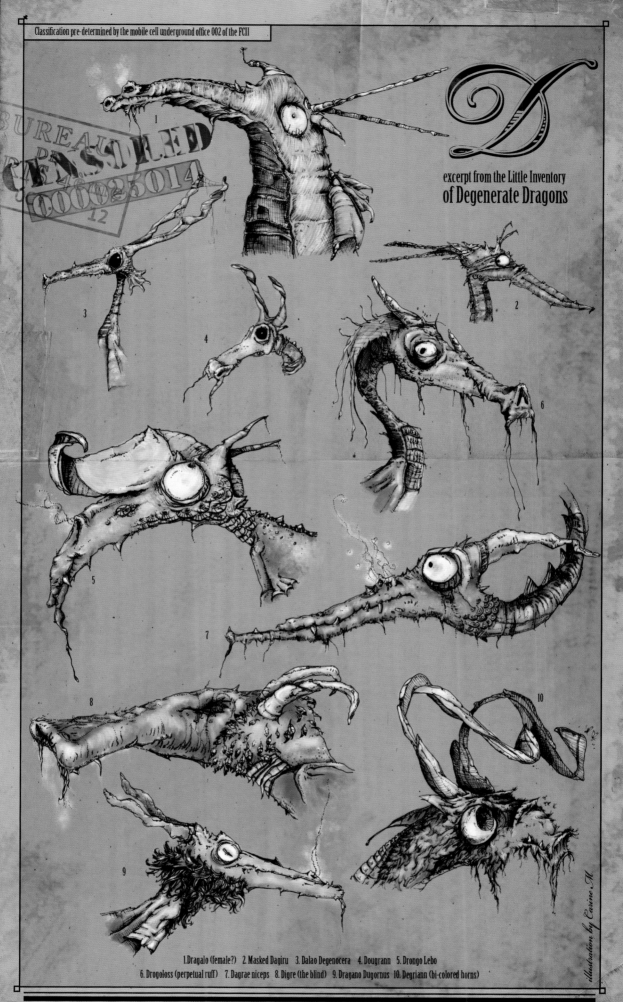

excerpt from the Little Inventory
of Degenerate Dragons

illustration by Carine M.

1.Dragalo (female?) 2. Masked Dagiru 3. Dalao Degenocera 4. Dougrann 5. Drongo Lebo
6. Drogoloss (perpetual ruff) 7. Dagrae niceps 8. Digre (the blind) 9. Dragano Dugornus 10. Degriann (bi-colored horns)

form printed and published by the FCII
CLASSIFICATION 035 NOT CATALOGUED

The venerable F.C.i.i(?)

✗ Mr. de la Mole, talkative creature that he is, doesn't have a great sense of hospitality. However, once I was comfortably installed in a small office adjacent to the «Grand Gallery,» I was finally able to accept his offer of a well-deserved snack.

This was the moment that he chose to finally reveal the reason for my «Summons.» A brief summary follows...

The venerable Fantastical Creatures Investigation Institute had chosen me to solve the mystery of the disappearance of an expedition of theirs that hadn't been seen since setting out on the trail of a lost civilization!

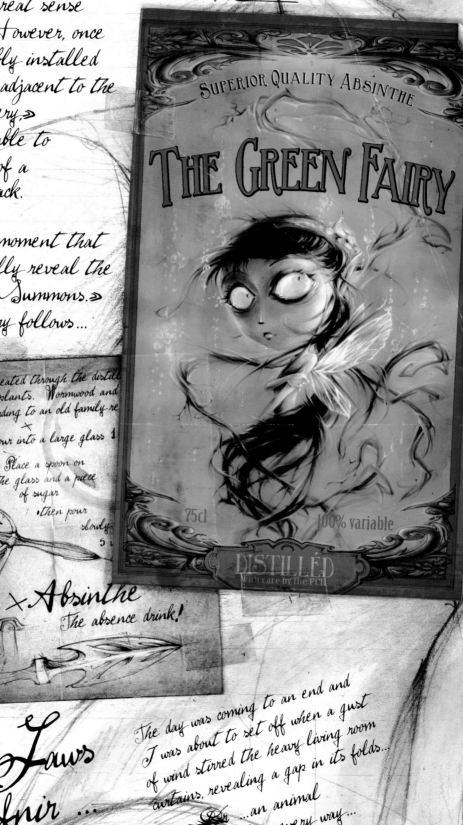

SUPERIOR QUALITY ABSINTHE

THE GREEN FAIRY

75cl 100% variable

DISTILLED
with care by the FCII

(according to Placide de la Mole)

This beverage is created through the distill of a mixture of plants. Wormwood and green anise according to an old family re

✗ Preparation: • pour into a large glass 1

• Place a spoon on the glass and a piece of sugar

• then pour slowly

5

✗ Absinthe
The absence drink!

In the Laws of Fafnir ...

The day was coming to an end and I was about to set off when a gust of wind stirred the heavy living room curtains, revealing a gap in its folds...

...an animal exceptional in every way... Absinthe has unique virtues...

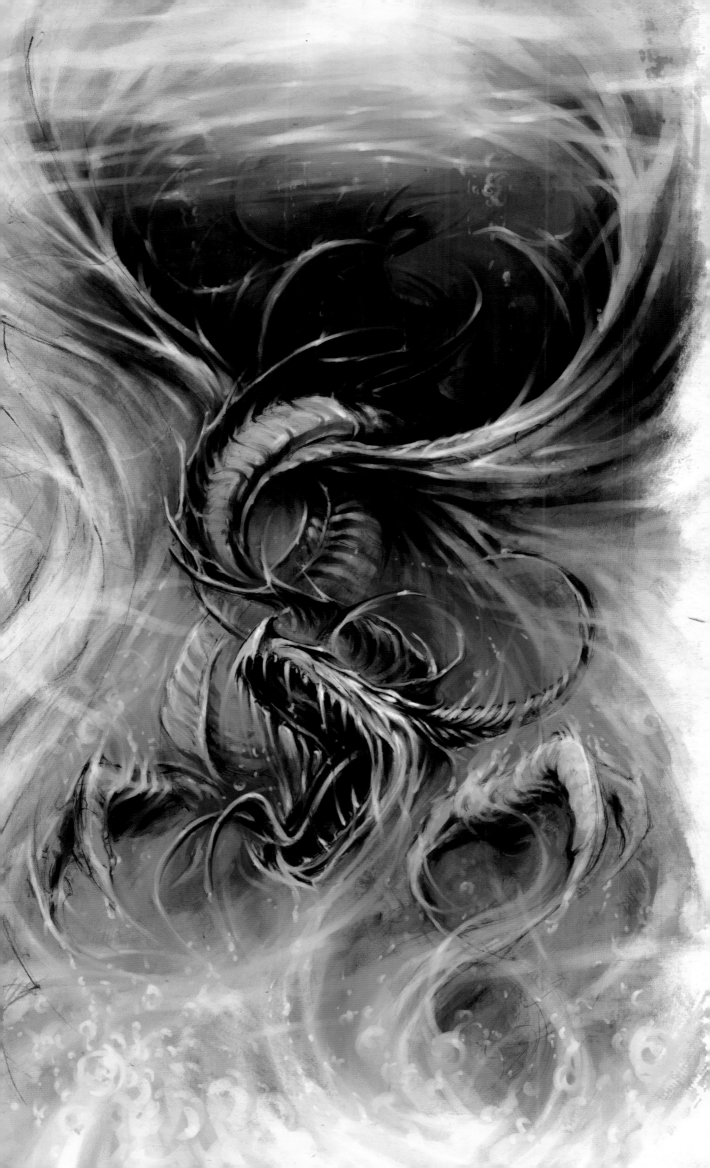

✗ Paris Notes

According to Placide de la Mole, the image that Jekyll sent me seems to have been taken at the actual campsite.

However, it seems that all members of the expedition led by Professor Ollafsen of the University of Reykjavik had mysteriously abandoned the place.

. What circumstances led
this photograph to fall into
the hands of Timothy Burnott,
the F.C.i.i. representative
in Iceland?

No one knows.
. Well, whatever happens,
I know my next destination!

(Monday the 25th)

✗ The Start of the expedition

Strangely, I am supposed to
meet up with the other members
in Bavaria, since, for reasons
unknown, they too are headed
for Iceland.

I arrived this morning in Leisenstad, a small
village in the heart of the Black Forest, where
Placide had told me a surprise waited for me there.

And it's true: an airship swayed
gently at the end
of a steel cable.

My traveling companions, two traditionally
dressed Japanese men, greeted me with
overwhelming deference and respect.

All a bit embarrassing.

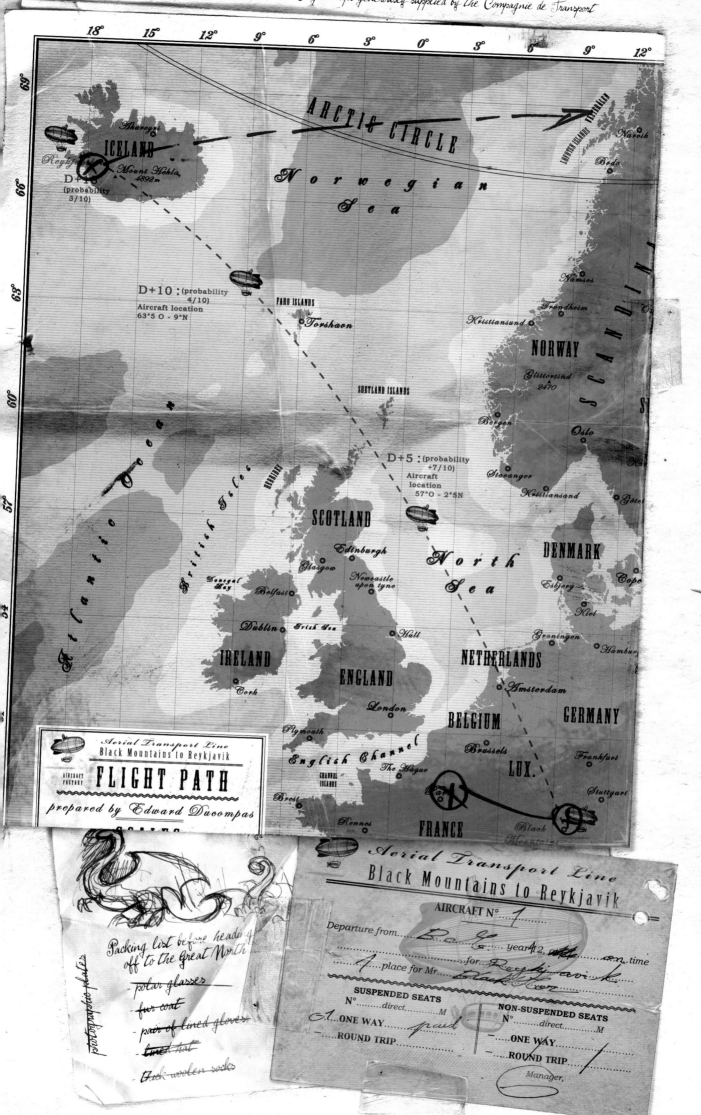

- Maiden voyage -

Accompanied by the creaking of the gondola, we puttered along at the speed
of the little engine that took us on our voyage. Our skipper, Marcus, a voluble
Serbo-Croatian, talked and laughed non-stop with the patient Mr. Toshiro
– neither one understanding the language of the other.

(I fell asleep.)

✕

Toshiro's loud shouts
woke me. Circling
around us, just a short
distance from the
Zeppelin, was

a *great winged
creature.*

✕

As if in some evil dance
it disappeared into the clouds
only to reappear in
the rays of the sun
before approaching
the starboard side in
a beautiful swooping dive...

✕

~~...Everything became~~

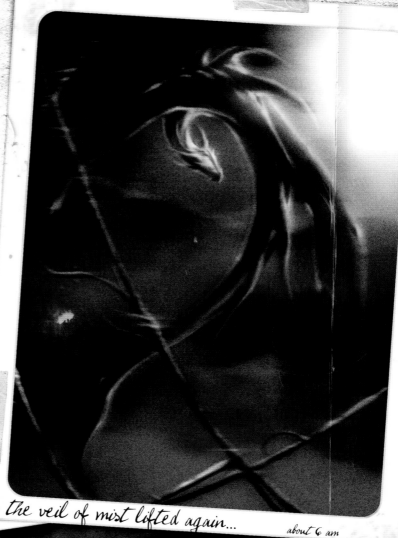

- the veil of mist lifted again...

about 6 am

7 am ? - emotion overwhelmed me,
 my heart pounded like a drum...

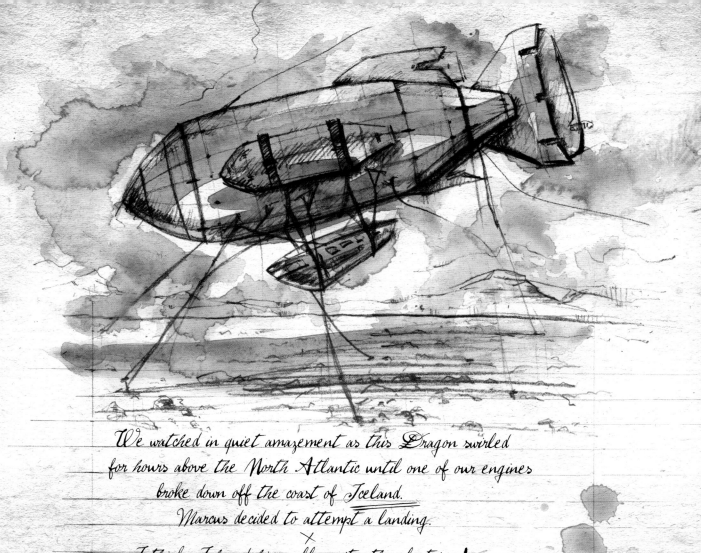

We watched in quiet amazement as this Dragon swirled
for hours above the North Atlantic until one of our engines
broke down off the coast of Iceland.
Marcus decided to attempt a landing.

✕

I think I heard him yell, « it's the electrics ! »
as I set off alone towards Reykjavik, through
the fuming geysers and the rubble desert.

✕

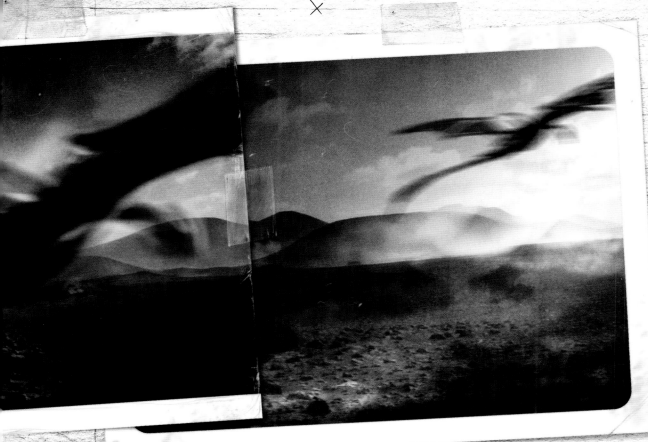

We had landed in a lunar landscape
in a region called Landmannalaugar.

The Brothers from the Ashes

Two great Dragons slumber in the Icelandic earth,
one lurks in the depths of Hekla, the molten heart of the island,
the other wanders in the dusty winds of Landmannalaugar.

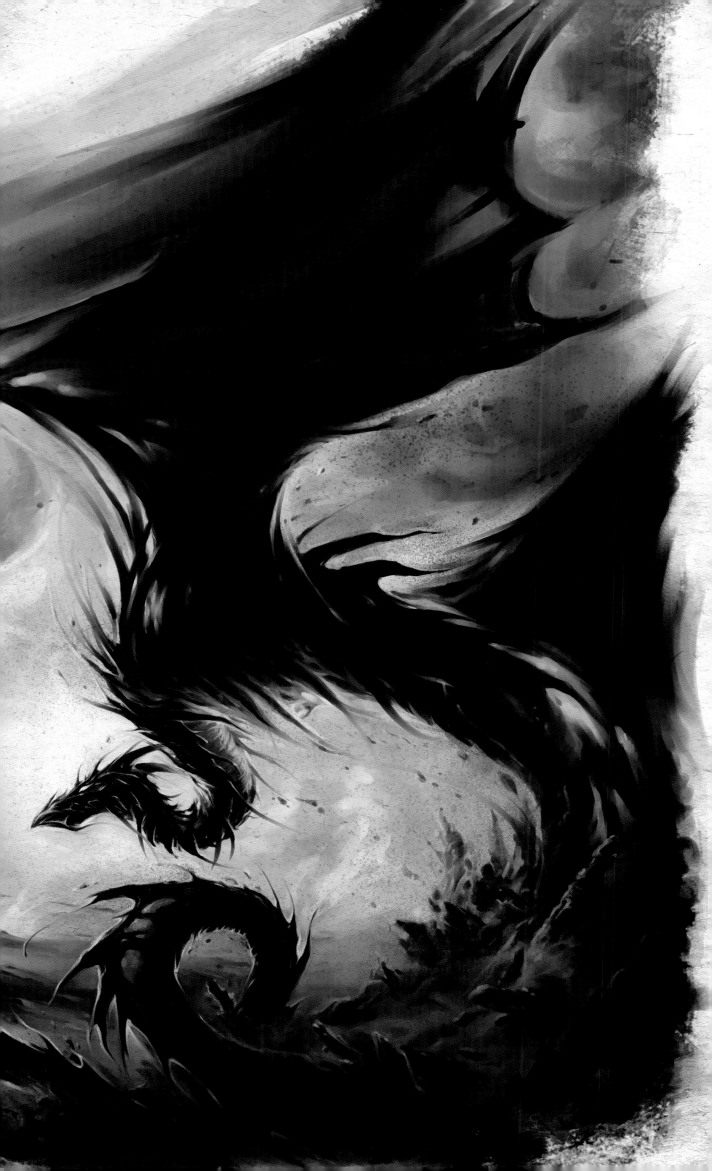

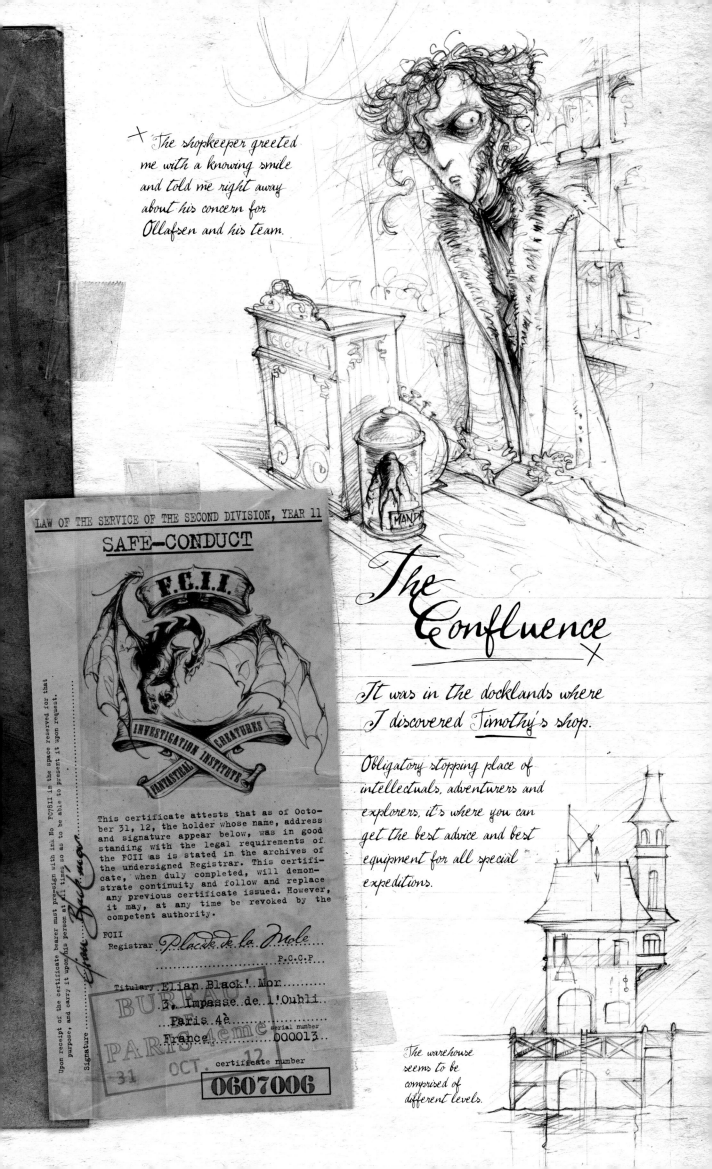

✗ The shopkeeper greeted me with a knowing smile and told me right away about his concern for Ollafsen and his team.

LAW OF THE SERVICE OF THE SECOND DIVISION, YEAR 11

SAFE-CONDUCT

F.C.I.I.

INVESTIGATION CREATURES
FANTASTICAL INSTITUTE

This certificate attests that as of October 31, 12, the holder whose name, address and signature appear below, was in good standing with the legal requirements of the FCII as is stated in the archives of the undersigned Registrar. This certificate, when duly completed, will demonstrate continuity and follow and replace any previous certificate issued. However, it may, at any time be revoked by the competent authority.

FCII
Registrar ..Placik.de.la.Mole.......
 P.C.C.P.

Titulary .Elian.Black'.Mor.........
.....3. Impasse.de..l'Oubli..
......Paris.4è...................
......France4ème....... serial number
 000013

BUR..
PARIS 4eme
31 OCT. 12

certificate number
0607006

The Confluence
✗

It was in the docklands where I discovered Timothy's shop.

Obligatory stopping place of intellectuals, adventurers and explorers, it's where you can get the best advice and best equipment for all special expeditions.

The warehouse seems to be comprised of different levels.

First revelations

It was as he showed me the great Knorr that Timothy explained the situation of what Ollafsen had discovered during one of his previous expeditions.

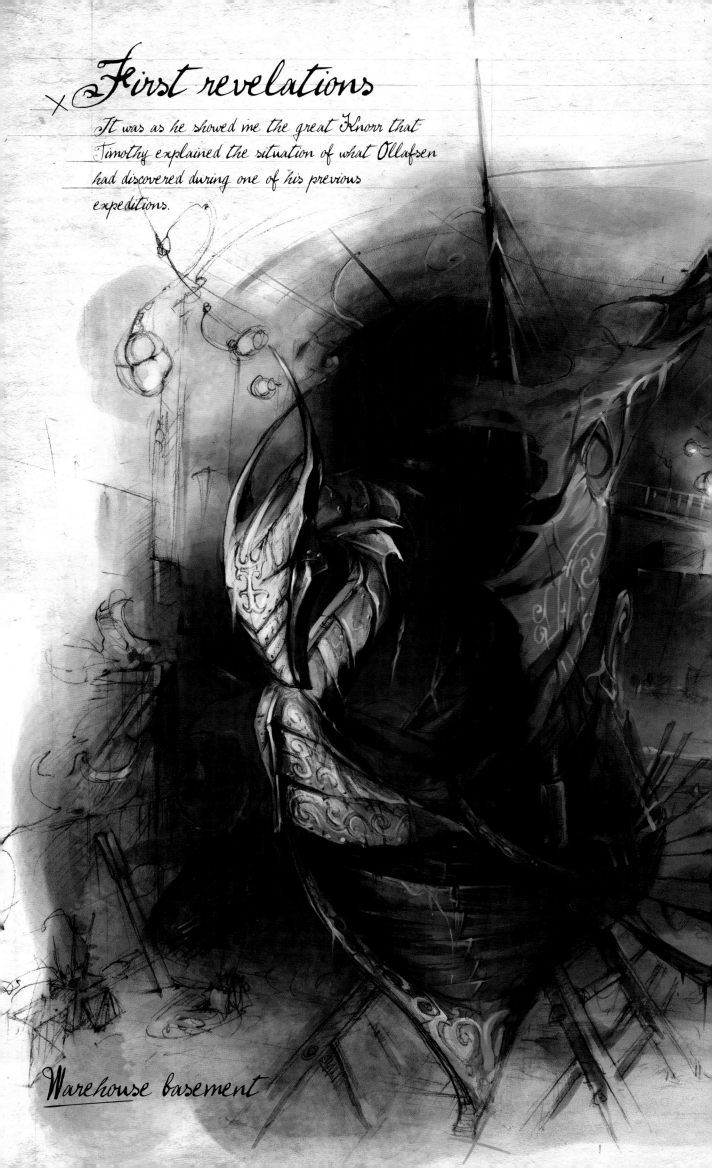

Warehouse basement

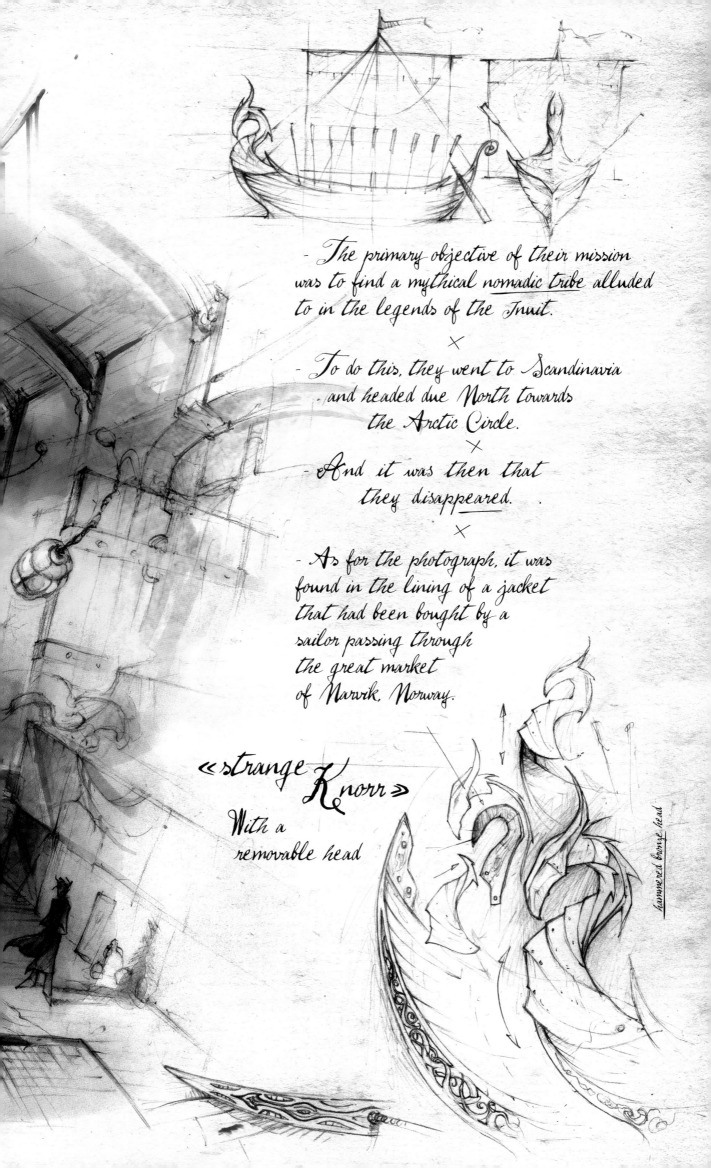

- The primary objective of their mission was to find a mythical nomadic tribe alluded to in the legends of the Inuit.

×

- To do this, they went to Scandinavia and headed due North towards the Arctic Circle.

×

- And it was then that they disappeared.

×

- As for the photograph, it was found in the lining of a jacket that had been bought by a sailor passing through the great market of Narvik, Norway.

«strange *Knorr*»

With a removable head

hammered bronze head

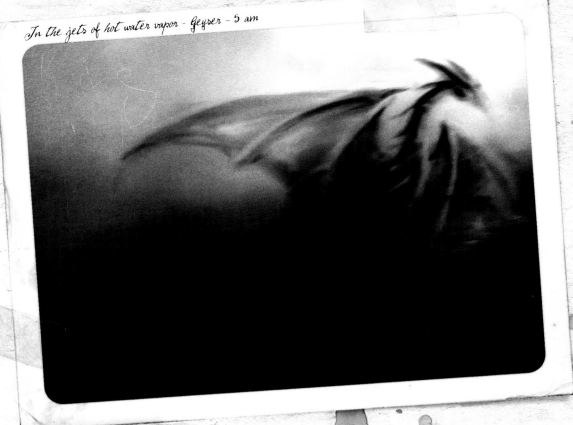

In the jets of hot water vapor - Geyser - 5 am

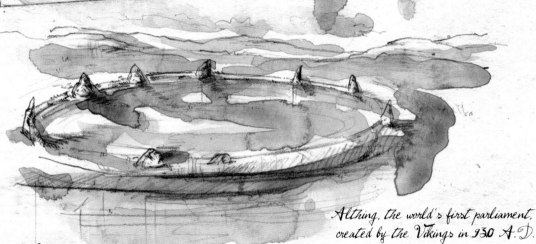

Althing, the world's first parliament, created by the Vikings in 930 A.D.

Thingvellir; the fault in the parliament

In great wonderment I walked ~~this earth~~ the
molten crust of this new earth, a ghost in the fields
of lava, as a newborn on the first morning, finding
~~my way~~ to Thingvellir.

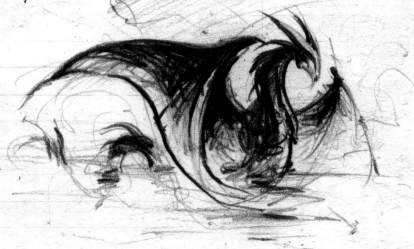

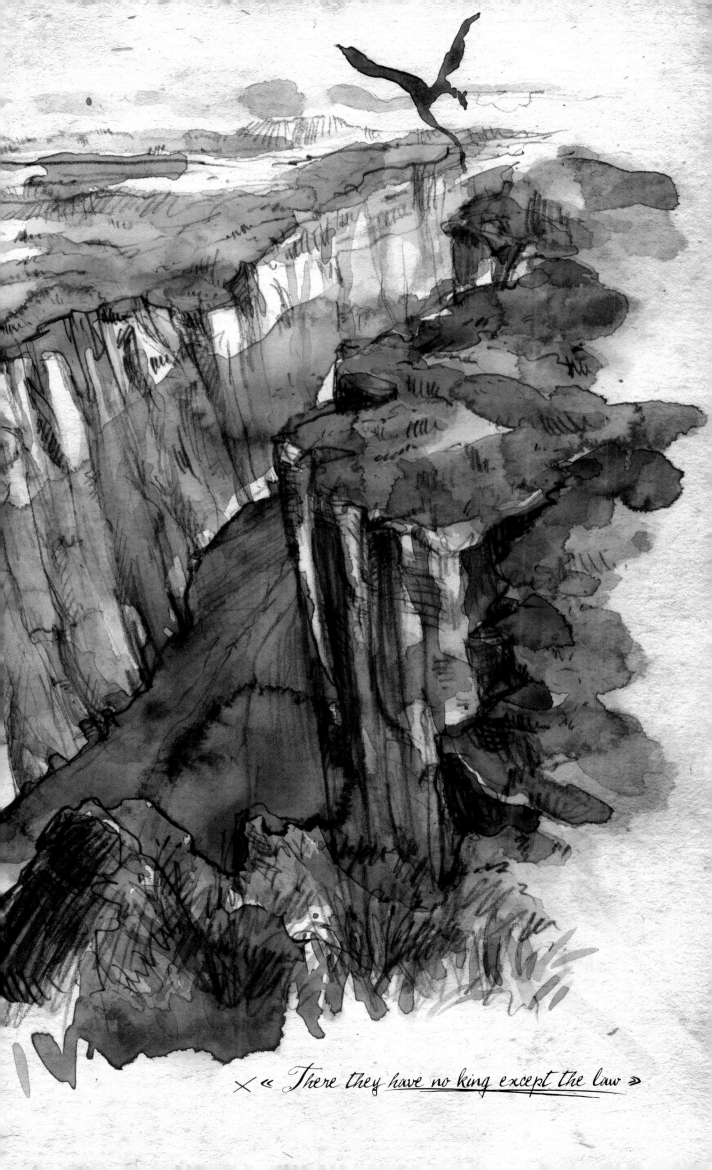

« There they have <u>no</u> king except the law »

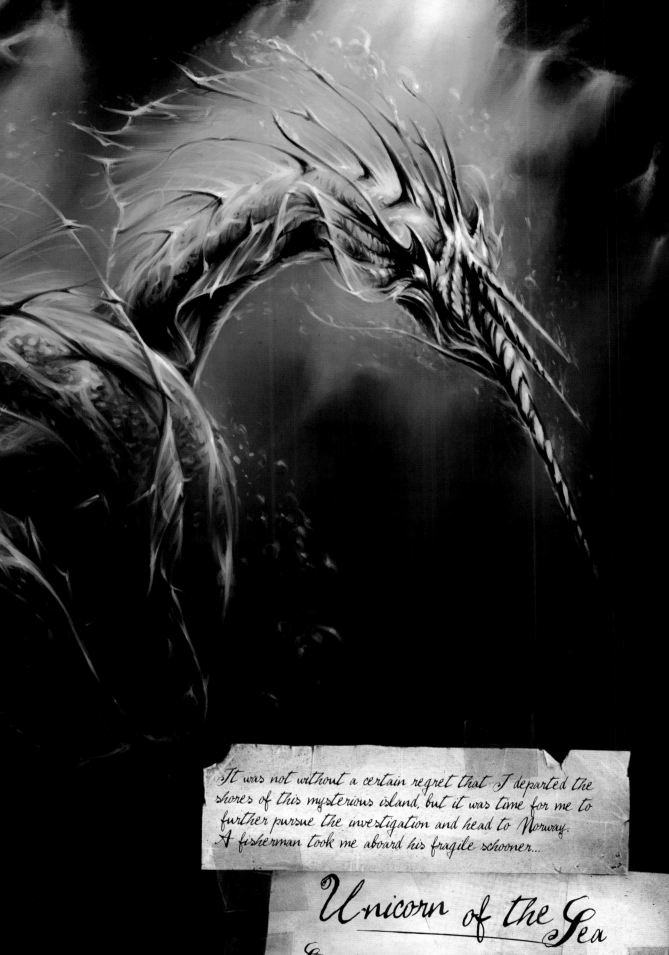

It was not without a certain regret that I departed the shores of this mysterious island, but it was time for me to further pursue the investigation and head to Norway. A fisherman took me aboard his fragile schooner...

Unicorn of the Sea

Staring off into space and the distant horizon, I hardly noticed at first as a vague form emerged sporadically from the waves.

A narwhal, unicorn of the sea, pointed its twisted horn and played in the foam and spray...

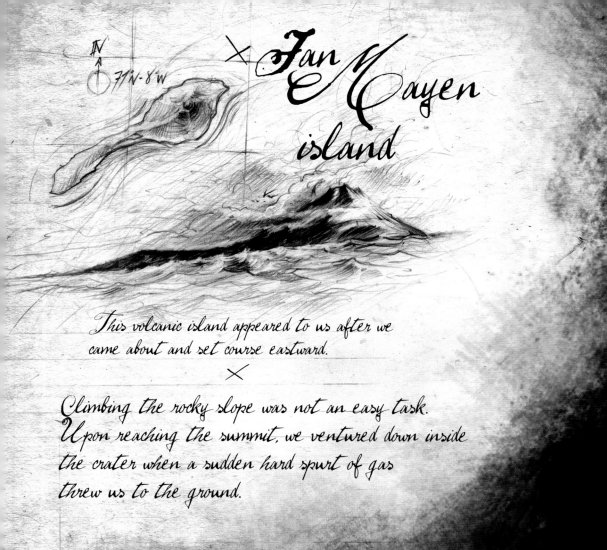

Jan Mayen island

71 N - 8 W

This volcanic island appeared to us after we
came about and set course eastward.

×

Climbing the rocky slope was not an easy task.
Upon reaching the summit, we ventured down inside
the crater when a sudden hard spurt of gas
threw us to the ground.

A few feet above our heads, a gaping mouth
spat incandescent cinders within a vaporous
cloud of ammonia and caustic soda.

As the toxic stench penetrated the depths of my being,
I became more than nauseous: it had embedded itself
in my blood and was oozing from my every pore...

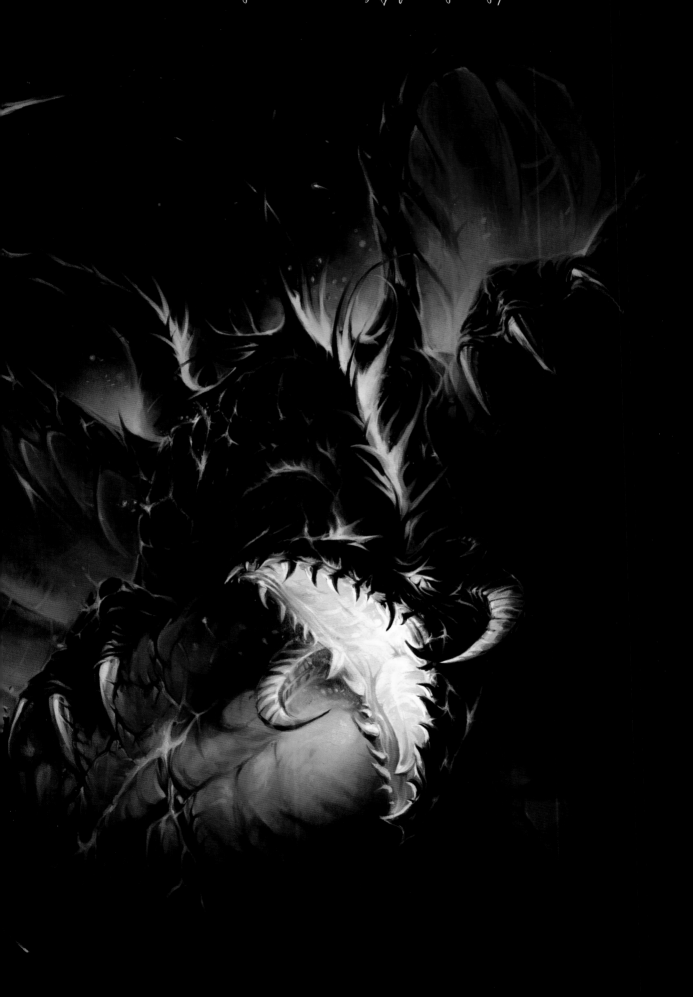

CARTA MARINA · ANNO DNI 1539

MIDELFJORD

REDH HOLM

EGGE

MALANGER

HASEVO

LOKHELLE

GALLEA PEREGRIN

OSTRAFJORD

GILLEFJORD

SANDER

GIGASVND

SKARTASVND

QVEDEFIOD

LANGE

ROLLEN

CAINMNES

TRONDANES

ROST

DVVANES

ANDANES

DOMVS BIRCARORVM

HECEST HORRENDA CARIBDIS

SCONGEN

VINDER VAL

LOFAT

GAMBLAVIK

VAST

PISCES HVETE DICT

YGAVIK

HELGALA

TERRA NOBILIVM

FISCA

HO PISCIV CAV BVS

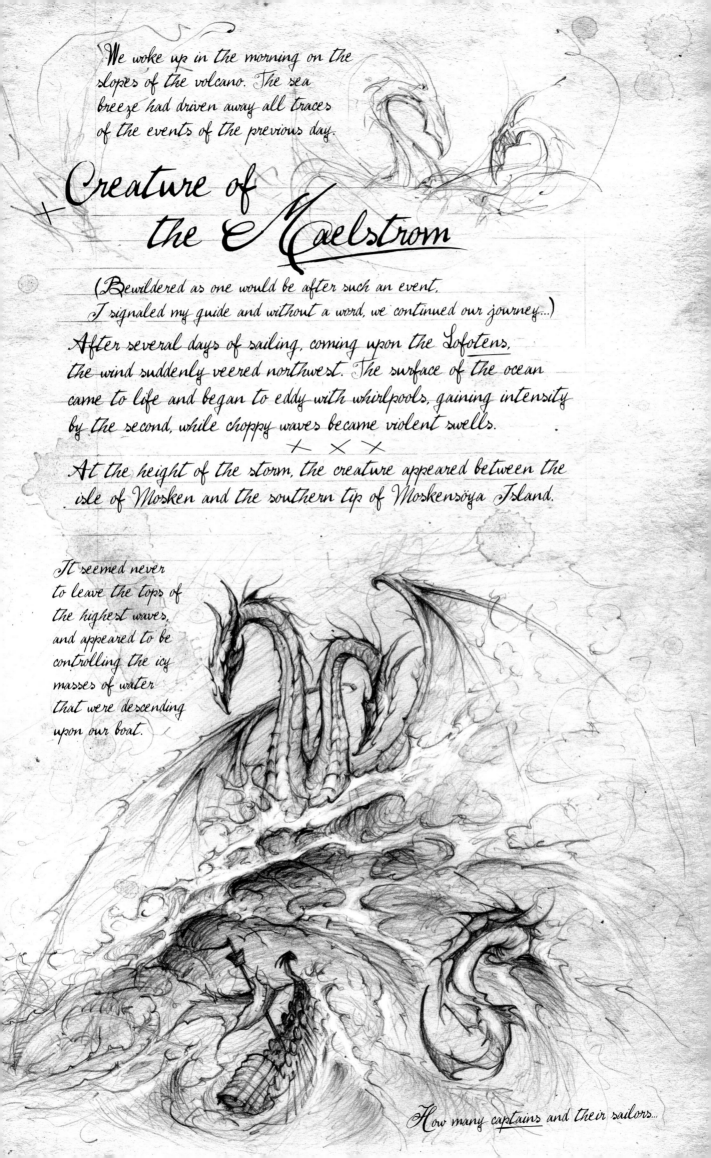

We woke up in the morning on the slopes of the volcano. The sea breeze had driven away all traces of the events of the previous day.

Creature of the Maelstrom

(Bewildered as one would be after such an event, I signaled my guide and without a word, we continued our journey...)

After several days of sailing, coming upon the Lofotens, the wind suddenly veered northwest. The surface of the ocean came to life and began to eddy with whirlpools, gaining intensity by the second, while choppy waves became violent swells.

At the height of the storm, the creature appeared between the isle of Mosken and the southern tip of Moskensöya Island.

It seemed never to leave the tops of the highest waves, and appeared to be controlling the icy masses of water that were descending upon our boat.

How many captains and their sailors...

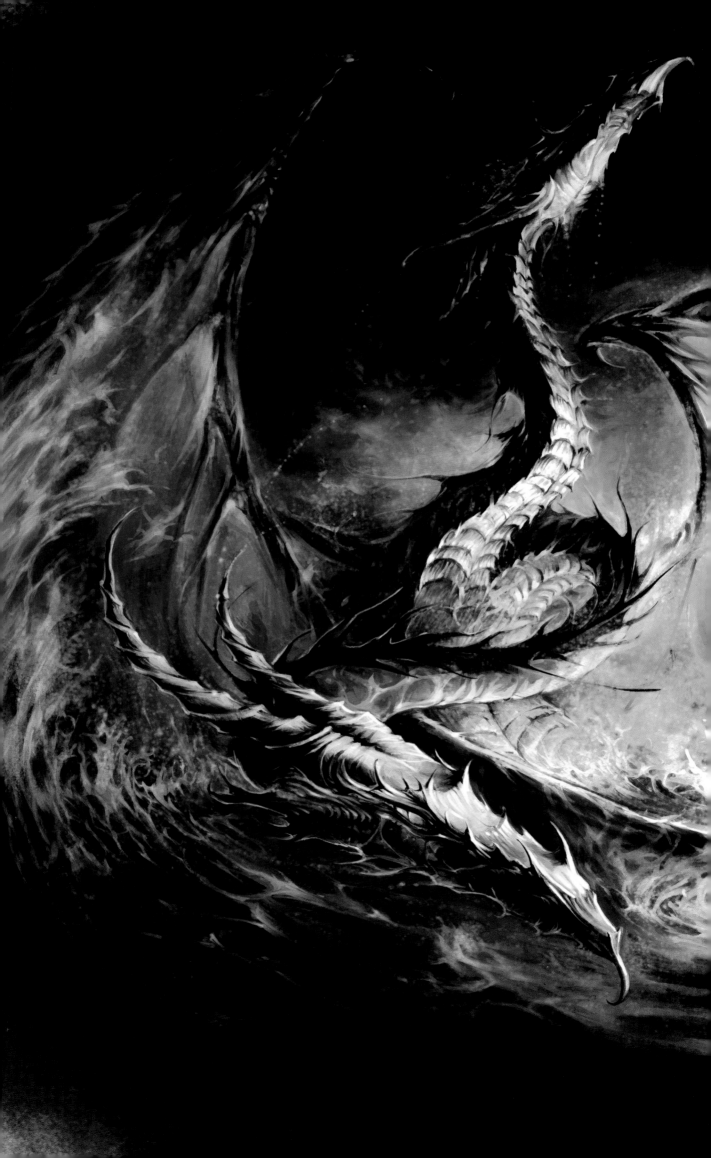

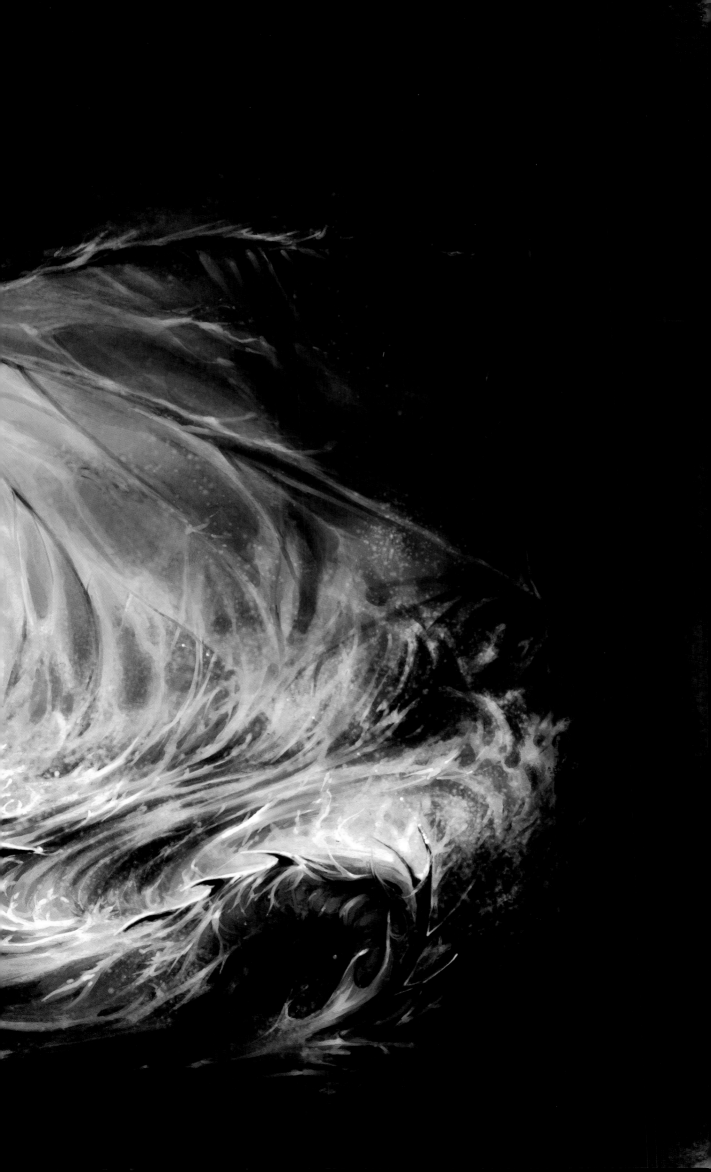

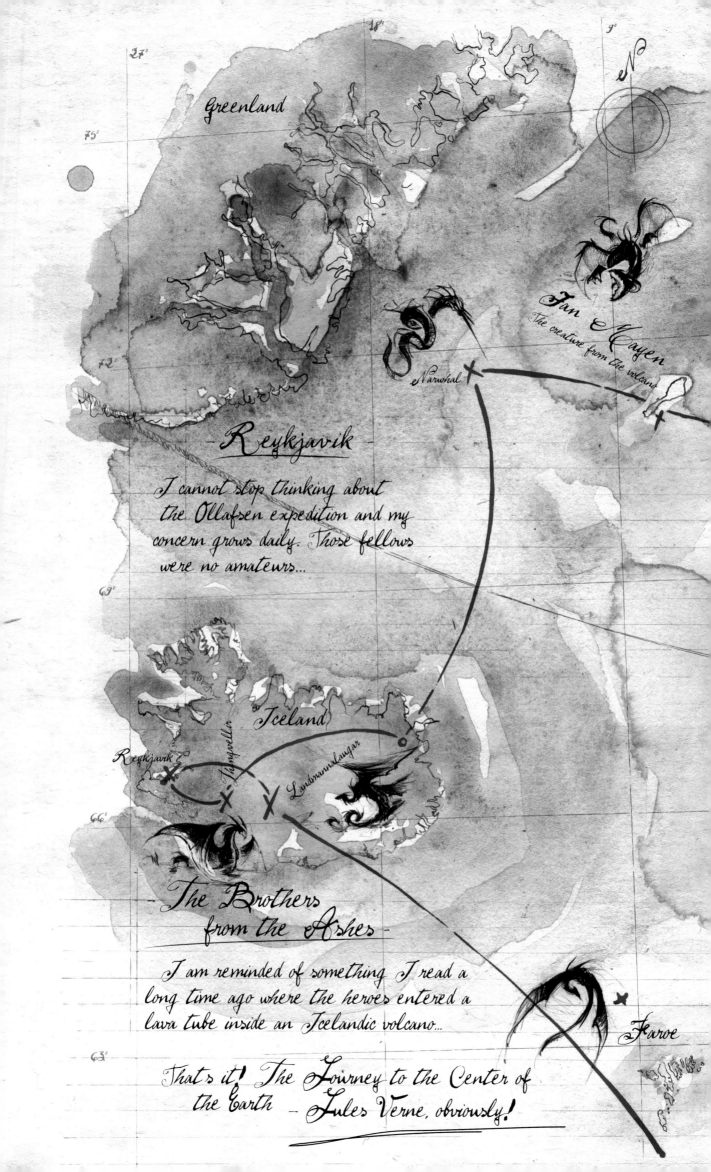

Greenland

N

75°

72°

Narwhal

Jan Mayen
The creature from the volcano

— Reykjavik —

*I cannot stop thinking about
the Ollafsen expedition and my
concern grows daily. Those fellows
were no amateurs...*

69°

Iceland

Reykjavik

Þingvellir

Landmannalaugar

66°

— The Brothers
from the Ashes —

*I am reminded of something I read a
long time ago where the heroes entered a
lava tube inside an Icelandic volcano...*

63°

*That's it! The Journey to the Center of
the Earth — Jules Verne, obviously!*

Faroe

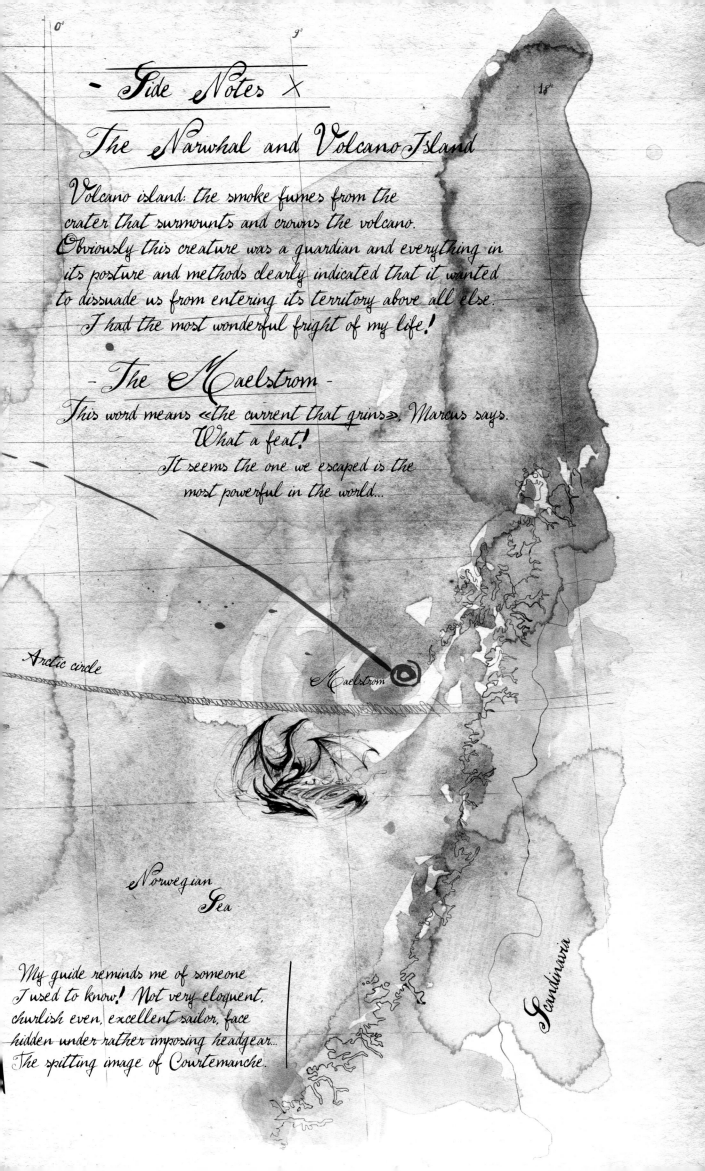

- Side Notes X

The Narwhal and Volcano Island

Volcano island: the smoke fumes from the
crater that surmounts and crowns the volcano.
Obviously this creature was a guardian and everything in
its posture and methods clearly indicated that it wanted
to dissuade us from entering its territory above all else.
I had the most wonderful fright of my life!

- The Maelstrom -

This word means «the current that grins». Marcus says.
What a feat!
It seems the one we escaped is the
most powerful in the world...

Arctic circle

Maelstrom

Norwegian
Sea

Scandinavia

My guide reminds me of someone
I used to know! Not very eloquent,
churlish even, excellent sailor, face
hidden under rather imposing headgear...
The spitting image of Courtemanche.

0° 9° 18°

Passage of the Lords of the Fjord

Exhausted, we arrived within sight of the Scandinavian shores just as the day came to an end.

My pilot steered the vessel very ably through the breaking surf and into a narrow and steep sided fjord.

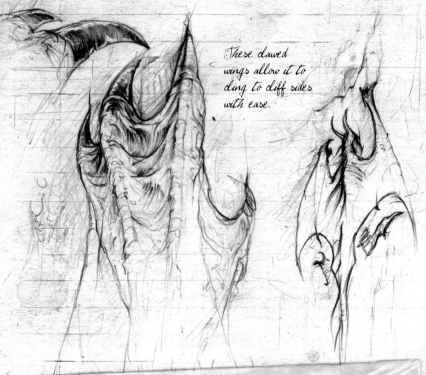

These clawed wings allow it to cling to cliff sides with ease.

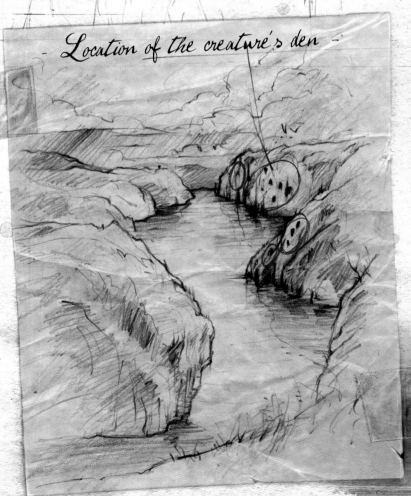

- Location of the creature's den -

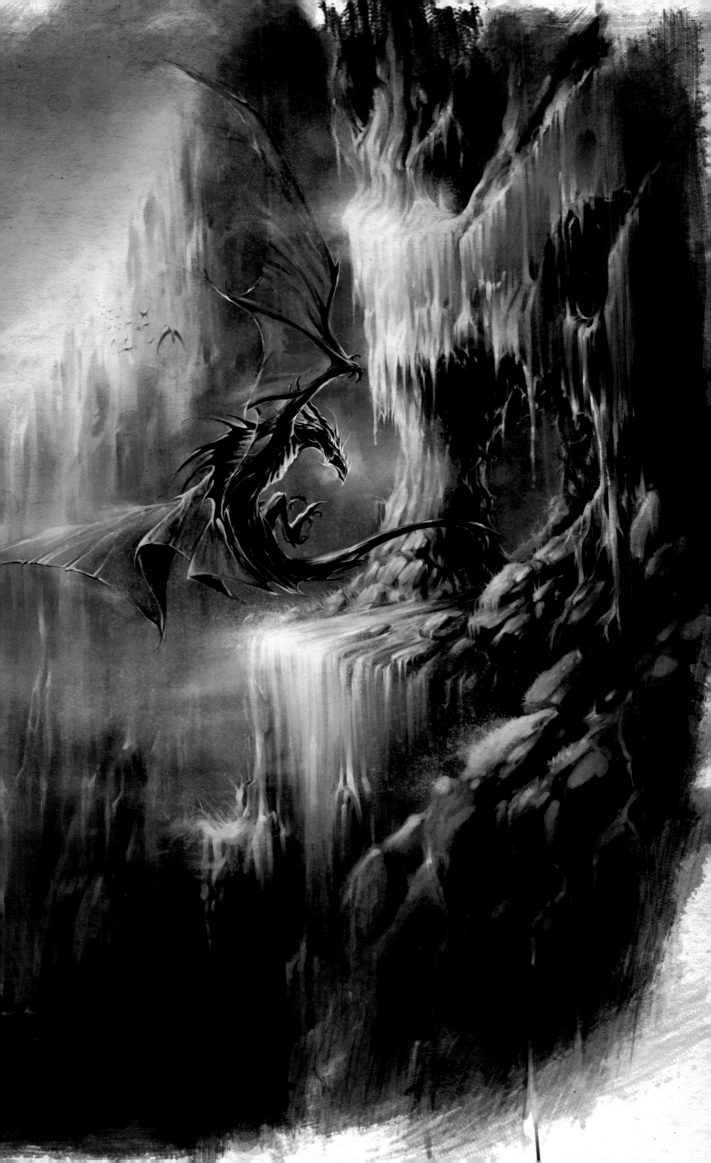

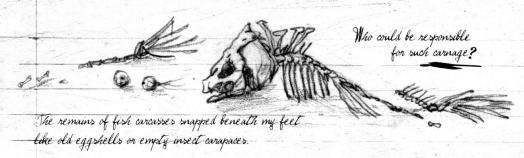

Who could be responsible for such carnage?

The remains of fish carcasses snapped beneath my feet like old eggshells or empty insect carapaces.

Meeting Jenny Haniver—

There was much agitation in the small fishing village where I found refuge. Adjacent to each of the dwellings, numerous drying racks set out for smoking fish are regularly ravaged and plundered with no notion of who or what could be responsible...

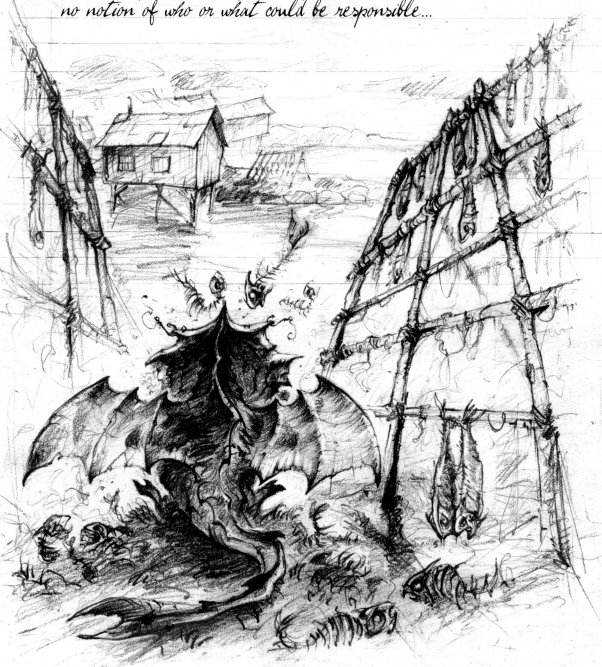

I was able to catch a brief glimpse of it due to the moonlight's reflection on what appeared to be scales.

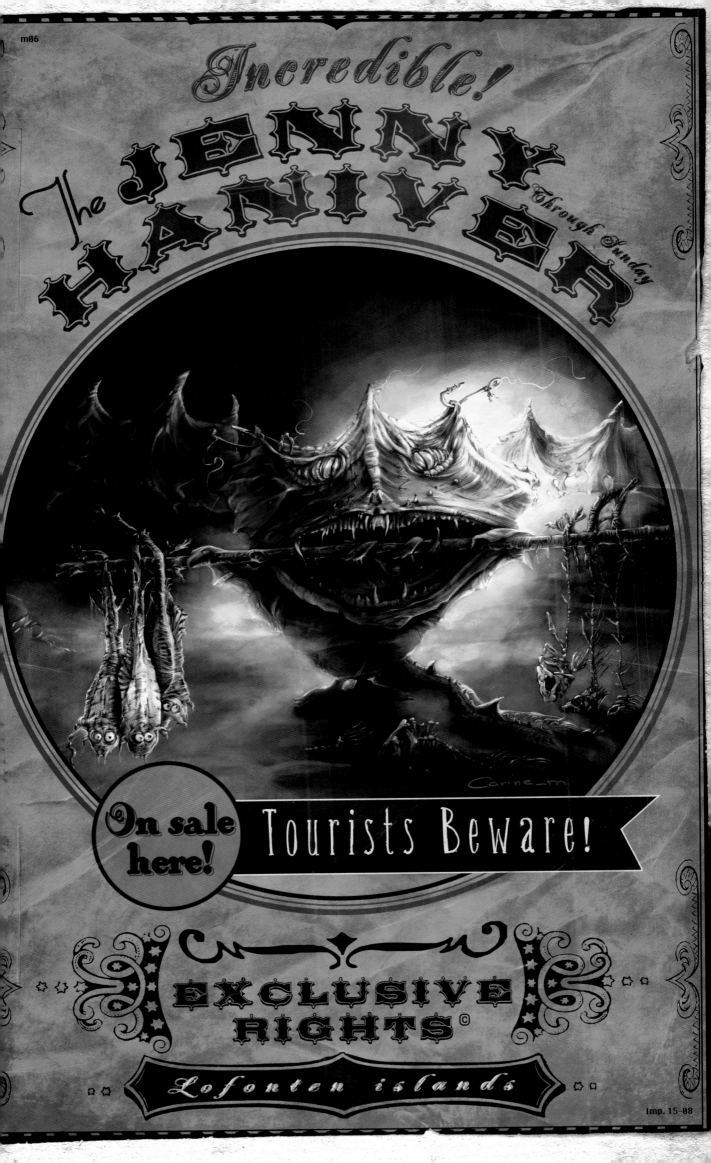

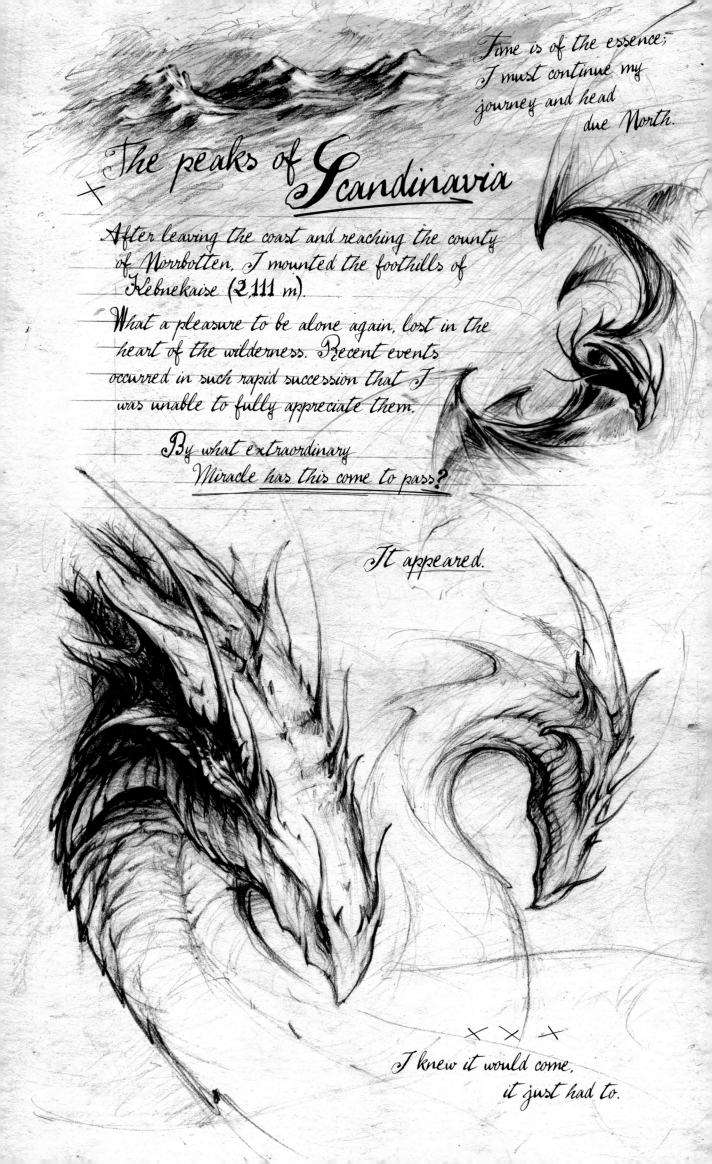

Time is of the essence; I must continue my journey and head due North.

The peaks of Scandinavia

After leaving the coast and reaching the county of Norrbotten, I mounted the foothills of Kebnekaise (2,111 m).

What a pleasure to be alone again, lost in the heart of the wilderness. Recent events occurred in such rapid succession that I was unable to fully appreciate them.

By what extraordinary Miracle has this come to pass?

It appeared.

I knew it would come, it just had to.

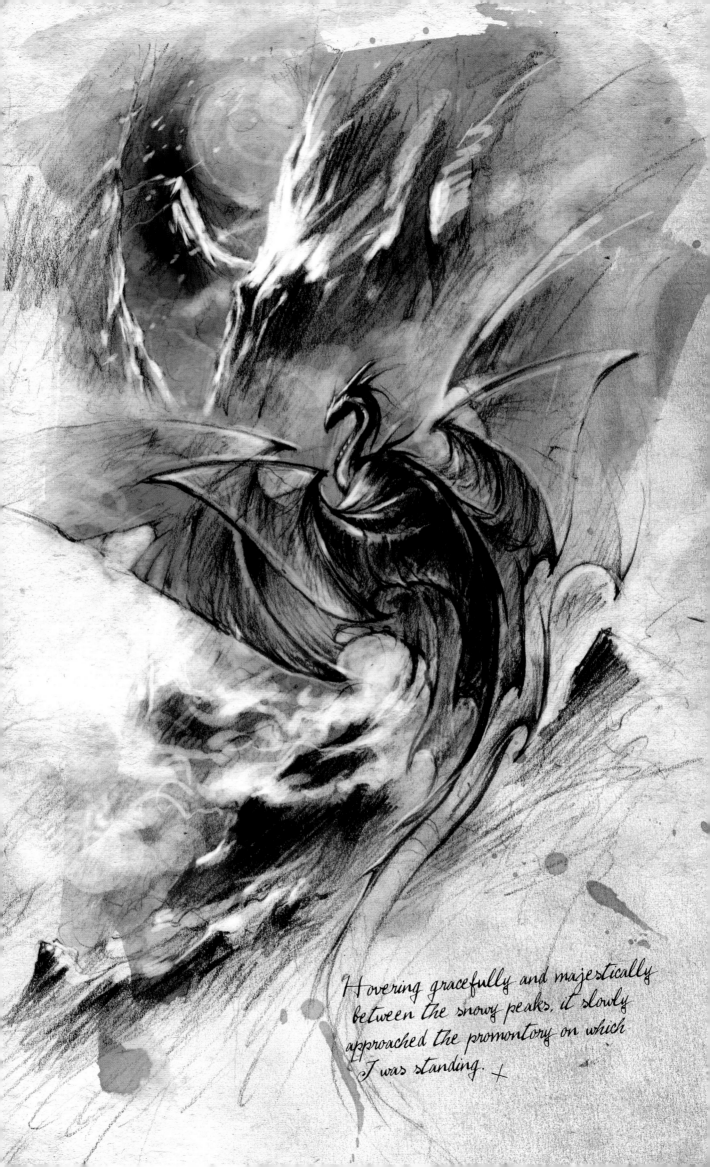

Hovering gracefully and majestically between the snowy peaks, it slowly approached the promontory on which I was standing. ✝

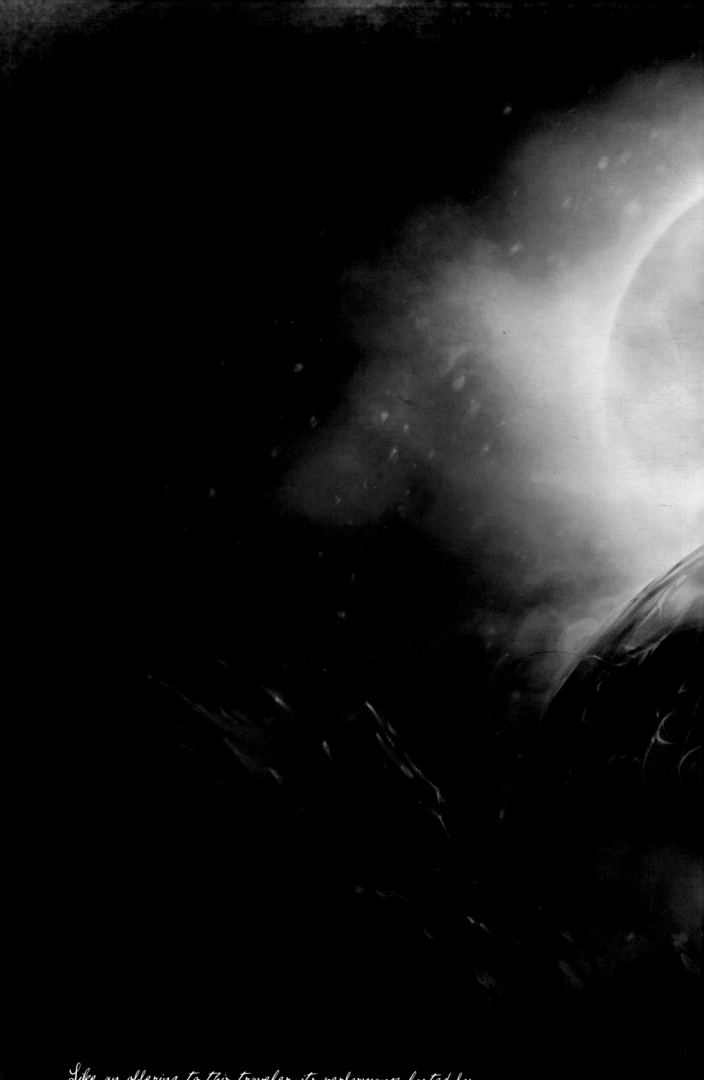

Like an offering to this traveler, its performance lasted for several hours, and then, as night fell, off it flew, into the East.

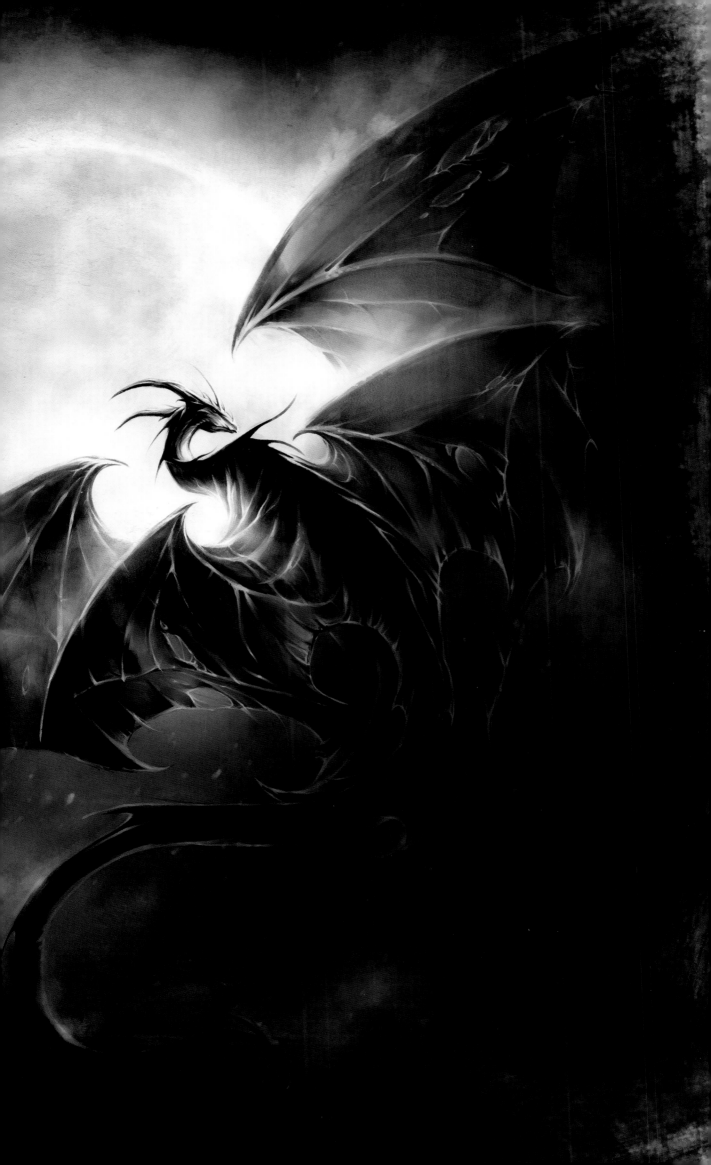

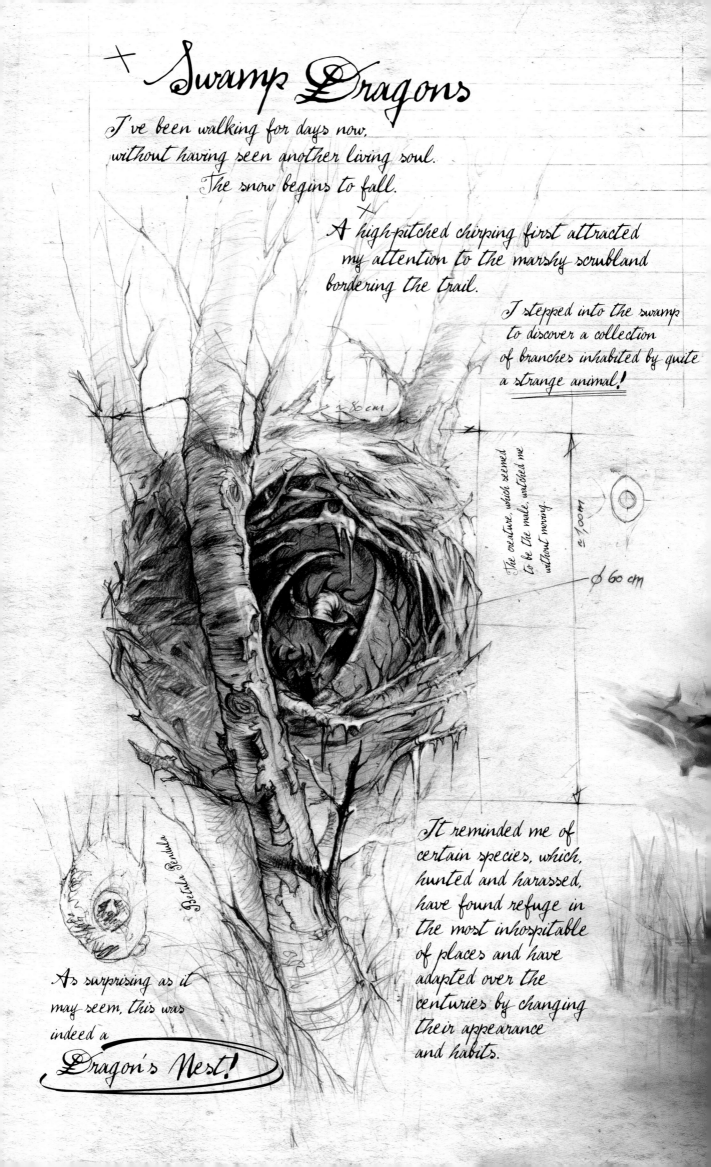

Swamp Dragons

I've been walking for days now,
without having seen another living soul.
The snow begins to fall.

A high-pitched chirping first attracted
my attention to the marshy scrubland
bordering the trail.

I stepped into the swamp
to discover a collection
of branches inhabited by quite
a strange animal!

The creature, which seemed
to be the male, watched me
without moving.

ø 60 cm

Betula Pendula

As surprising as it
may seem, this was
indeed a

Dragon's Nest!

It reminded me of
certain species, which,
hunted and harassed,
have found refuge in
the most inhospitable
of places and have
adapted over the
centuries by changing
their appearance
and habits.

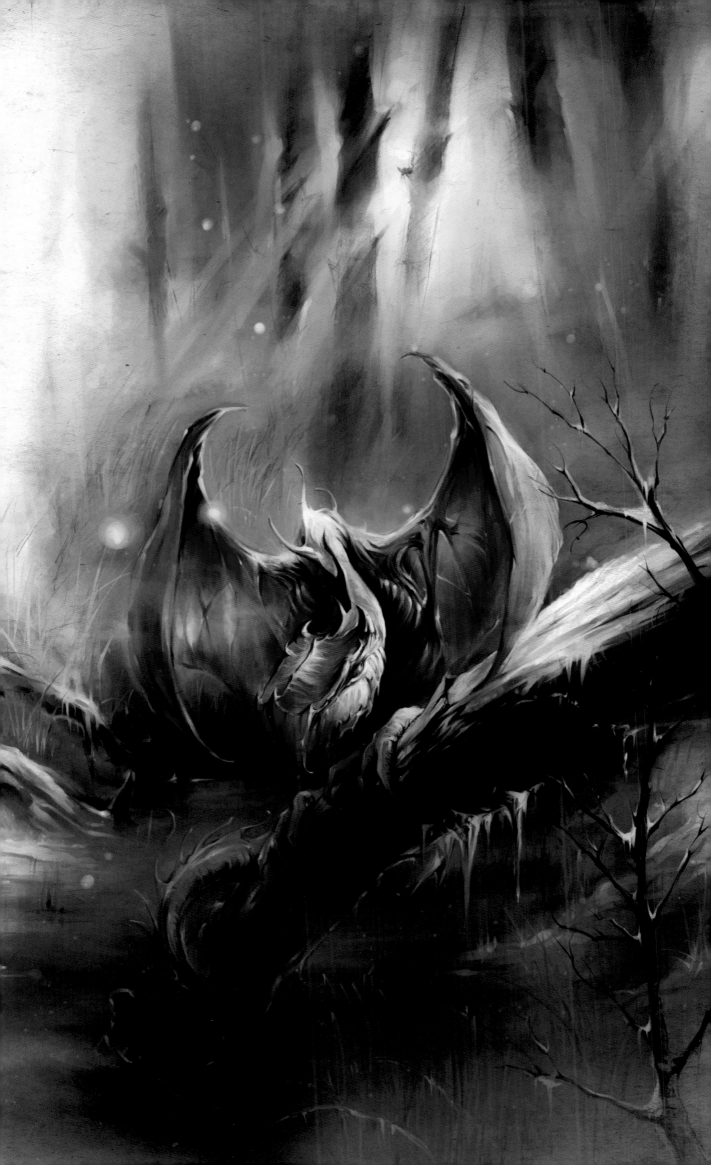

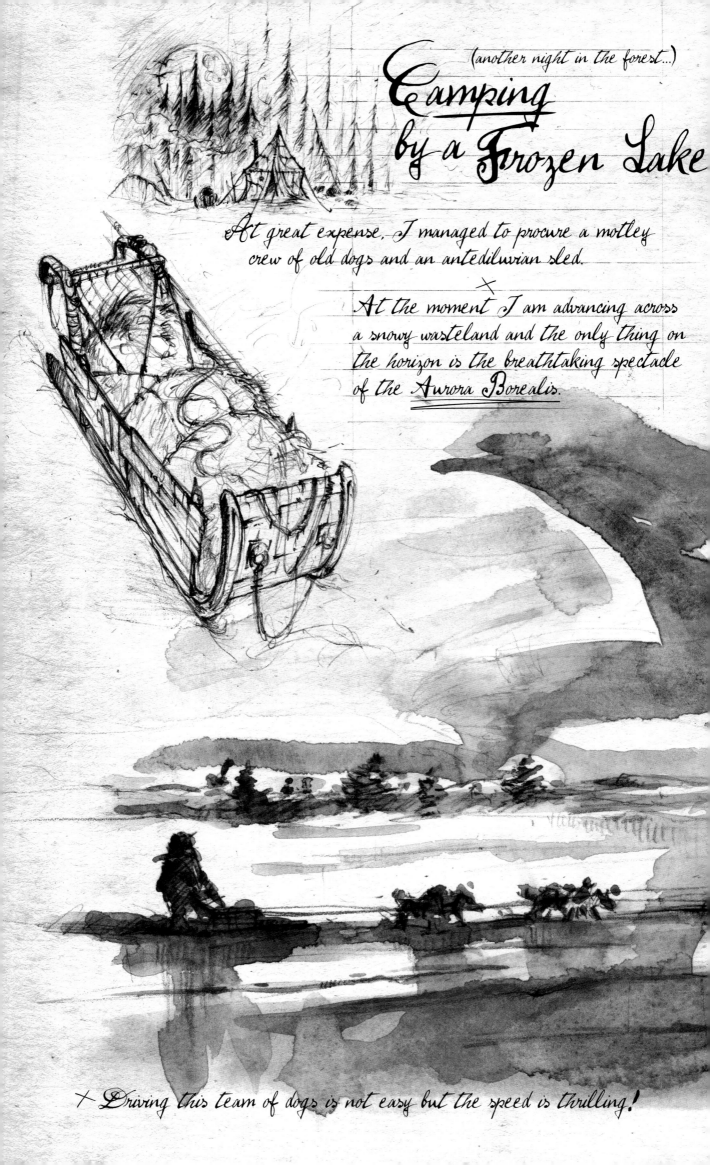

Camping by a Frozen Lake

At great expense, I managed to procure a motley crew of old dogs and an antediluvian sled.

At the moment I am advancing across a snowy wasteland and the only thing on the horizon is the breathtaking spectacle of the Aurora Borealis.

✕ Driving this team of dogs is not easy but the speed is thrilling!

The pack is frightened!

(The beginning of a great
struggle against the icy wind.)

the dogs are afraid...
they sense
a presence!

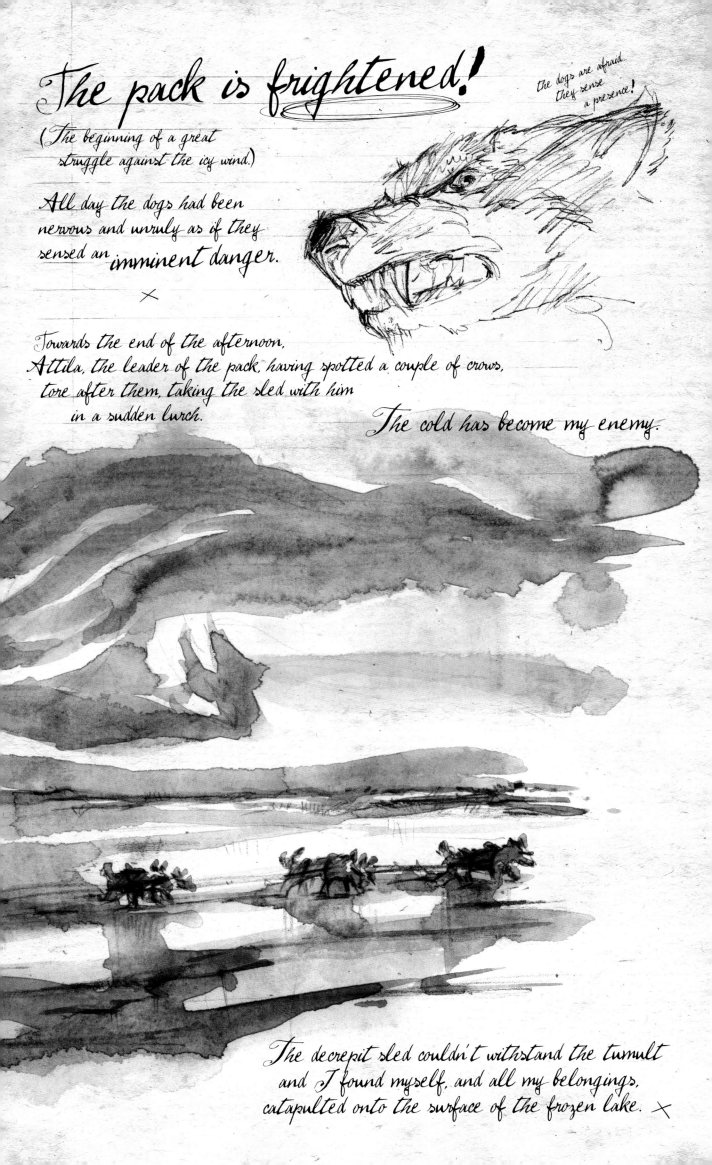

All day the dogs had been
nervous and unruly as if they
sensed an *imminent danger.*

✕

Towards the end of the afternoon,
Attila, the leader of the pack, having spotted a couple of crows,
tore after them, taking the sled with him
in a sudden lurch.

The cold has become my enemy.

The decrepit sled couldn't withstand the tumult
and I found myself, and all my belongings,
catapulted onto the surface of the frozen lake. ✕

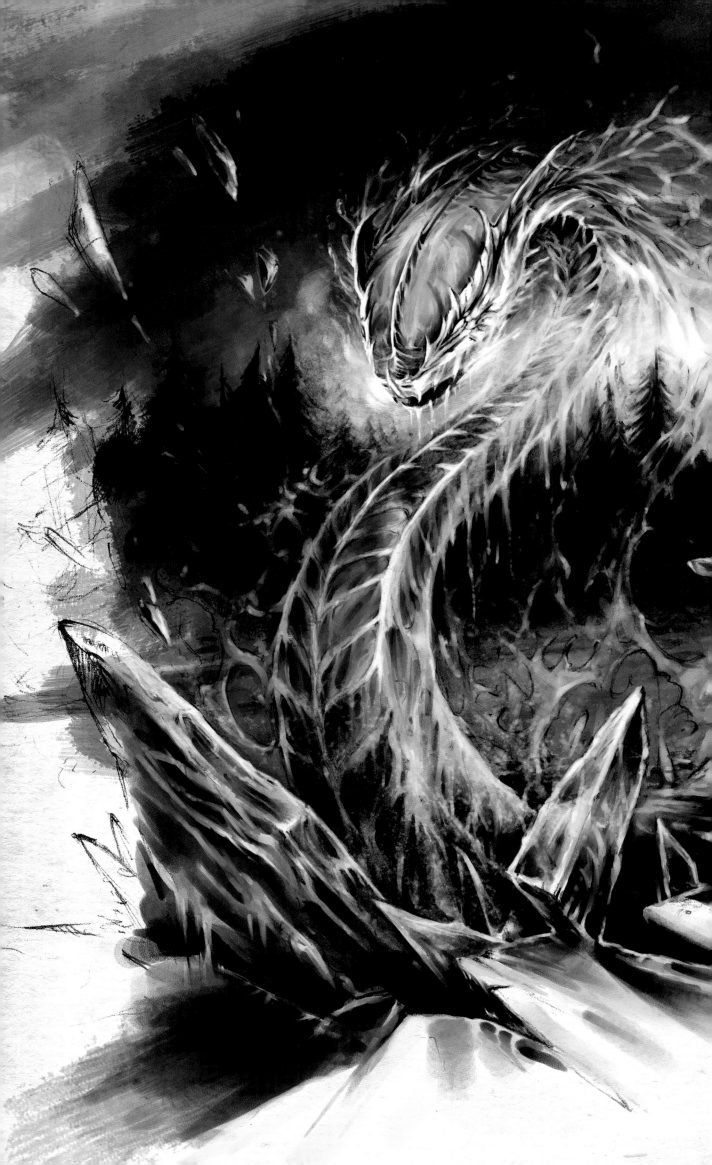

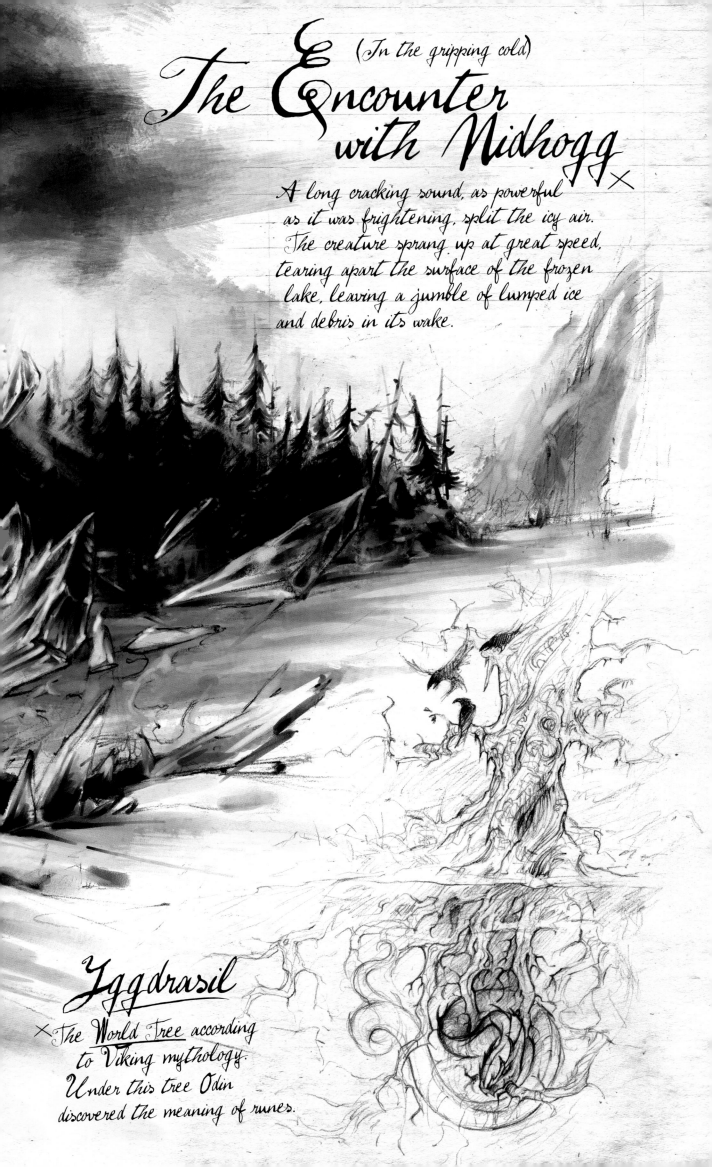

The Encounter with Nidhogg

(In the gripping cold)

A long cracking sound, as powerful as it was frightening, split the icy air. The creature sprang up at great speed, tearing apart the surface of the frozen lake, leaving a jumble of lumped ice and debris in its wake.

Yggdrasil

✕ The World Tree according to Viking mythology. Under this tree Odin discovered the meaning of runes.

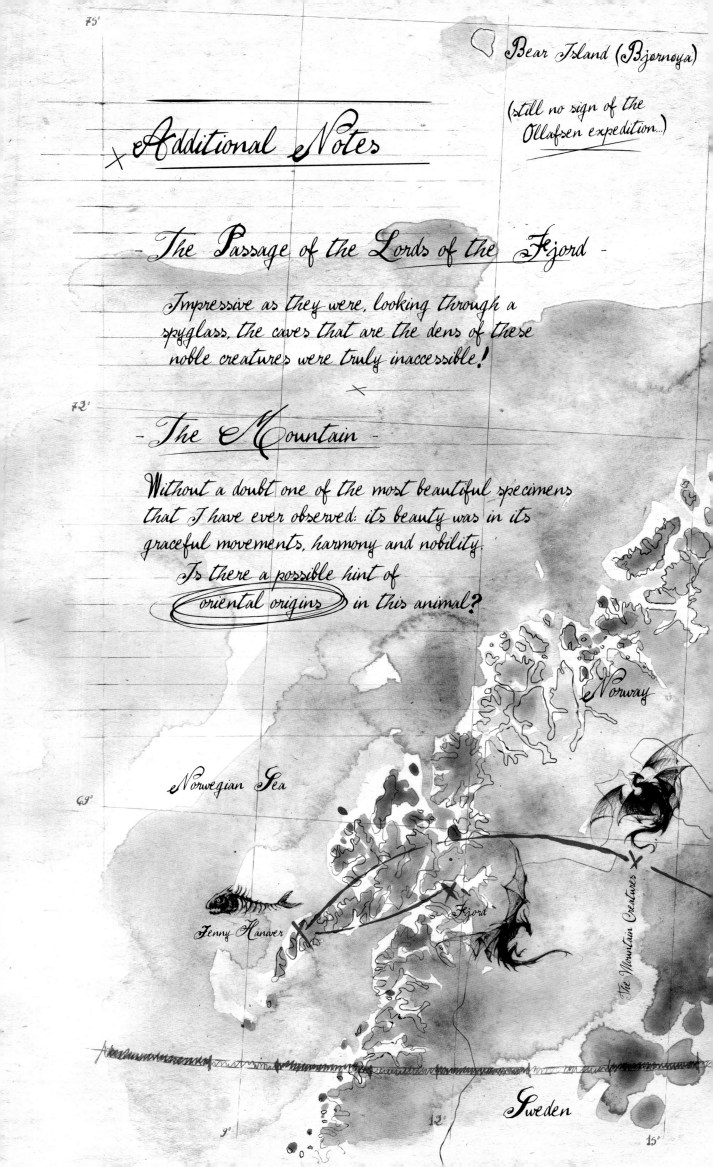

Bear Island (Bjørnøya)

(still no sign of the
Ollafsen expedition...)

Additional Notes

- The Passage of the Lords of the Fjord -

Impressive as they were, looking through a
spyglass, the caves that are the dens of these
noble creatures were truly inaccessible!

- The Mountain -

Without a doubt one of the most beautiful specimens
that I have ever observed: its beauty was in its
graceful movements, harmony and nobility.
 Is there a possible hint of
oriental origins in this animal?

Norway

Norwegian Sea

Jenny Hanver

Fjord

The Mountain Creatures

Sweden

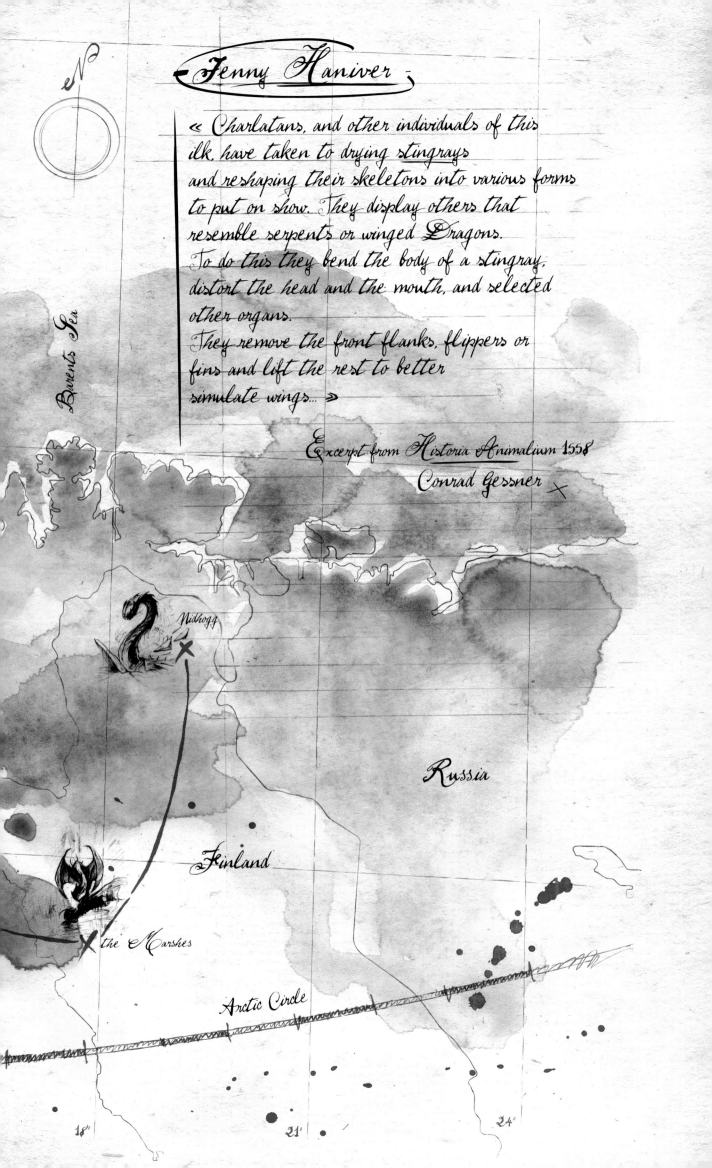

Fenny Haniver

« Charlatans, and other individuals of this
ilk, have taken to drying stingrays
and reshaping their skeletons into various forms
to put on show. They display others that
resemble serpents or winged Dragons.
To do this they bend the body of a stingray,
distort the head and the mouth, and selected
other organs.
They remove the front flanks, flippers or
fins and lift the rest to better
simulate wings... »

Excerpt from Historia Animalium 1558
Conrad Gessner

Barents Sea

Nidhogg

Russia

Finland

the Marshes

Arctic Circle

The Cold Trail

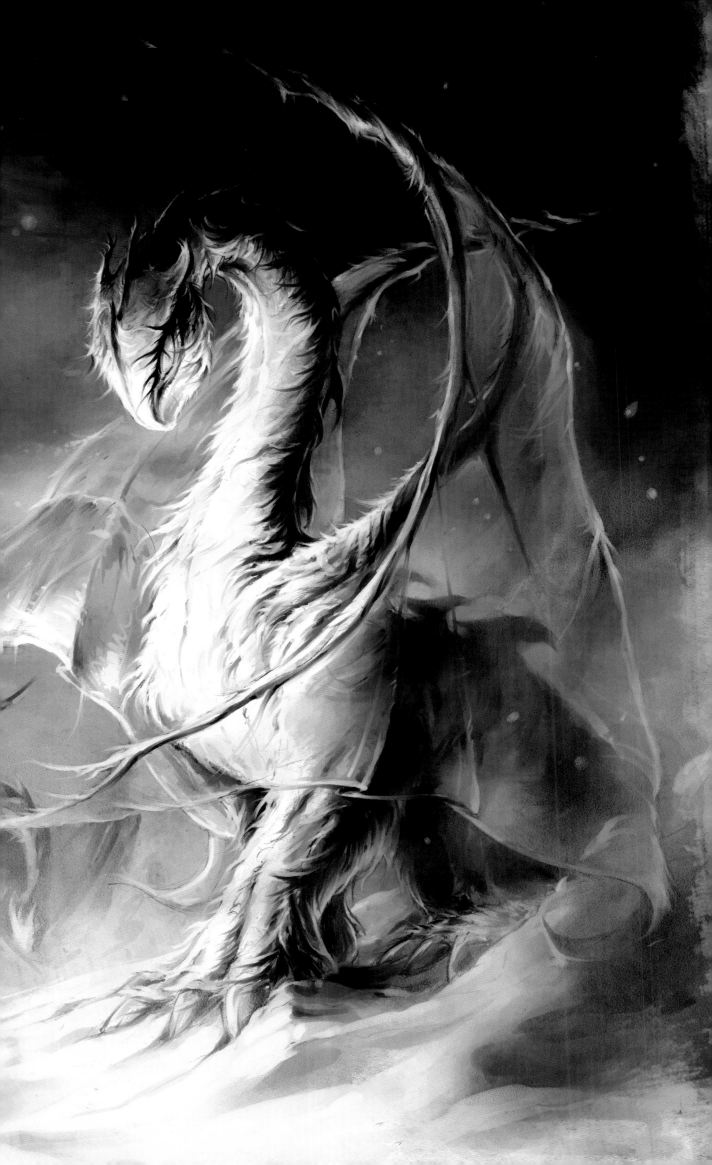

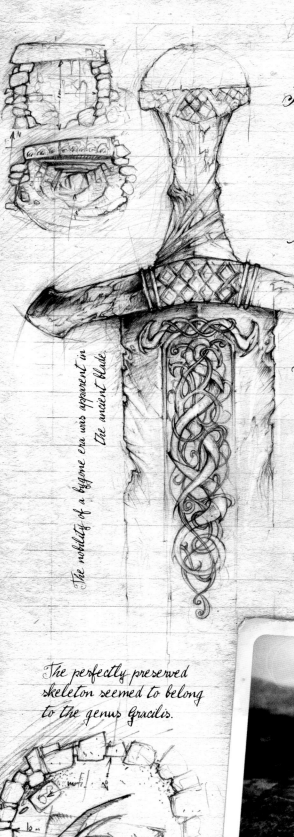

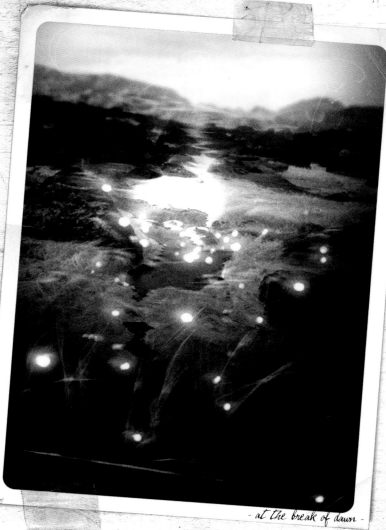

I had been walking for hours,
pierced by the winds,
when a flurry of
bright dots
sparkled in front of me.
Strange little beings that resembled
Fairy-like creatures led me to the
opening of a cairn built
of large blocks of granite.

×

Where I stepped into
this wonderous grotto...

the Fairy Trail

There was a mummified body of a medium
sized Dragon. It belonged to the common
classification of Draco Borealus

The nobility of a bygone era was apparent in
the ancient blade.

The perfectly preserved
skeleton seemed to belong
to the genus Gracilis.

- at the break of dawn -

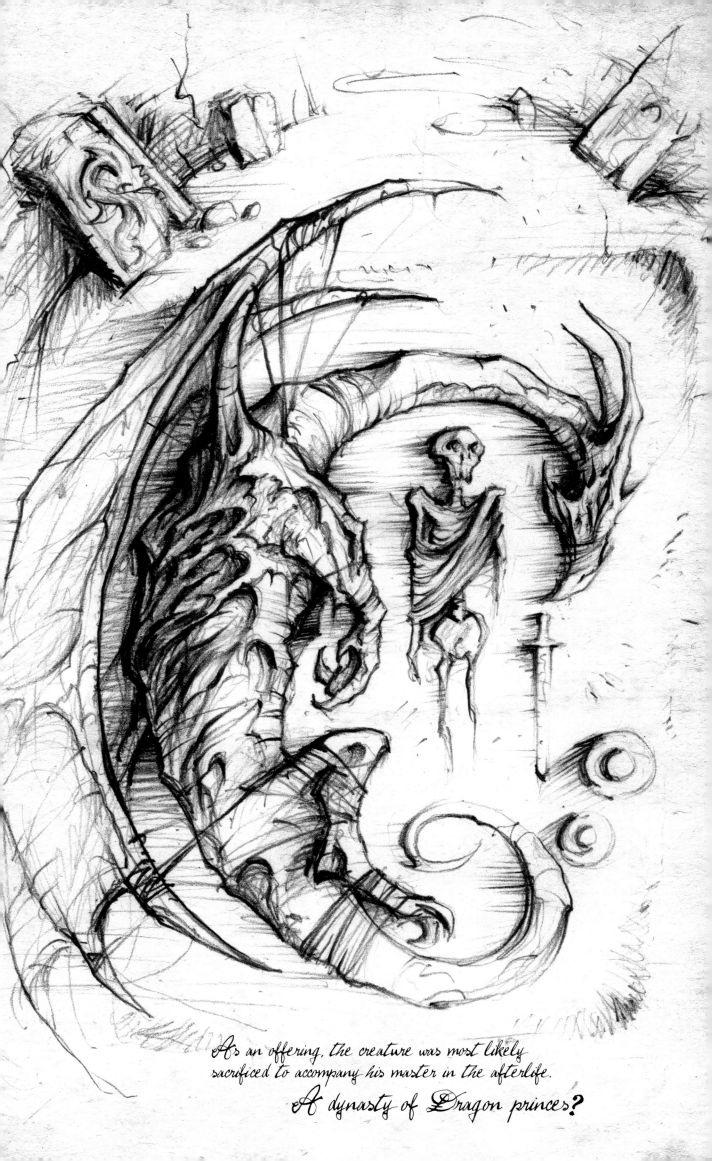

As an offering, the creature was most likely
sacrificed to accompany his master in the afterlife.

A dynasty of Dragon princes?

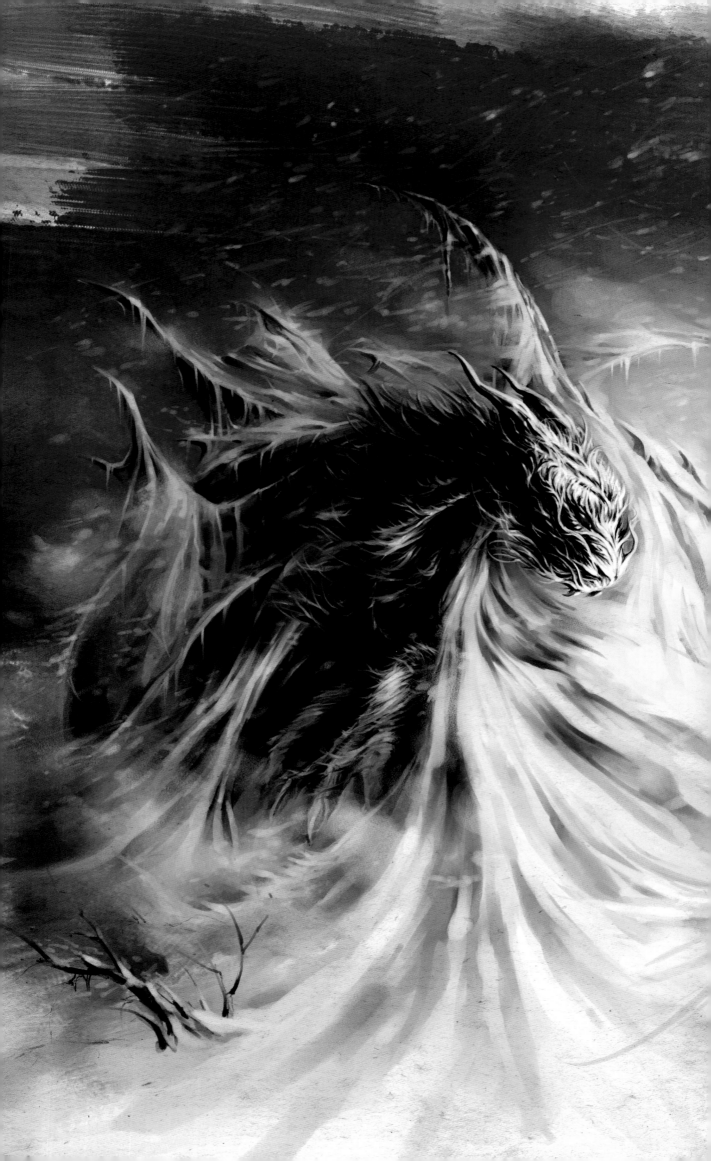

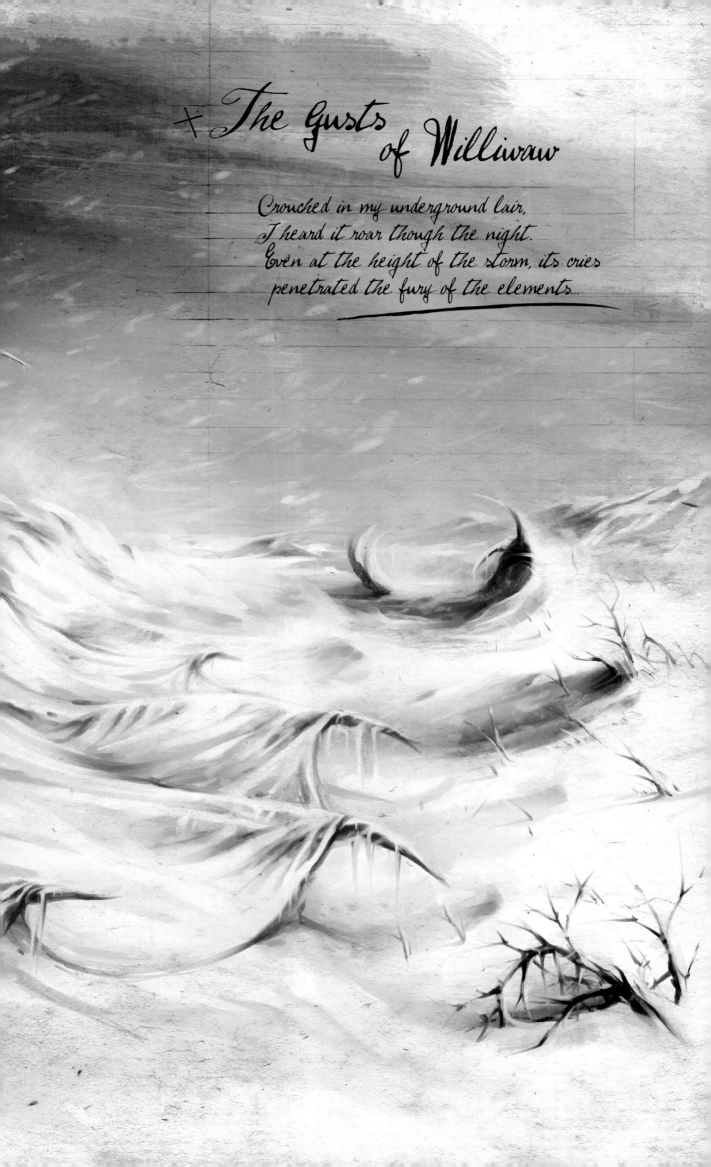

The Gusts of Williwaw

Crouched in my underground lair,
I heard it roar though the night.
Even at the height of the storm, its cries
penetrated the fury of the elements...

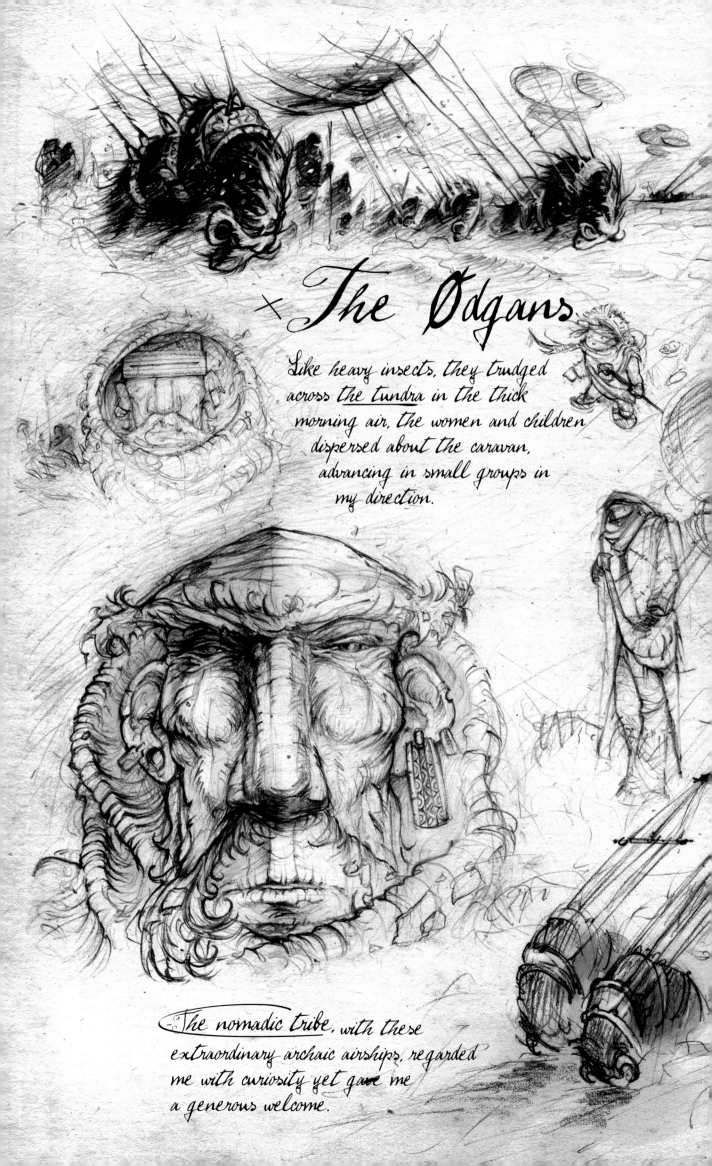

The Odgans

Like heavy insects, they trudged across the tundra in the thick morning air, the women and children dispersed about the caravan, advancing in small groups in my direction.

The nomadic tribe, with these extraordinary archaic airships, regarded me with curiosity yet gave me a generous welcome.

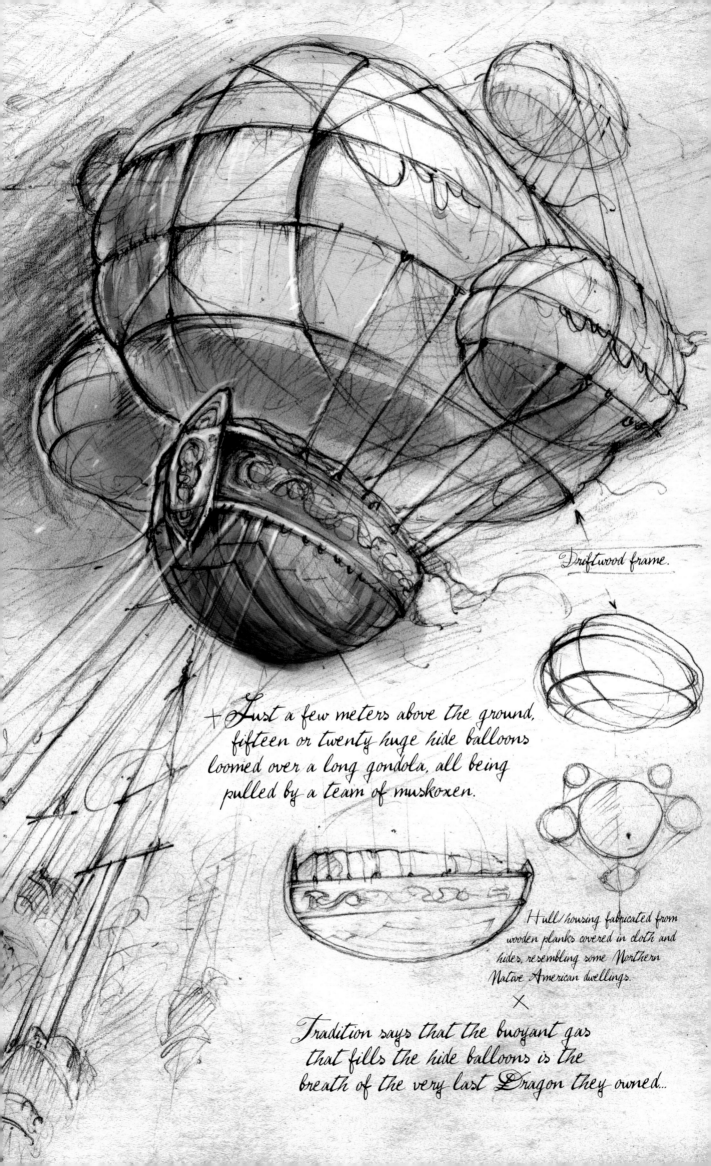

Driftwood frame.

+ Just a few meters above the ground, fifteen or twenty huge hide balloons loomed over a long gondola, all being pulled by a team of muskoxen.

Hull/housing fabricated from wooden planks covered in cloth and hides, resembling some Northern Native American dwellings.

×

Tradition says that the buoyant gas that fills the hide balloons is the breath of the very last Dragon they owned...

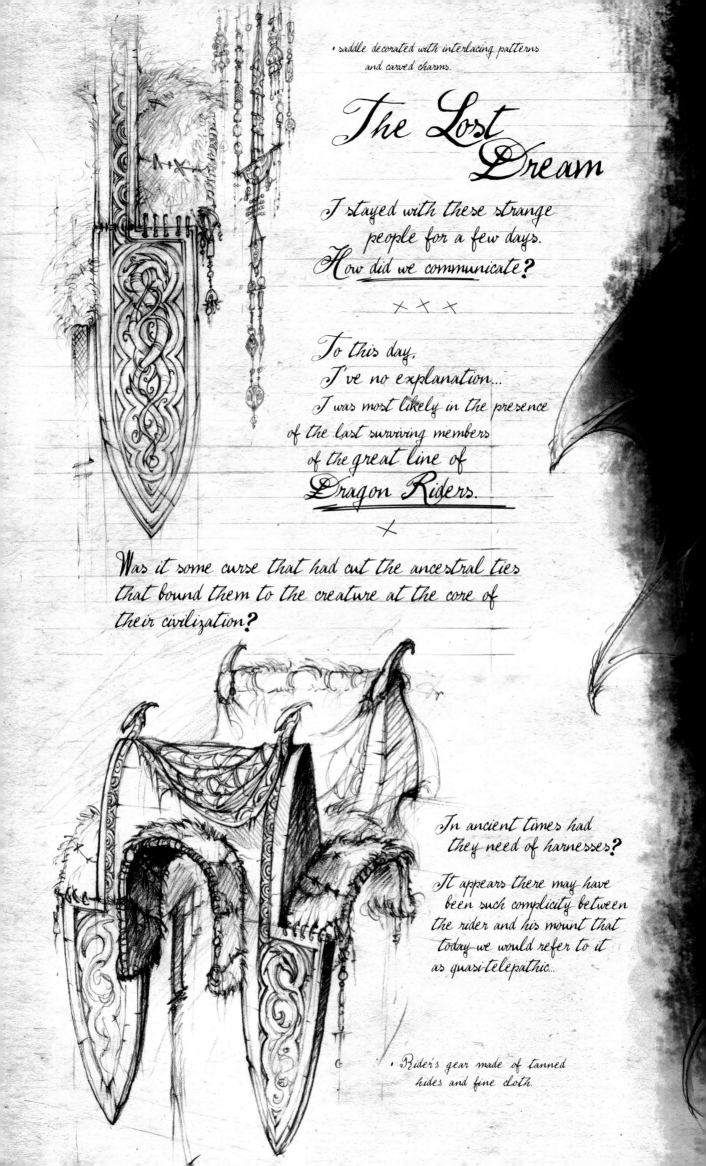

· saddle decorated with interlacing patterns
and carved charms.

The Lost Dream

I stayed with these strange
people for a few days.
How did we communicate?

× × ×

To this day,
I've no explanation...
I was most likely in the presence
of the last surviving members
of the great line of
Dragon Riders.

×

Was it some curse that had cut the ancestral ties
that bound them to the creature at the core of
their civilization?

In ancient times had
they need of harnesses?

It appears there may have
been such complicity between
the rider and his mount that
today we would refer to it
as quasi-telepathic...

· Rider's gear made of tanned
hides and fine cloth.

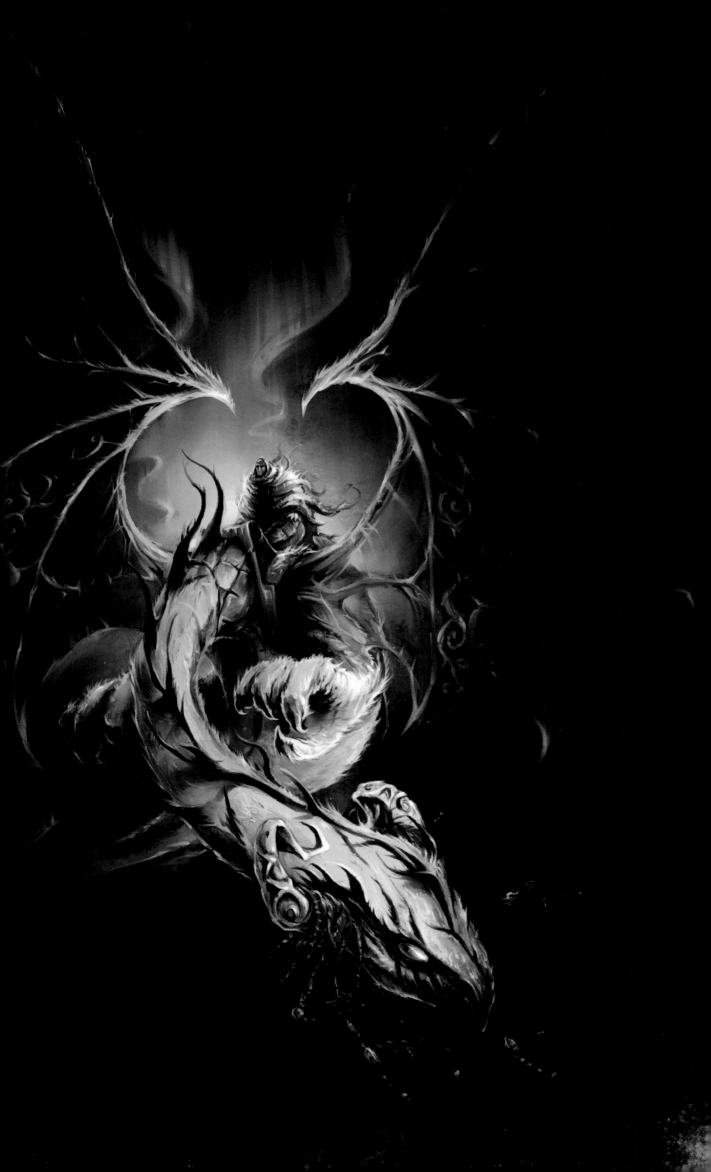

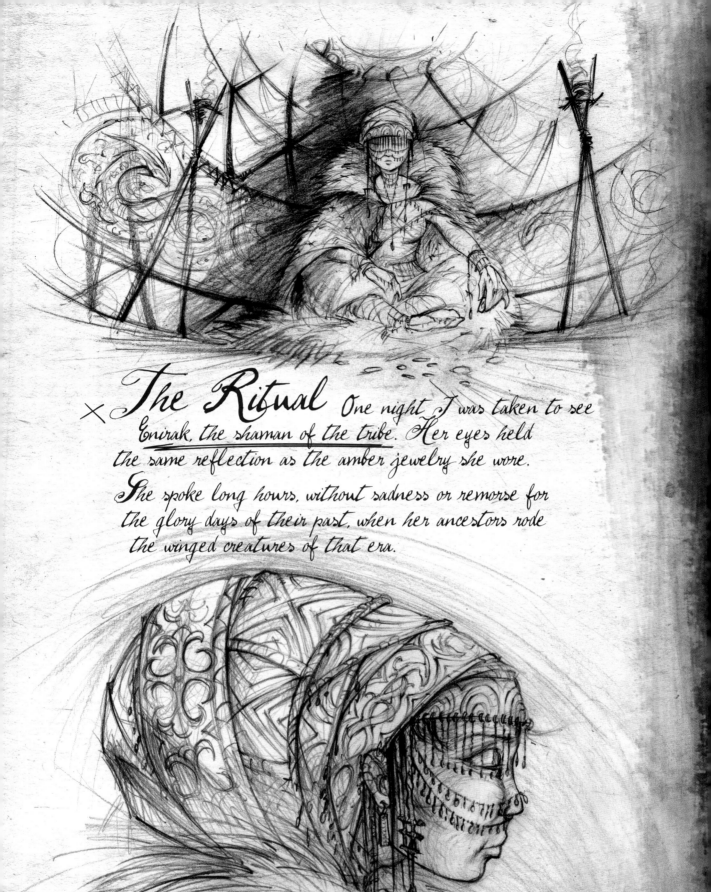

The Ritual

One night I was taken to see Enirak, the shaman of the tribe. Her eyes held the same reflection as the amber jewelry she wore.

She spoke long hours, without sadness or remorse for the glory days of their past, when her ancestors rode the winged creatures of that era.

According to Odgan mythology, the tears of the last great Dragons of the North are the origins of amber.

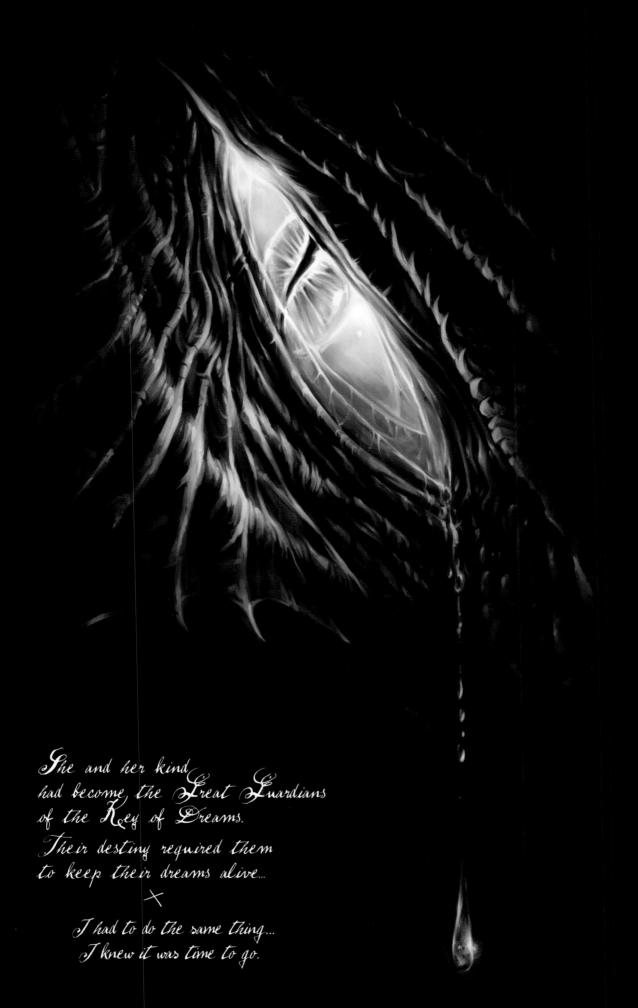

She and her kind
had become, the Great Guardians
of the Key of Dreams.
Their destiny required them
to keep their dreams alive...

I had to do the same thing...
I knew it was time to go.

Dreamtime

The creature awaited me at the entrance of a
long crevasse that crossed the width of the glacier.

I followed it to the city of the dragon people...

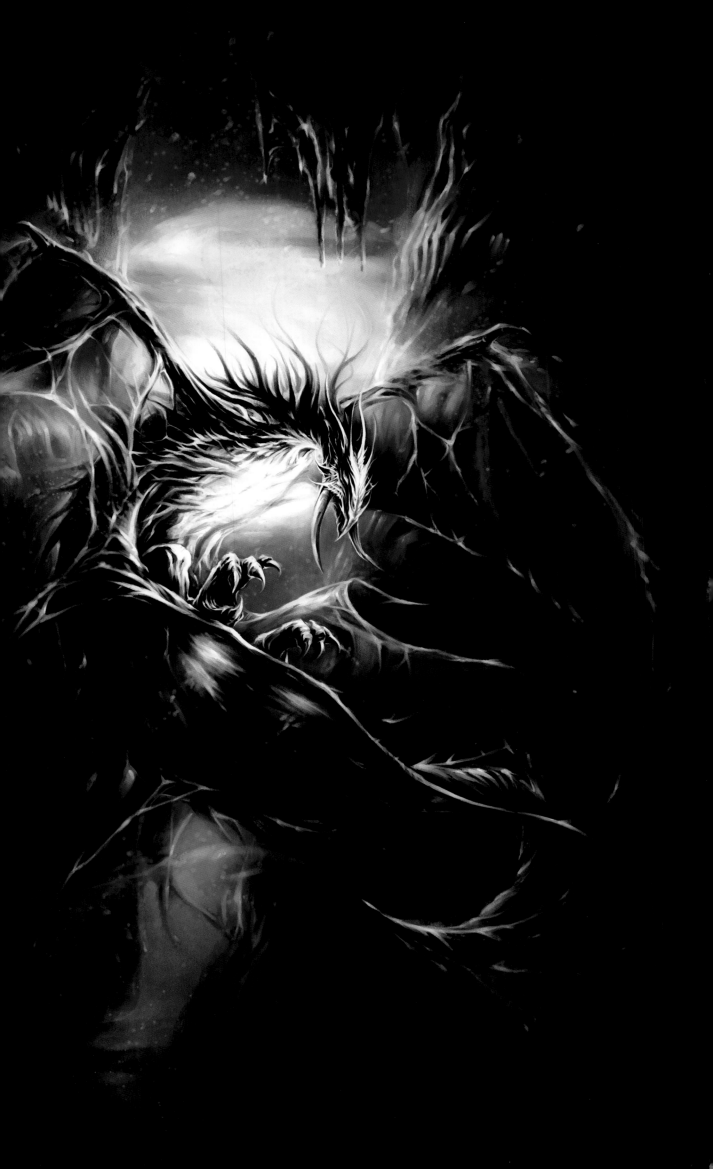

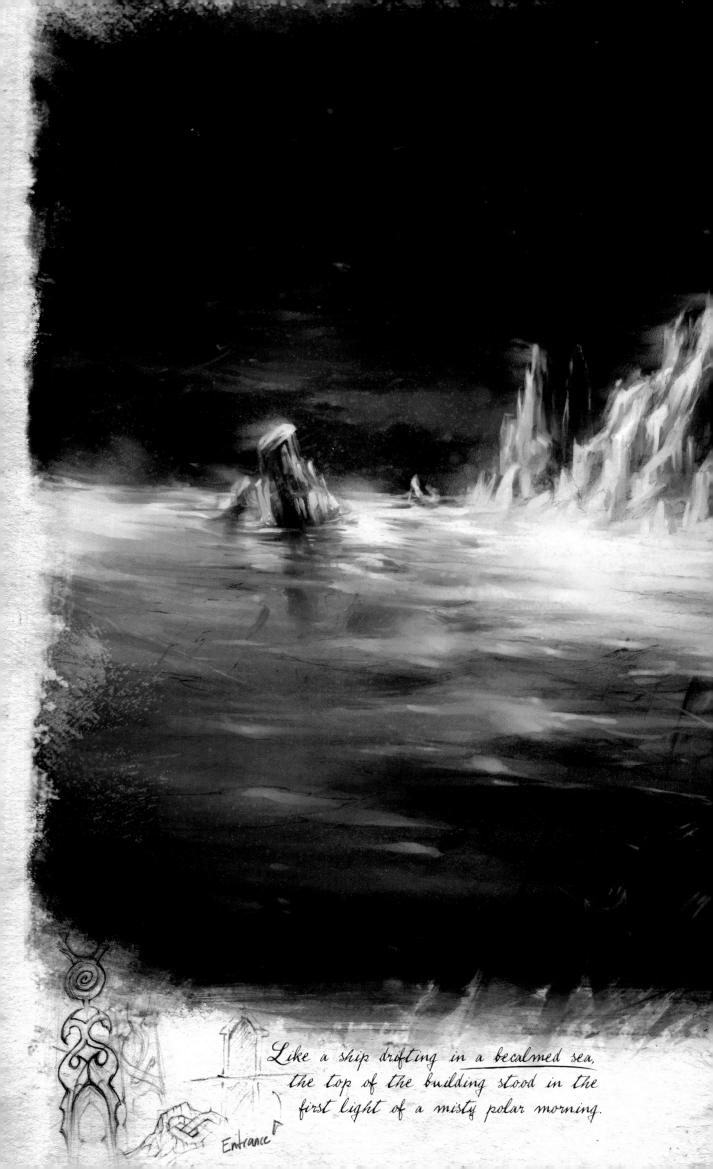

*Like a ship drifting in a becalmed sea,
the top of the building stood in the
first light of a misty polar morning.*

Entrance

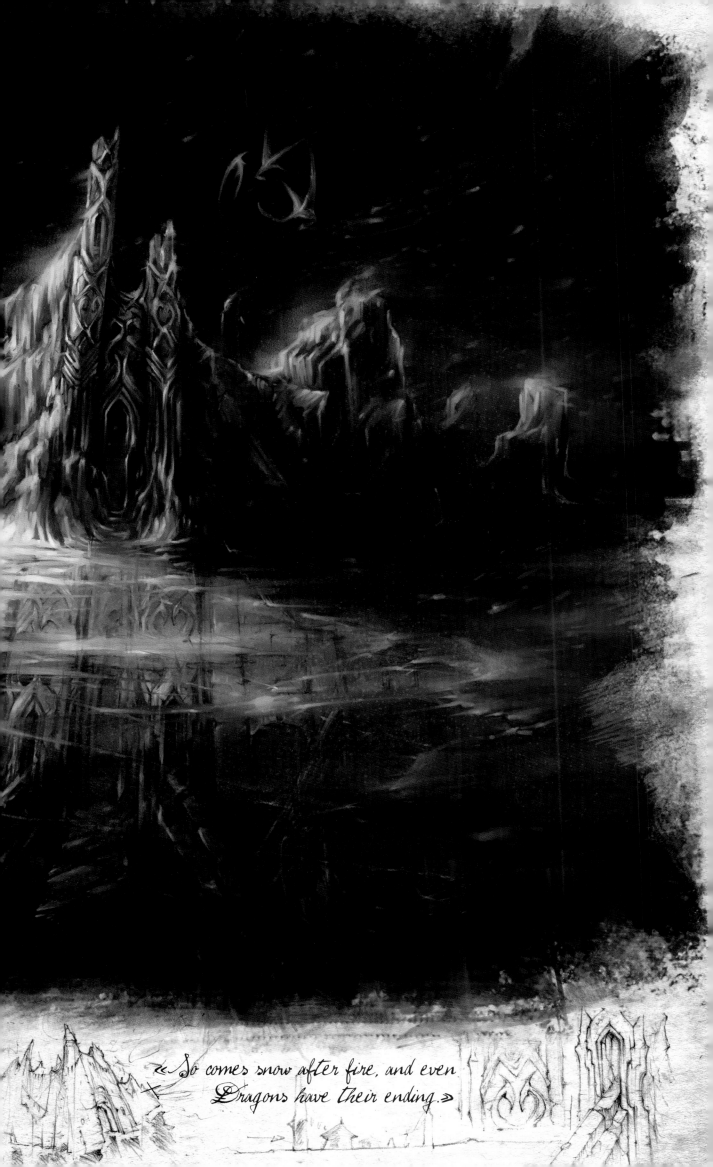

«So comes snow after fire, and even Dragons have their ending.»

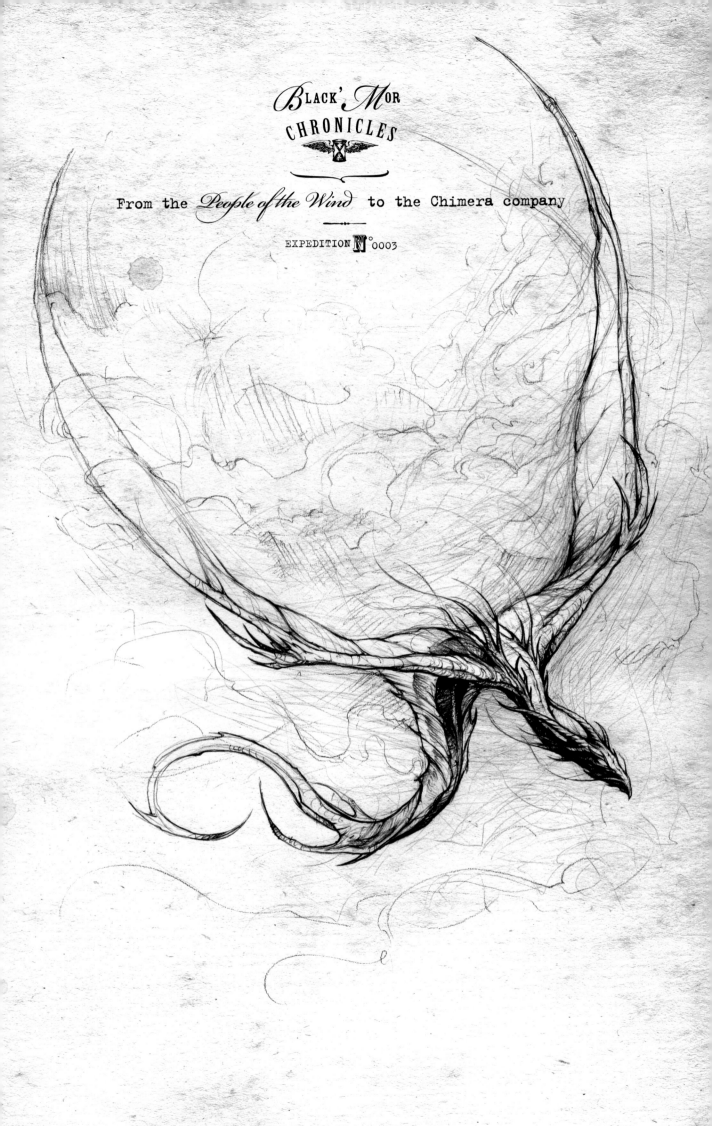

BLACK'MOR
CHRONICLES

From the *People of the Wind* to the Chimera company

EXPEDITION N°0003

From the *People of the Wind* to the Chimera company

« Those who dream by day are cognizant of many things
that escape those who dream only at night. »
× Edgar Allan Poe ×

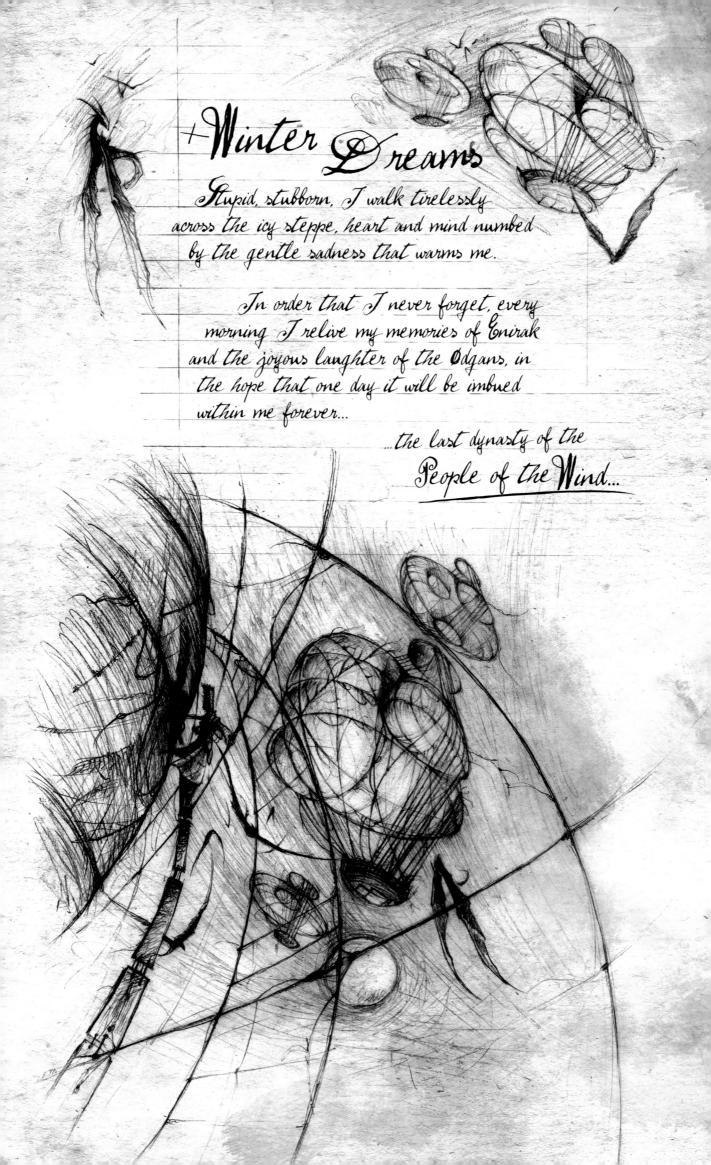

Winter Dreams

Stupid, stubborn, I walk tirelessly
across the icy steppe, heart and mind numbed
by the gentle sadness that warms me.

In order that I never forget, every
morning I relive my memories of Enirak
and the joyous laughter of the Odgans, in
the hope that one day it will be imbued
within me forever...

...the last dynasty of the
People of the Wind...

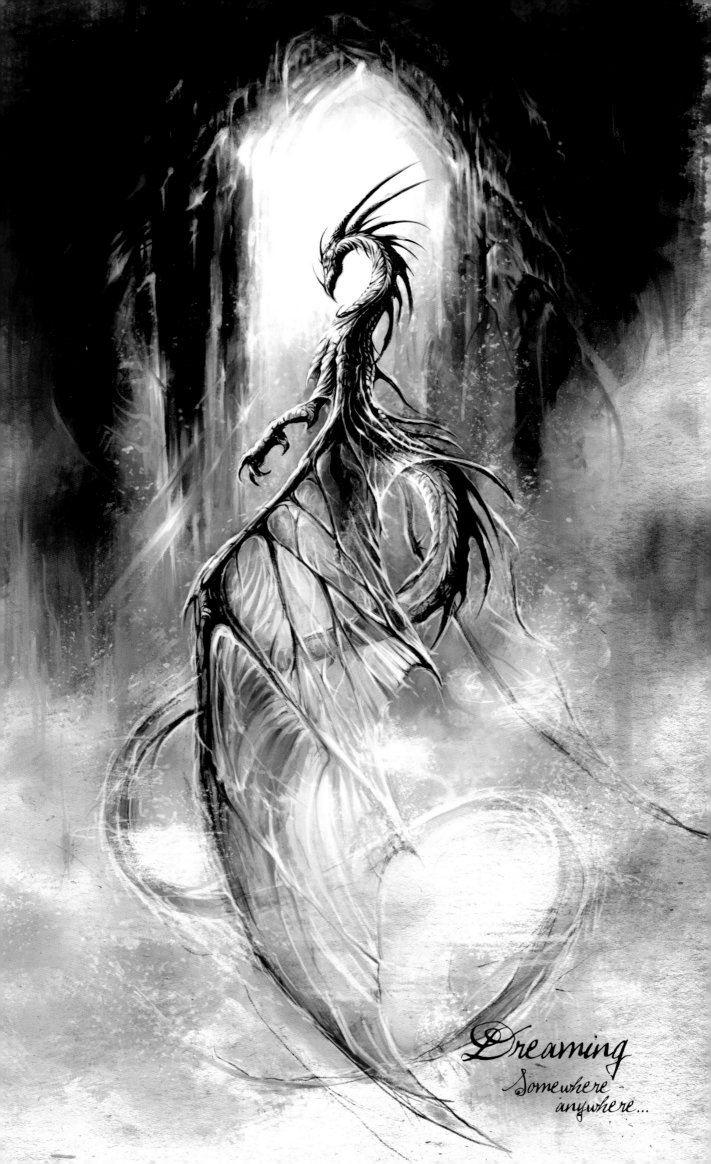

Dreaming
Somewhere
anywhere...

✕ *Helsinki*

By nightfall I had gained Helsinki
upon the Baltic shores where I was able, at
the best place in town, The Prince Gustav Hotel,
to indulge myself in some spicy pickled delights,
partake of the pleasure of a nice hot bath,
and finally get some sleep~~~~

 To my great surprise, as I crossed the
great hall this morning, the concierge signaled
to me, and without having understood a single
word, he handed me an envelope.

Sent by Pat Jekyll as if by magic, it
contained some newspaper articles, enlightening
to say the least, and commented on
in his hand... I was dumbstruck...

One thing is certain; I must go as quickly as possible to the location
of this « strange discovery »... My heart was pounding...

According to dear old Pat,
an interesting surprise
awaits me in a warehouse
on the docks of the old port.

I am concerned, however, the letter
had arrived weeks ago....

Mr. de la Mole asked me to include this ad that, according to him, could be of great interest to you.

Print run certified by A.B.D.C.

VOLUME : 3617

THE INCREDULOUS

THE PAPER FOR THOSE WHO AREN'T CREDULOUS

EDITION • MORLAIX : 35TH YEAR • UNAUTHORIZED COPIES PROHIBITED

PRICE: THREE CENTS

WEATHER: 95% HUMIDITY

Though the information received is imprecise, given your great geographical and orienting abilities I am not worried on this account.

OF THE GOBI DESERT

RANGE DISCOVERY

R THAT TOOK THIS PHOTO TELLS US MORE ON PAGE 2

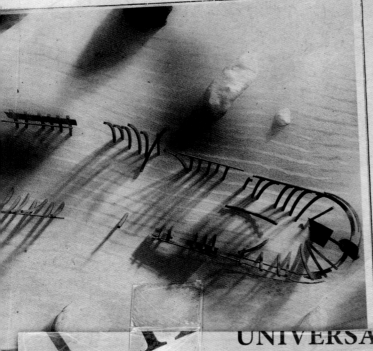

Alan Pyting, our correspondent for South East Asia who is presently investigating the diplomatic discords and the numerous border incidents between Russia and China, took this photograph.

While he was flying over the Burden Bulag region of Mongolia on his way to Ourga, the country's capital, he spotted this extraordinary ship's wreckage in the middle of the sands of the Gobi Desert! Without a doubt we are looking at the ancient Noah's Ark.

Alan risked his life to get this amazing photograph by climbing out of the cockpit of his plane, and onto and across one of the wings. Around the wooden structure we can see stone blocks emerging out of the dunes. Are they the tips of the gigantic reefs which impaled Noah?...

Continued on page 2

UNIVERSAL NEWSPAPER

WEEKLY

DRAGONS DO EXIST

A MADMAN TRIES TO MAKE US BELIEVE

Don't worry, we are working to correct this but I worry!

Who is this Elian Black'Mor, this shameless braggart that would have us believe such nonsense from another century?

The photographs of dragons that he took are rough montages, obvious fakes, created for the sole purpose of enticing the gullible and the naïve.

Do not listen to the song of the sirens, forget the fables and tales of our childhood; we're adults now, for pity's sake!

In our new era of modernity and sophistication there is no time to dream, we need to work and produce.

Illustration: Carine M unauthorized copies prohibited

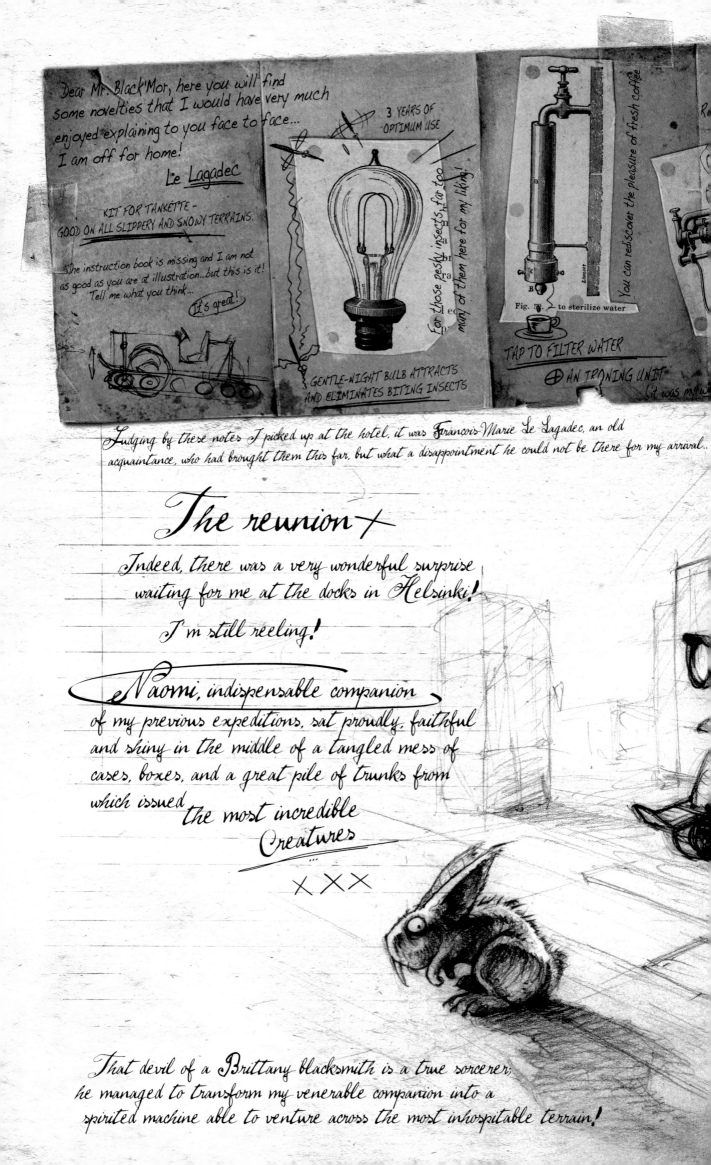

Dear Mr. Black'Mor, here you will find
some novelties that I would have very much
enjoyed explaining to you face to face...
I am off for home!

Le Lagadec

KIT FOR TANKETTE -
GOOD ON ALL SLIPPERY AND SNOWY TERRAINS.

The instruction book is missing and I am not
as good as you are at illustration...but this is it!
Tell me what you think...

It's great!

3 YEARS OF
OPTIMUM USE

For those pesky insects far too
many of them here for my liking...

GENTLE-NIGHT BULB ATTRACTS
AND ELIMINATES BITING INSECTS

You can rediscover the pleasure of fresh coffee

Fig. 3. to sterilize water

TAP TO FILTER WATER

AN IRONING UNIT

it was my...

Judging by these notes I picked up at the hotel, it was François-Marie Le Lagadec, an old
acquaintance, who had brought them this far, but what a disappointment he could not be there for my arrival...

The reunion

Indeed, there was a very wonderful surprise
waiting for me at the docks in Helsinki!

I'm still reeling!

Naomi, indispensable companion
of my previous expeditions, sat proudly, faithful
and shiny in the middle of a tangled mess of
cases, boxes, and a great pile of trunks from
which issued the most incredible
Creatures...

✕ ✕ ✕

That devil of a Brittany blacksmith is a true sorcerer;
he managed to transform my venerable companion into a
spirited machine able to venture across the most inhospitable terrain!

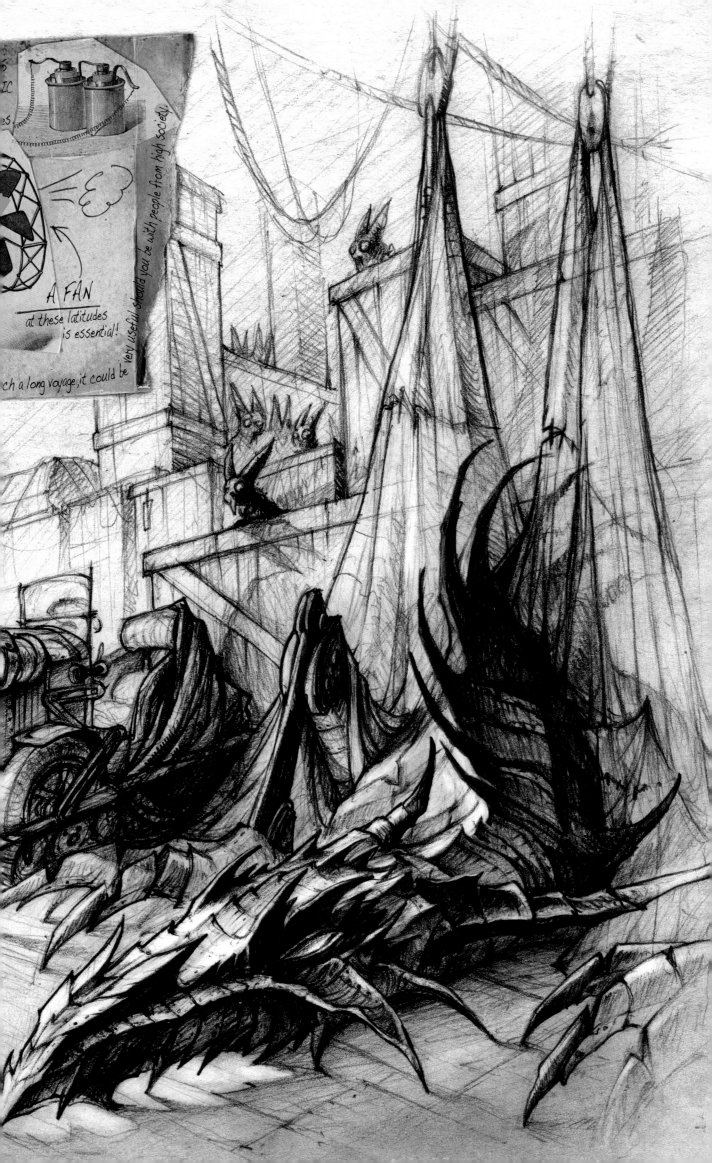

A FAN
at these latitudes
is essential!

Very useful should you be with people from high society.
...ch a long voyage, it could be

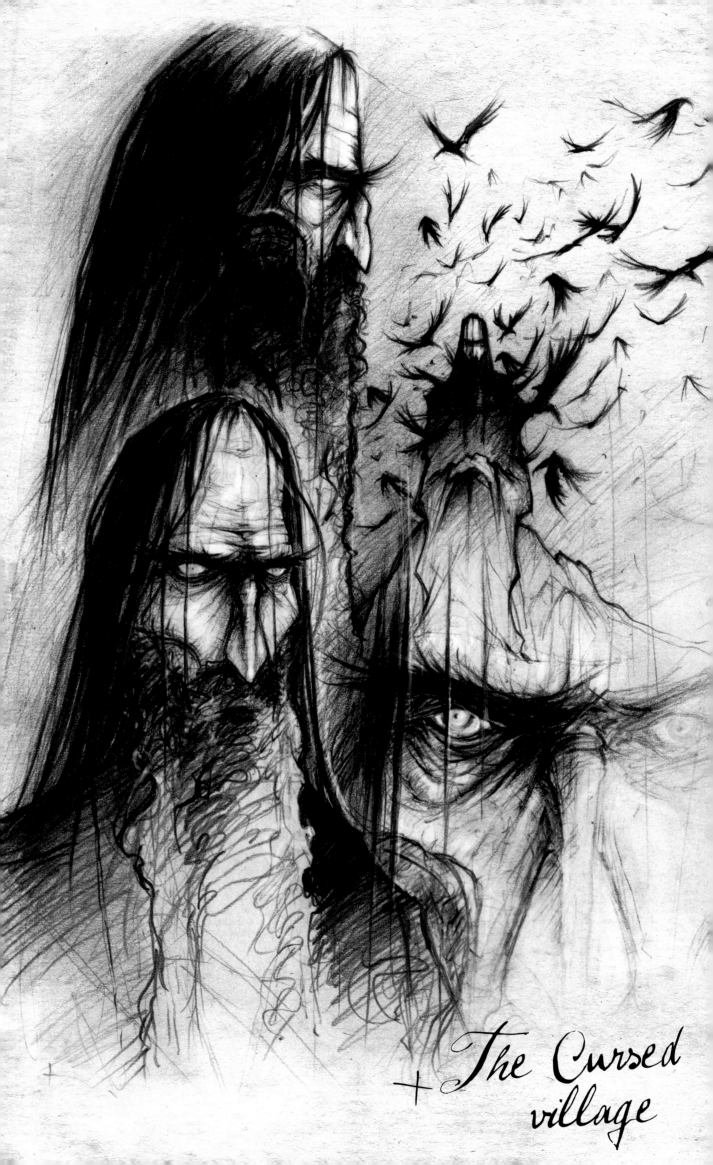

The Cursed village

I was delighted to be reunited with
Naomi's joyous backfires and velvet purr.
Across the endless open spaces of
the Great Russian Empire,
We have been driving for several days now,
bumping over dusty roads towards Moscow.

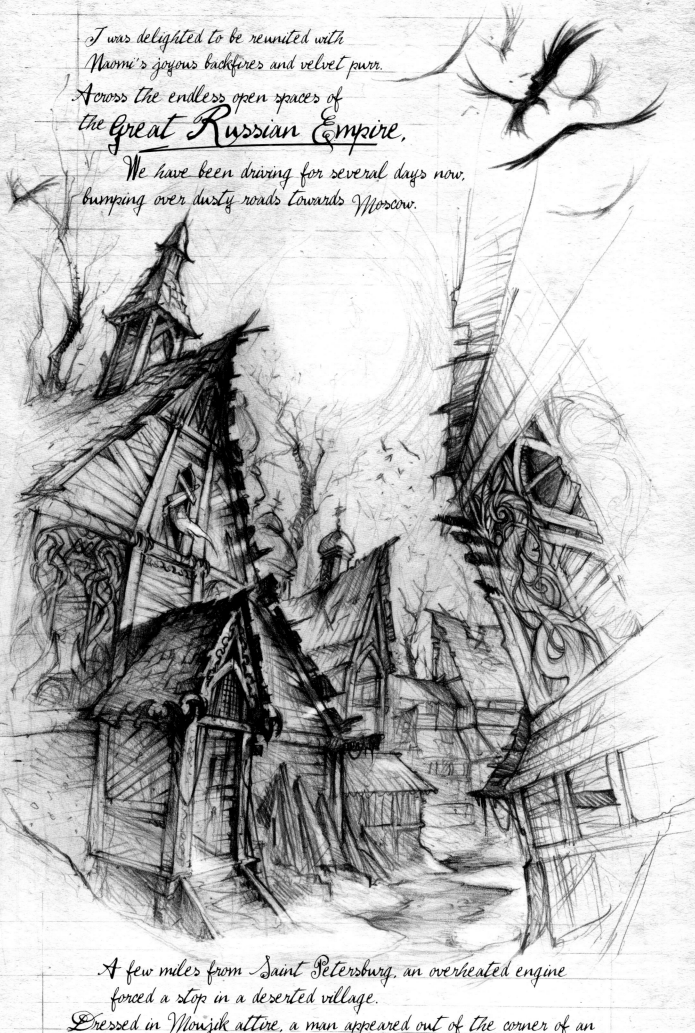

A few miles from Saint Petersburg, an overheated engine
forced a stop in a deserted village.
Dressed in Moujik attire, a man appeared out of the corner of an
alley. Grigori Lefimovitch that reputed preacher and famous healer,
seemed to have been expecting me. He let it be known he was en route
to the imperial court where the Tsar himself had summoned him...

He talked for some time, staring into
the darkness... He had the power, he said,
to look into the souls of men.
What he saw in mine seemed to have frightened him...

✝

I spent the night in a humble village dacha
where my sleep was restless and feverish...
Hordes of wolves invaded the Steppe, howling
to death as they ripped each other apart...
Amidst the wild beasts, the cruelest
one of them seemed to follow my trail...
Or was he walking beside me?

In the morning, Grigori
had disappeared and
I resumed my journey...

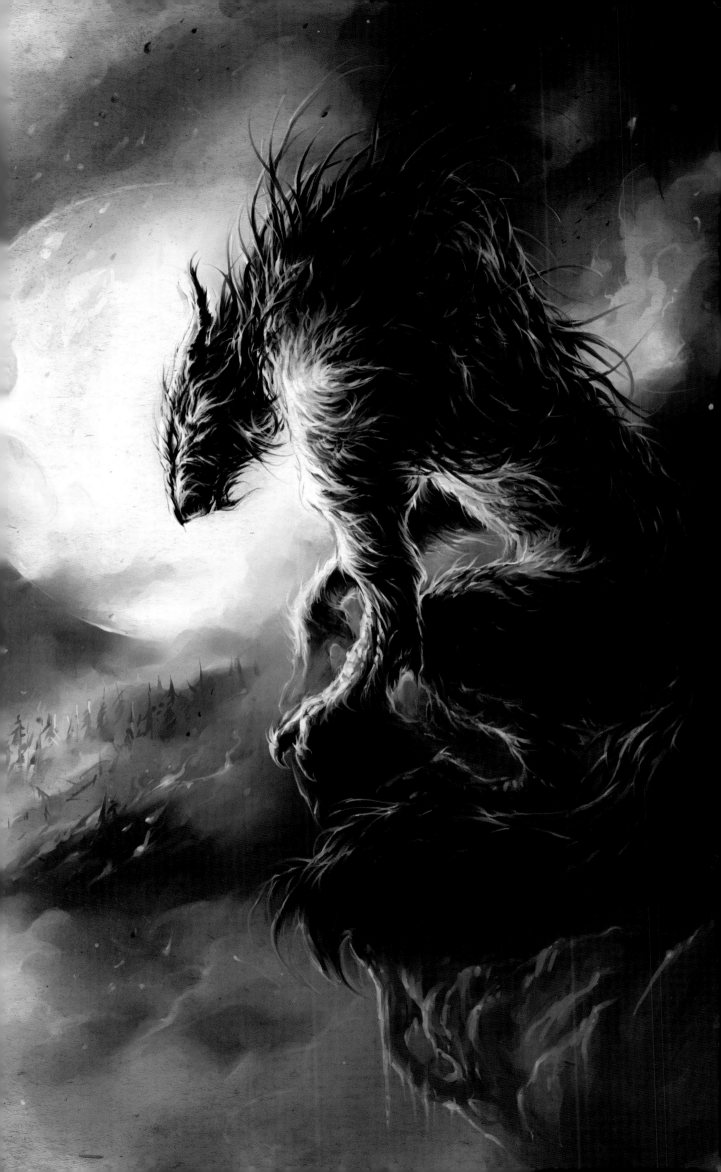

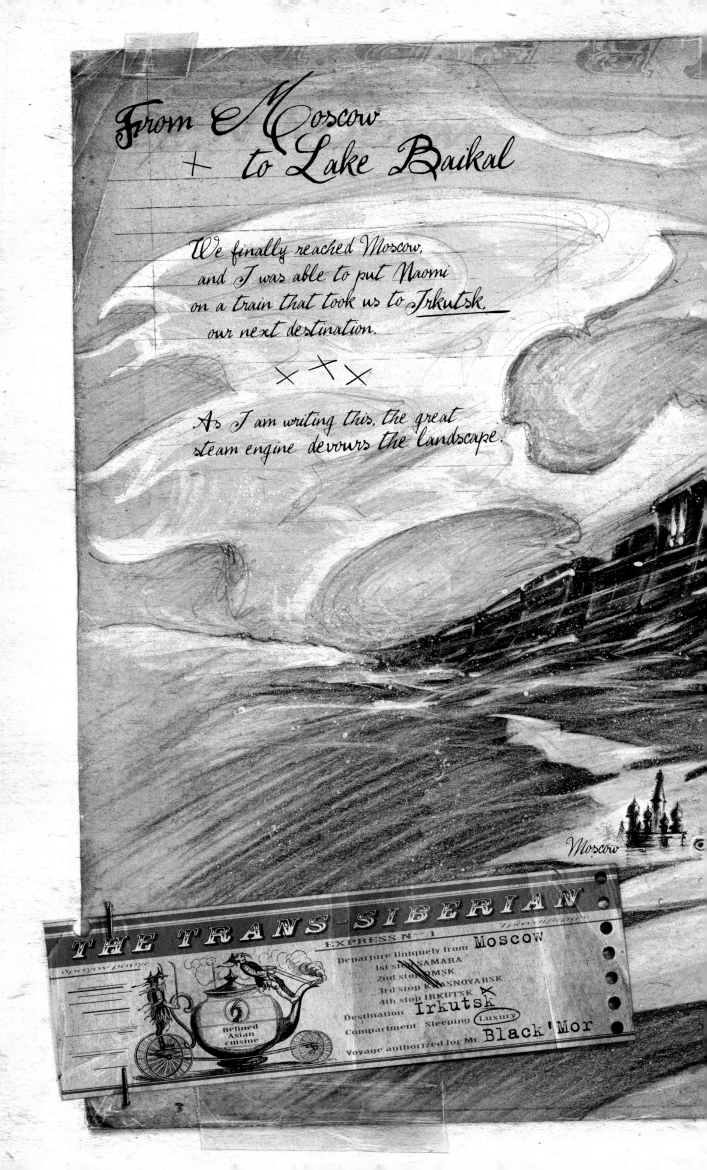

From Moscow
✛ to Lake Baikal

We finally reached Moscow,
and I was able to put Naomi
on a train that took us to Irkutsk,
our next destination.

✗ ✗ ✗

As I am writing this, the great
steam engine devours the landscape.

Moscow

THE TRANS-SIBERIAN

EXPRESS N° 1

Departure Uniquely from Moscow
1st stop SAMARA
2nd stop OMSK
3rd stop KRASNOYARSK
4th stop IRKUTSK
Destination Irkutsk
Compartment Sleeping Luxury
Voyage authorized for Mr. Black'Mor

Refined Asian cuisine

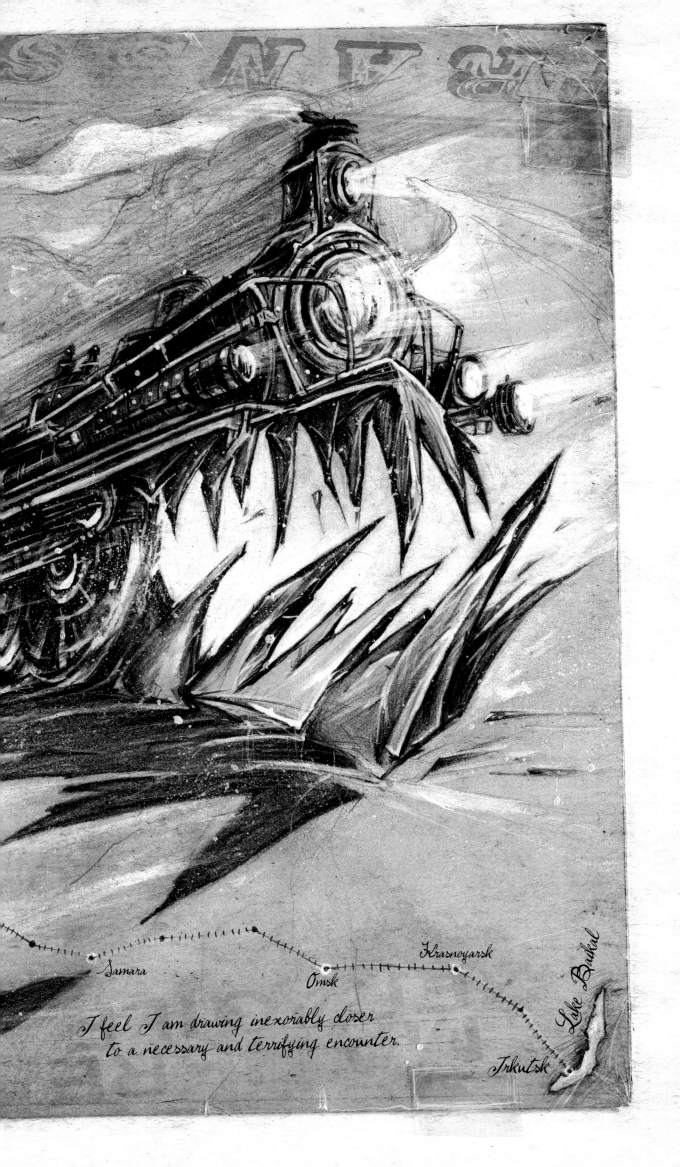

Samara

Omsk

Krasnoyarsk

Irkutsk

Lake Baikal

*I feel I am drawing inexorably closer
to a necessary and terrifying encounter.*

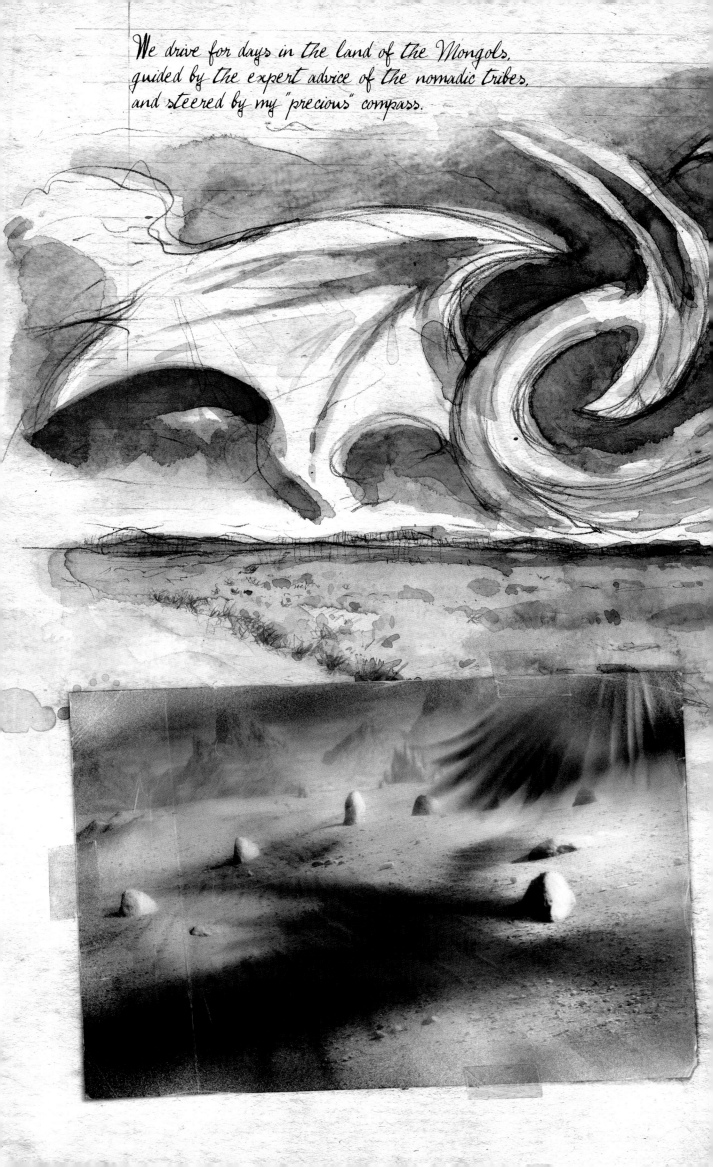

We drive for days in the land of the Mongols,
guided by the expert advice of the nomadic tribes,
and steered by my "precious" compass.

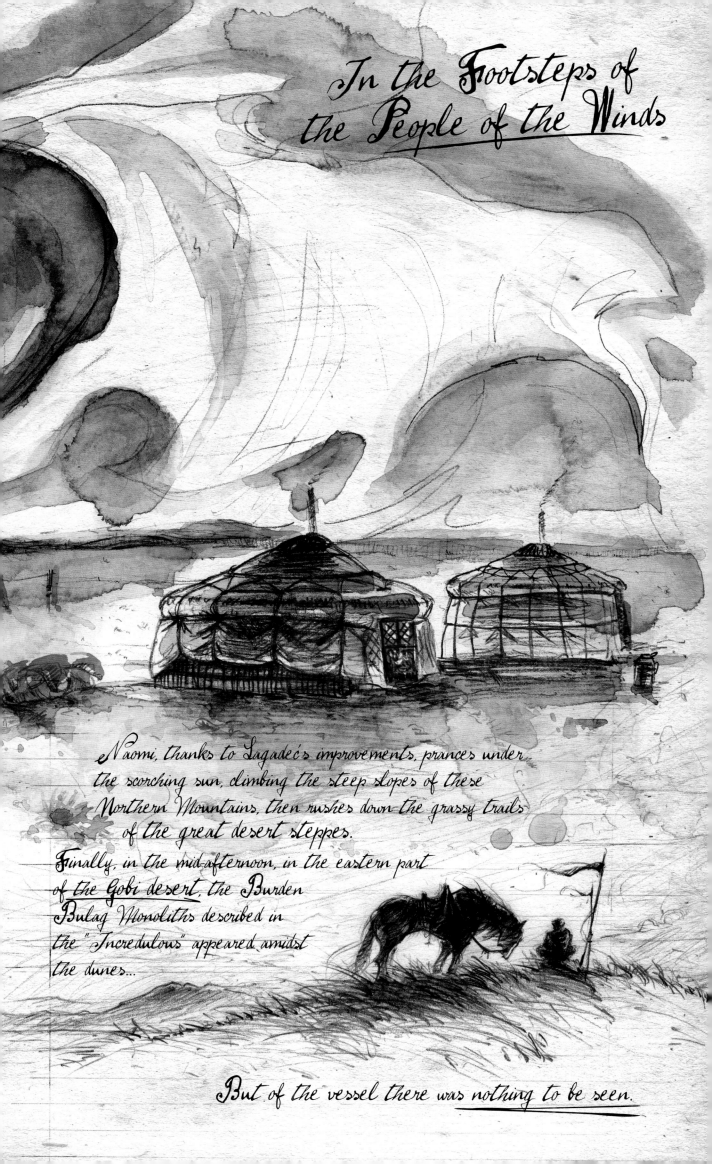

In the Footsteps of the People of the Winds

Naomi, thanks to Lagadec's improvements, prances under the scorching sun, climbing the steep slopes of these Northern Mountains, then rushes down the grassy trails of the great desert steppes.

Finally, in the mid-afternoon, in the eastern part of the Gobi desert, the Burden Bulag Monoliths described in the "Incredulous" appeared amidst the dunes...

But of the vessel there was nothing to be seen.

The Guardian
of Dreams
(Gobi Desert - 3 a.m.)

✕ While I was setting up the camp,
shortly after our arrival near the
Stone Circle, a storm came upon us.

Violent sand whirlwinds suddenly swept the countryside.
Then, a huge gust further obscured
the pale flickering light that had bathed the landscape
and a great, powerful shadow was right next to me.
Grains of sand like claws tore at my face,
blinding me.

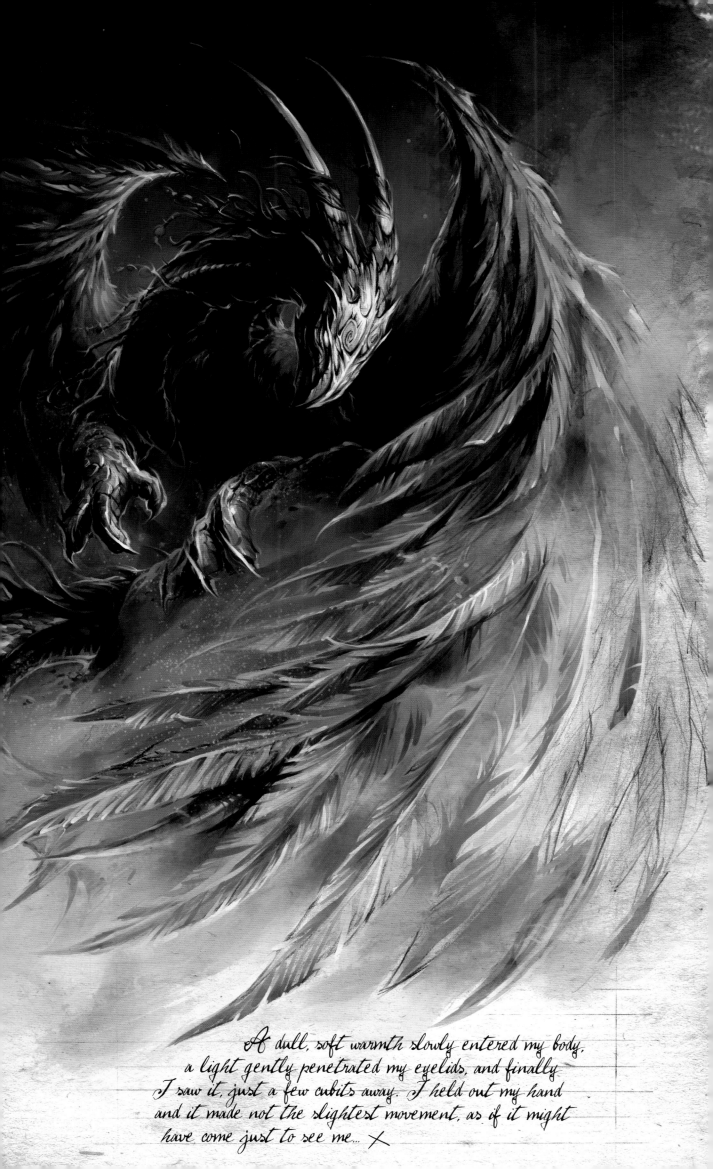

A dull, soft warmth slowly entered my body,
a light gently penetrated my eyelids, and finally
I saw it, just a few cubits away. I held out my hand
and it made not the slightest movement, as if it might
have come just to see me... ✗

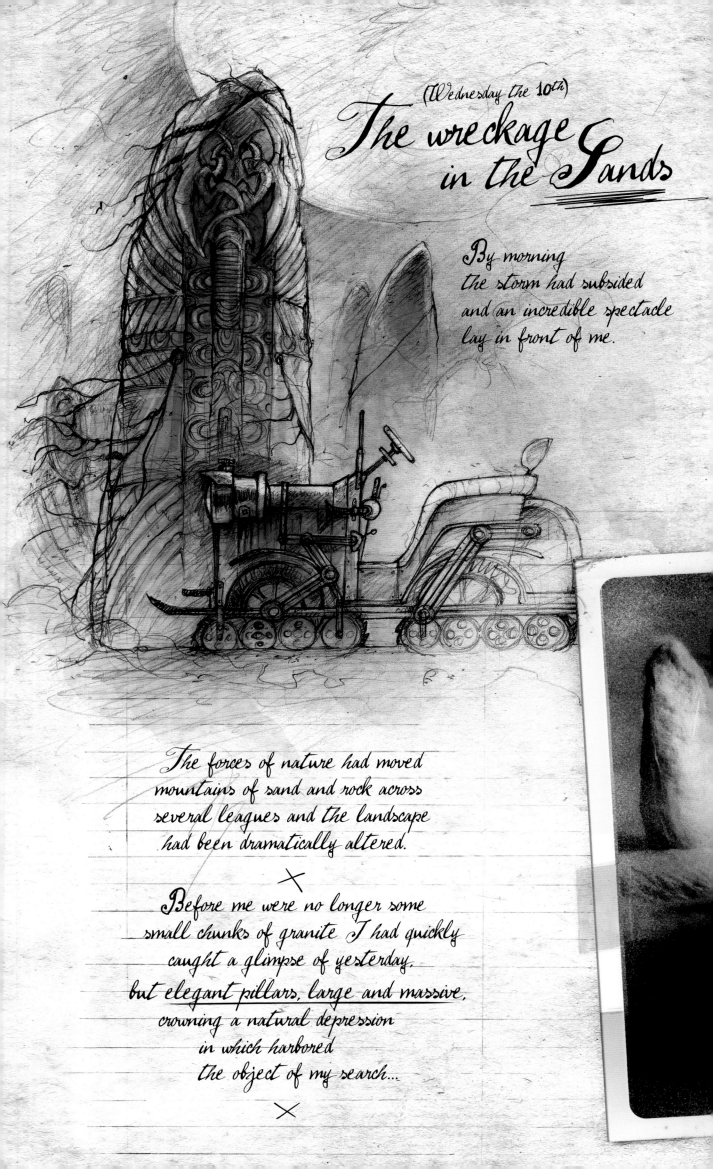

(Wednesday the 10th)

The wreckage in the Sands

By morning
the storm had subsided
and an incredible spectacle
lay in front of me.

The forces of nature had moved
mountains of sand and rock across
several leagues and the landscape
had been dramatically altered.

✕

Before me were no longer some
small chunks of granite I had quickly
caught a glimpse of yesterday,
but elegant pillars, large and massive,
crowning a natural depression
in which harbored
the object of my search...

✕

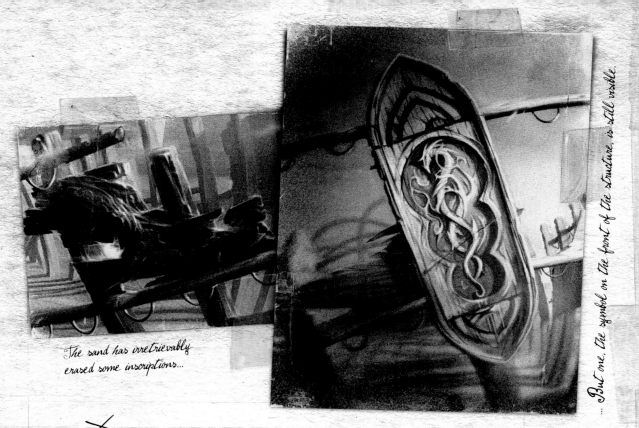

The sand has irretrievably erased some inscriptions...

... But one, the symbol on the front of the structure, is still visible.

✕ My hunch was right: without a doubt this wooden structure is of an **Ødgan Gondola**...

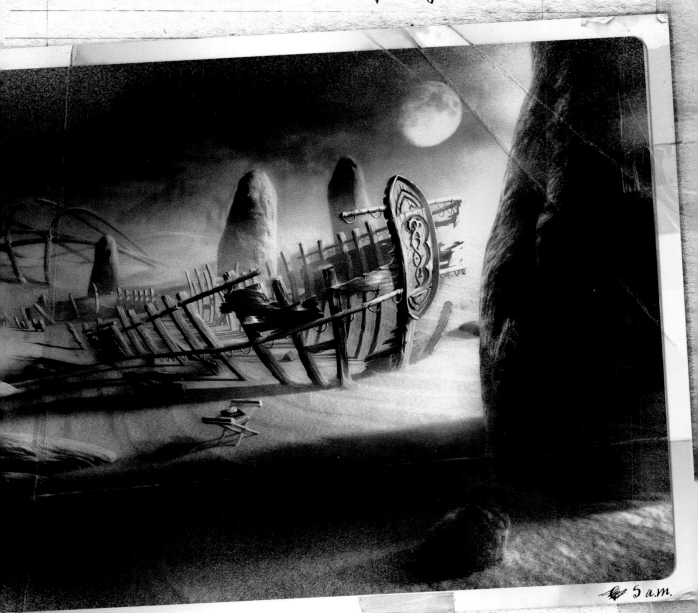

5 a.m.

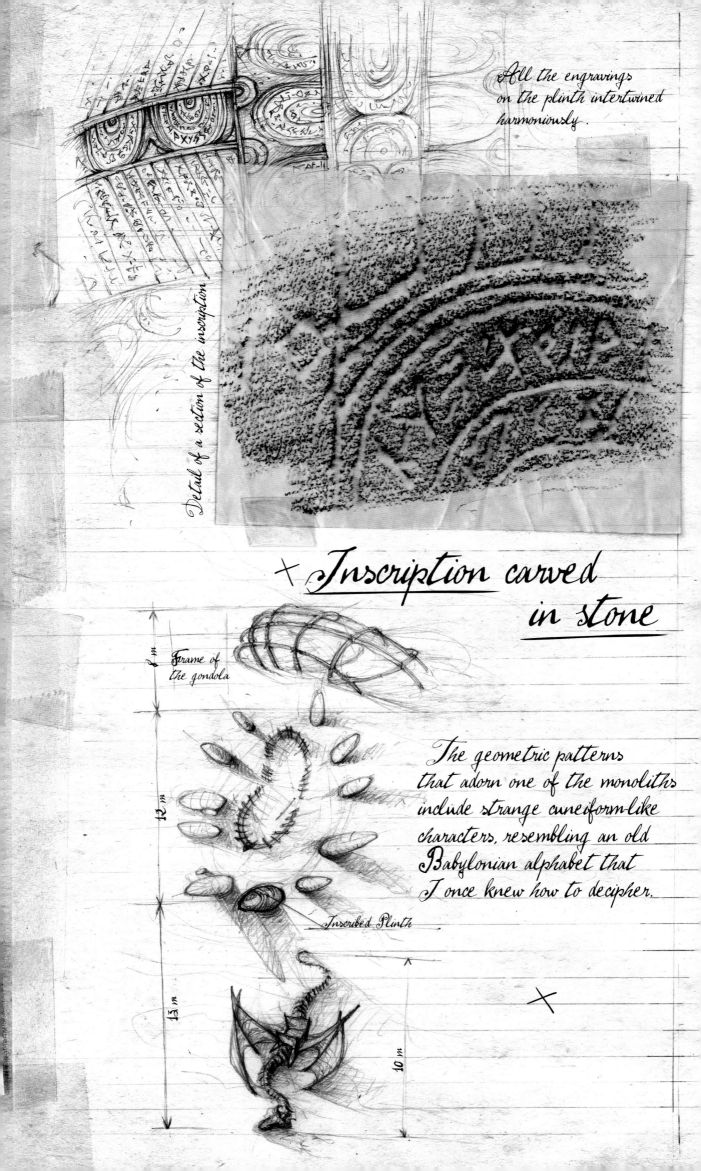

All the engravings
on the plinth intertwined
harmoniously.

Detail of a section of the inscription

× _Inscription carved
in stone_

Frame of
the gondola

8 m

13 m

15 m

10 m

The geometric patterns
that adorn one of the monoliths
include strange cuneiform-like
characters, resembling an old
Babylonian alphabet that
I once knew how to decipher.

Inscribed Plinth

×

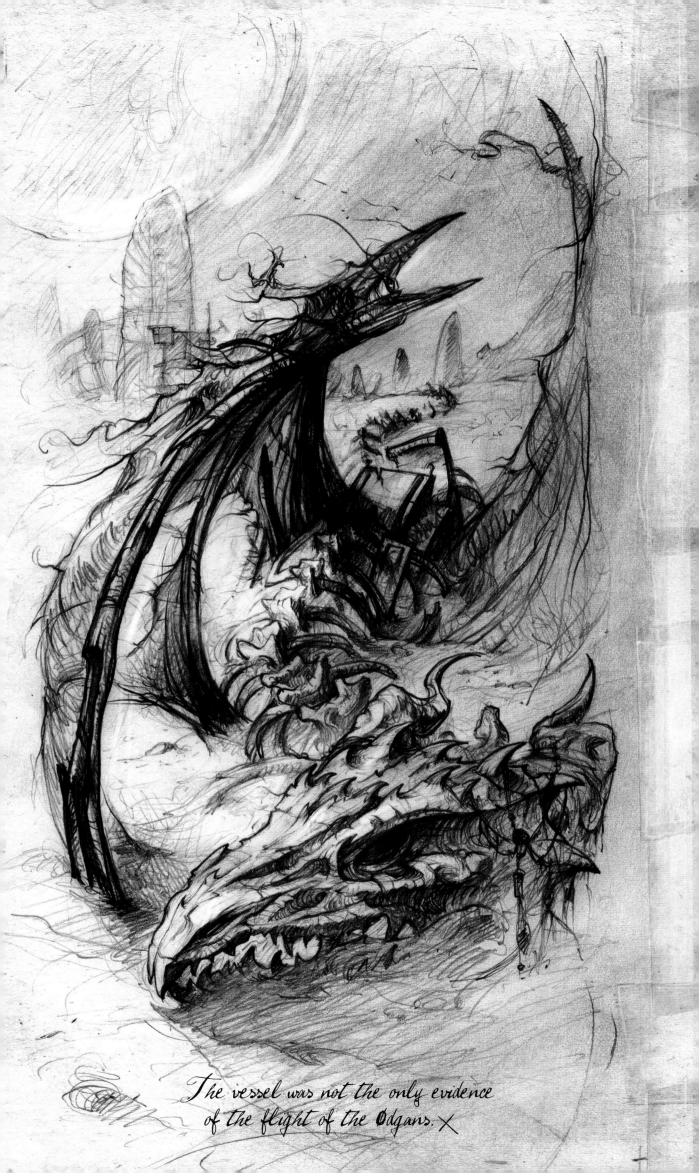

The vessel was not the only evidence
of the flight of the Ødgans. ✕

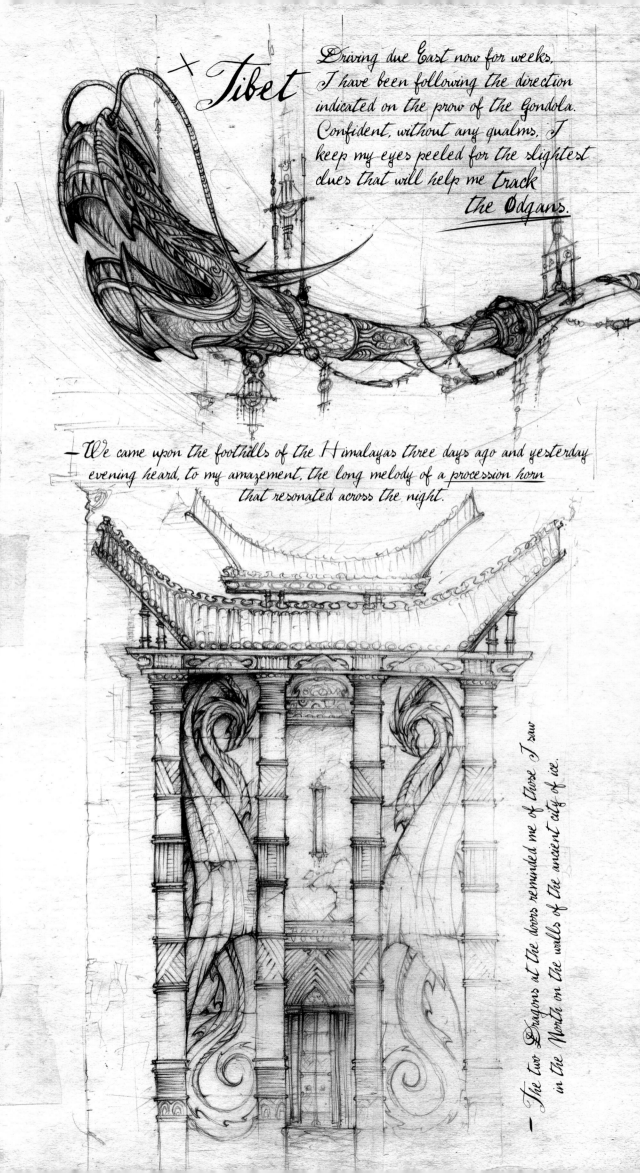

× Tibet

Driving due East now for weeks,
I have been following the direction
indicated on the prow of the Gondola.
Confident, without any qualms, I
keep my eyes peeled for the slightest
clues that will help me track
the Odgans.

— We came upon the foothills of the Himalayas three days ago and yesterday
evening heard, to my amazement, the long melody of a procession horn
that resonated across the night.

— The two Dragons at the doors reminded me of those I saw
in the North on the walls of the ancient city of ice.

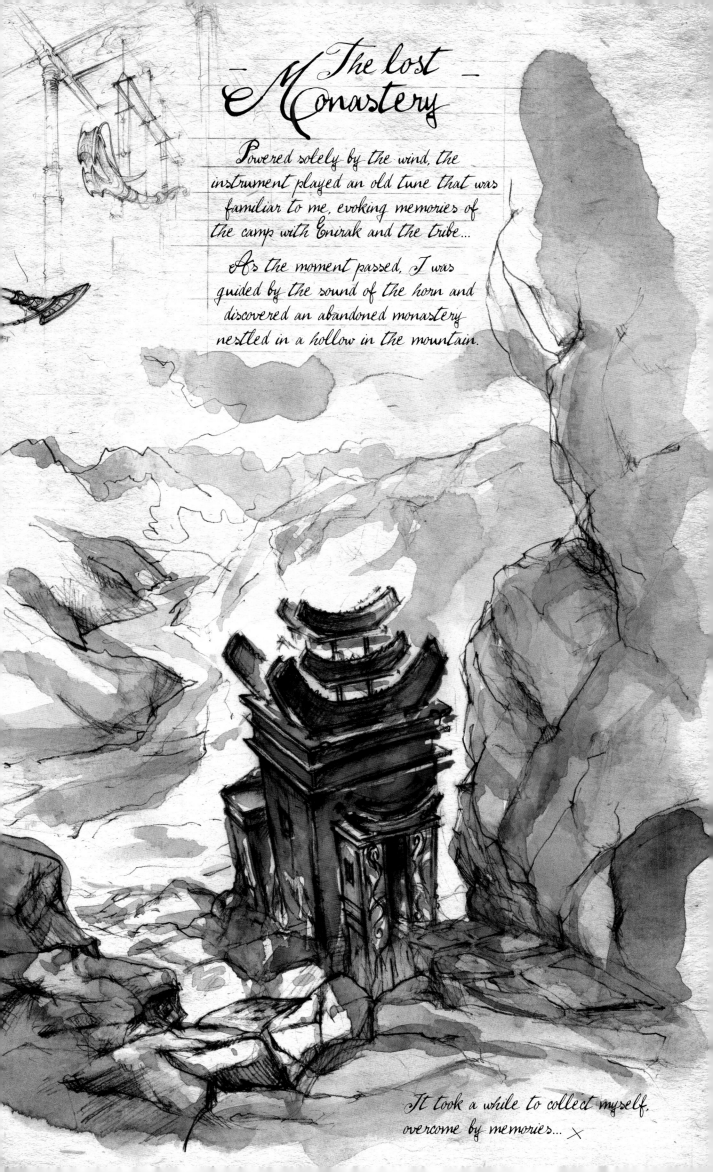

The lost Monastery

Powered solely by the wind, the
instrument played an old tune that was
familiar to me, evoking memories of
the camp with Enirak and the tribe...

As the moment passed, I was
guided by the sound of the horn and
discovered an abandoned monastery
nestled in a hollow in the mountain.

It took a while to collect myself,
overcome by memories... ✕

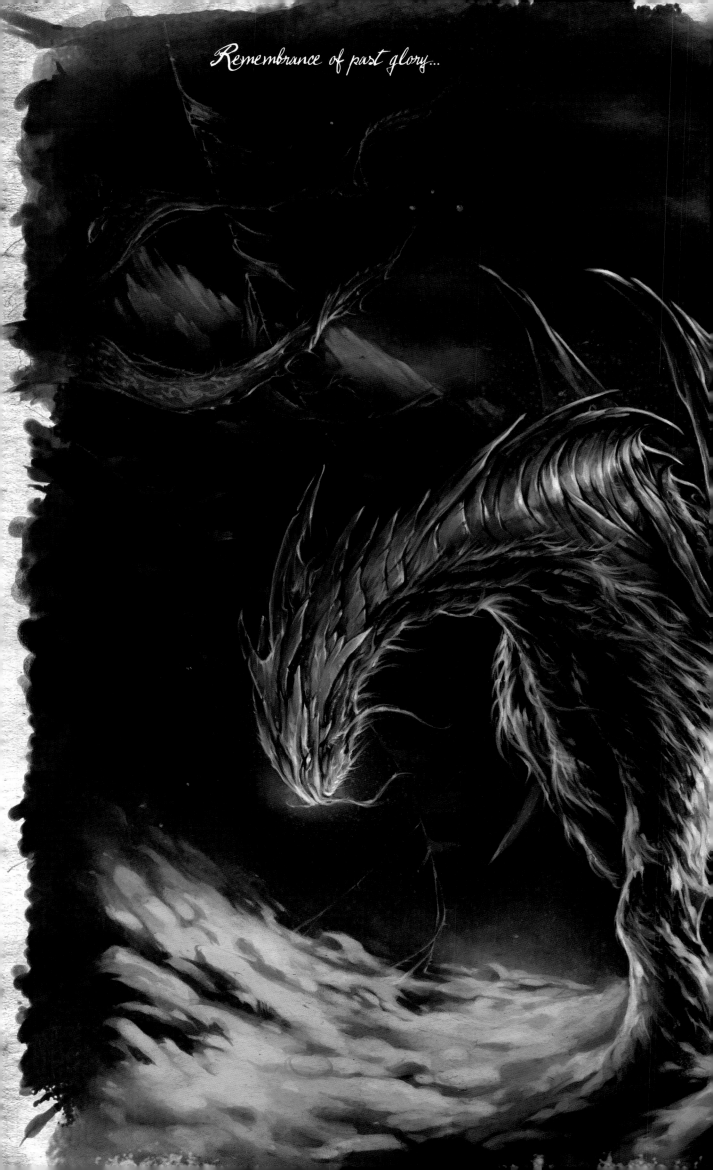

Remembrance of past glory...

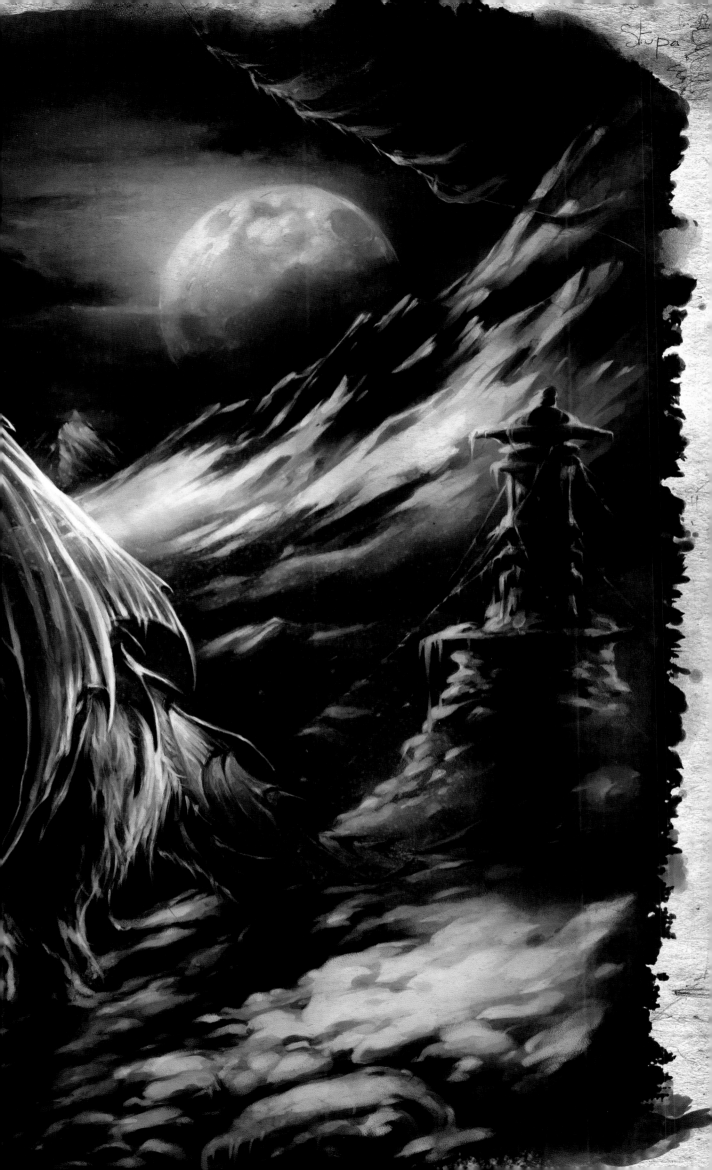

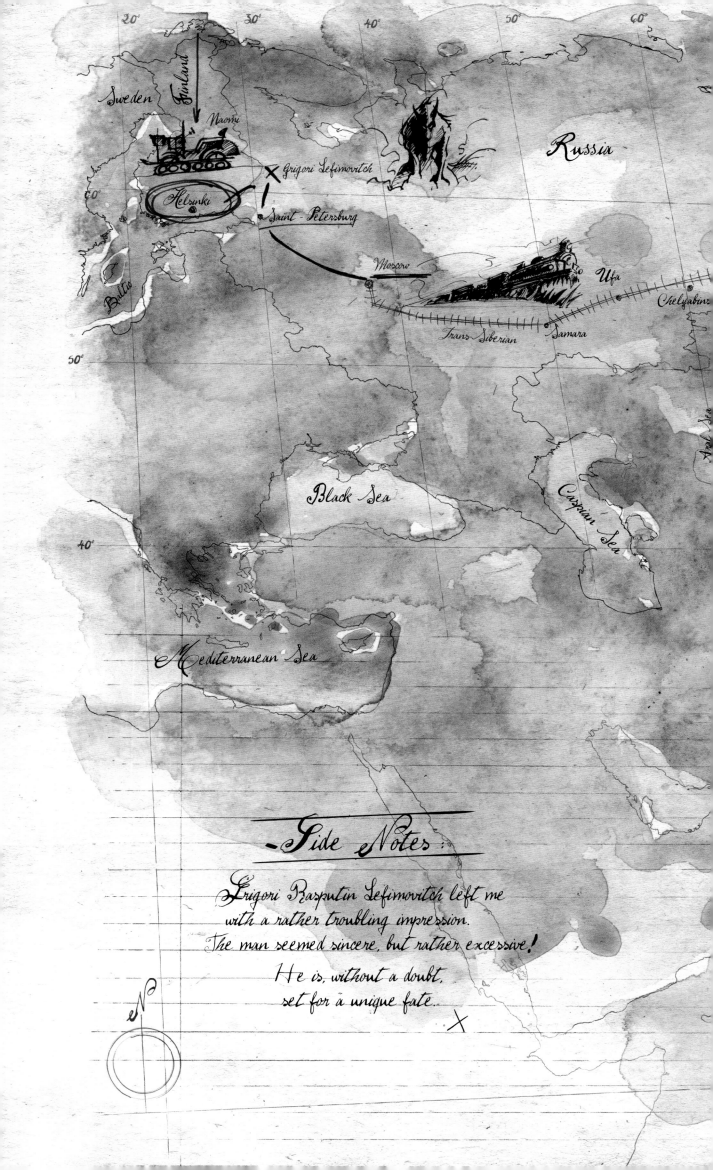

20° 30° 40° 50° 60°

Sweden Finland Naomi

Russia

Grigori Lefimovitch

Helsinki

Baltic

Saint - Petersburg

Moscow

Ufa

Chelyabin

Trans-Siberian Samara

Black Sea

Caspian Sea

Aral Sea

40°

Mediterranean Sea

50°

-Side Notes:-

Grigori Rasputin Lefimovitch left me
with a rather troubling impression.
The man seemed sincere, but rather excessive!

He is, without a doubt,
set for a unique fate.

X

N

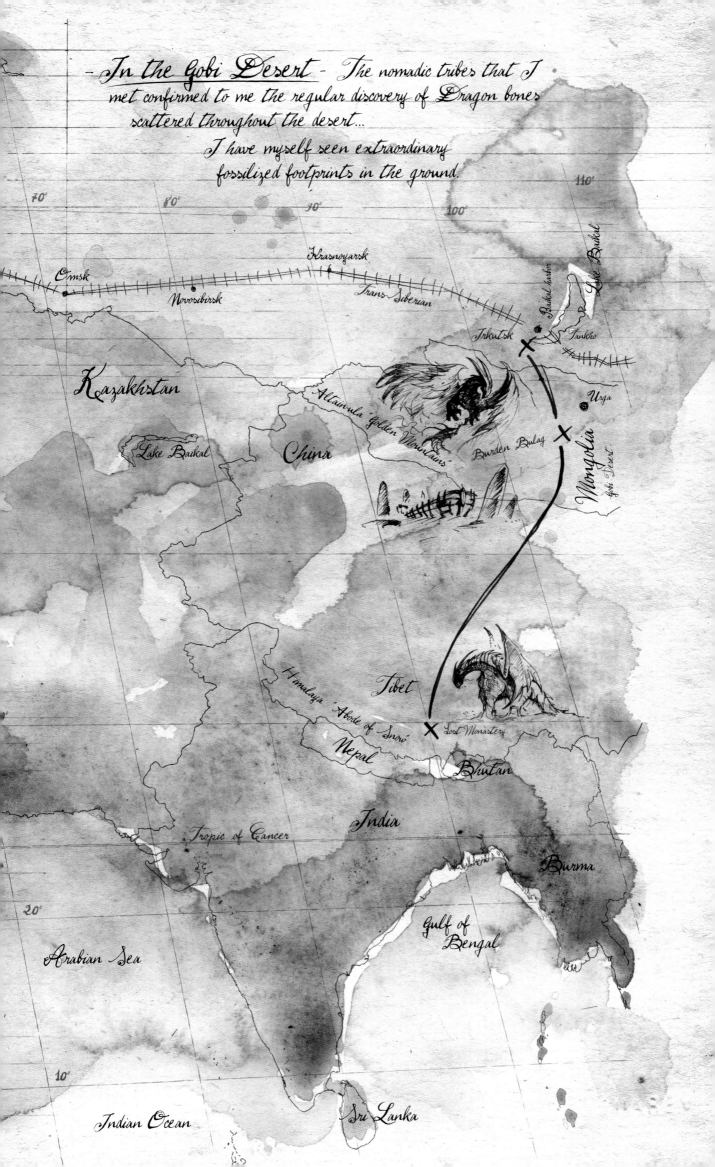

- In the Gobi Desert - The nomadic tribes that I met confirmed to me the regular discovery of Dragon bones scattered throughout the desert...

I have myself seen extraordinary fossilized footprints in the ground.

ONLY PERFORMANCE in CHENGDU

HOUDIN presents

In the JAWS OF the DRAGON

ONLY 300 SEATS

ON SALE AT : Tong, Br. Dragon Boutique, Chengdu. Teleph. 100

Chengdu Market (China)

I'd arrived in Chengdu a few days ago.
This city is just one big market where I like to lose
myself, melting into this motley industrious crowd.
This morning I spied a European man who took my full attention.

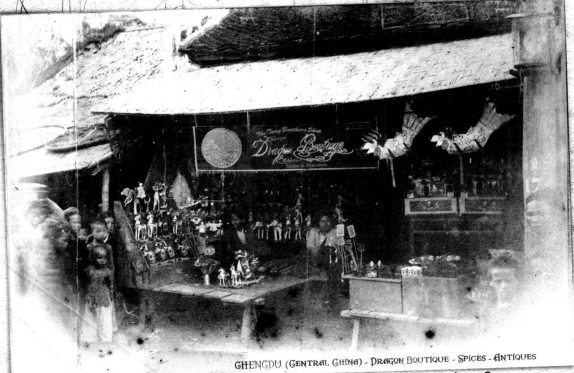

That face, described to me a thousand times,
and yet still unknown, appeared to be that of Ollafsen...
Instinctively, I followed him from stall to stall, then
into a shop where he disappeared.

CHENGDU (CENTRAL CHINA) - DRAGON BOUTIQUE - SPICES - ANTIQUES

- Entrance to the Tong Brothers shop -

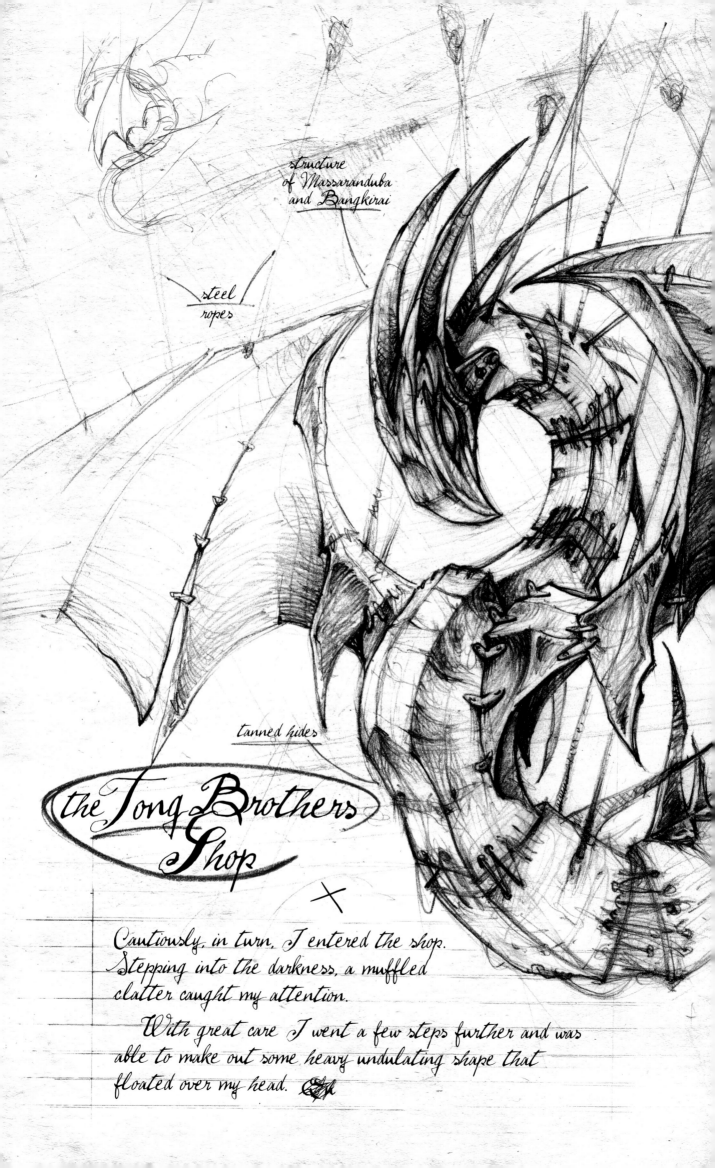

structure
of Massaranduba
and Bangkirai

steel
ropes

tanned hides

the Tong Brothers
Shop

×

Cautiously, in turn, I entered the shop.
Stepping into the darkness, a muffled
clatter caught my attention.

 With great care I went a few steps further and was
able to make out some heavy undulating shape that
floated over my head.

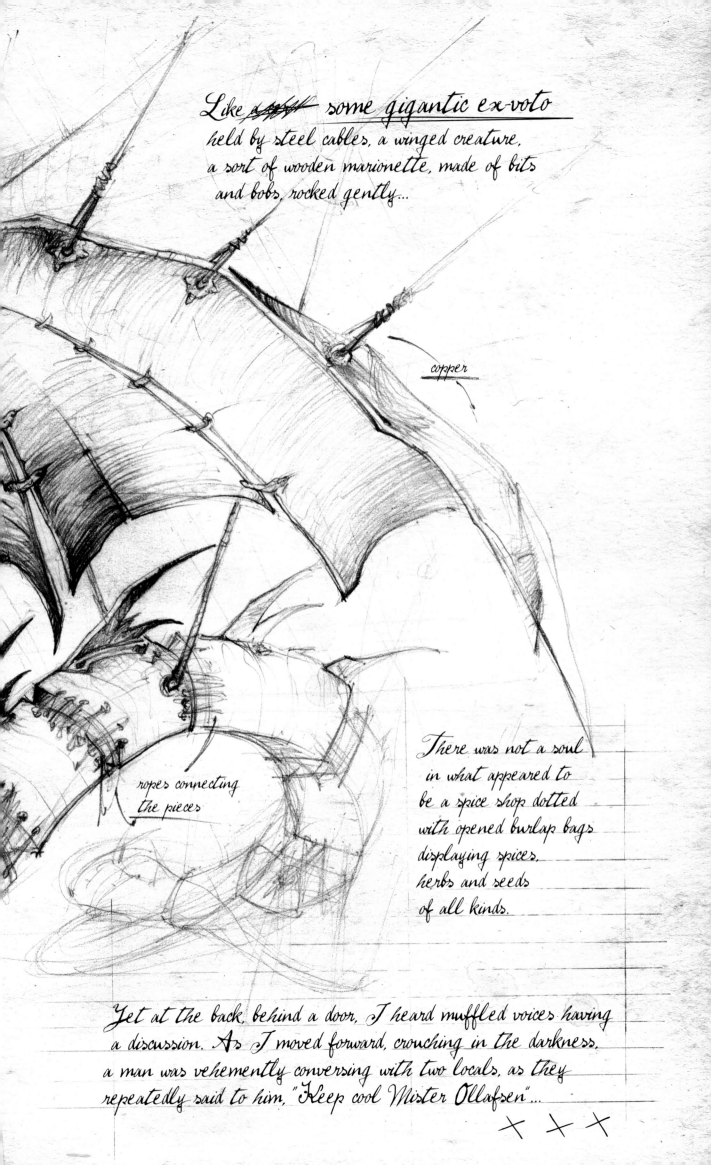

Like a ~~some~~ some gigantic ex-voto
held by steel cables, a winged creature,
a sort of wooden marionette, made of bits
and bobs, rocked gently...

copper

ropes connecting
the pieces

There was not a soul
in what appeared to
be a spice shop dotted
with opened burlap bags
displaying spices,
herbs and seeds
of all kinds.

Yet at the back, behind a door, I heard muffled voices having
a discussion. As I moved forward, crouching in the darkness,
a man was vehemently conversing with two locals, as they
repeatedly said to him, "Keep cool Mister Ollafsen"...

X X X

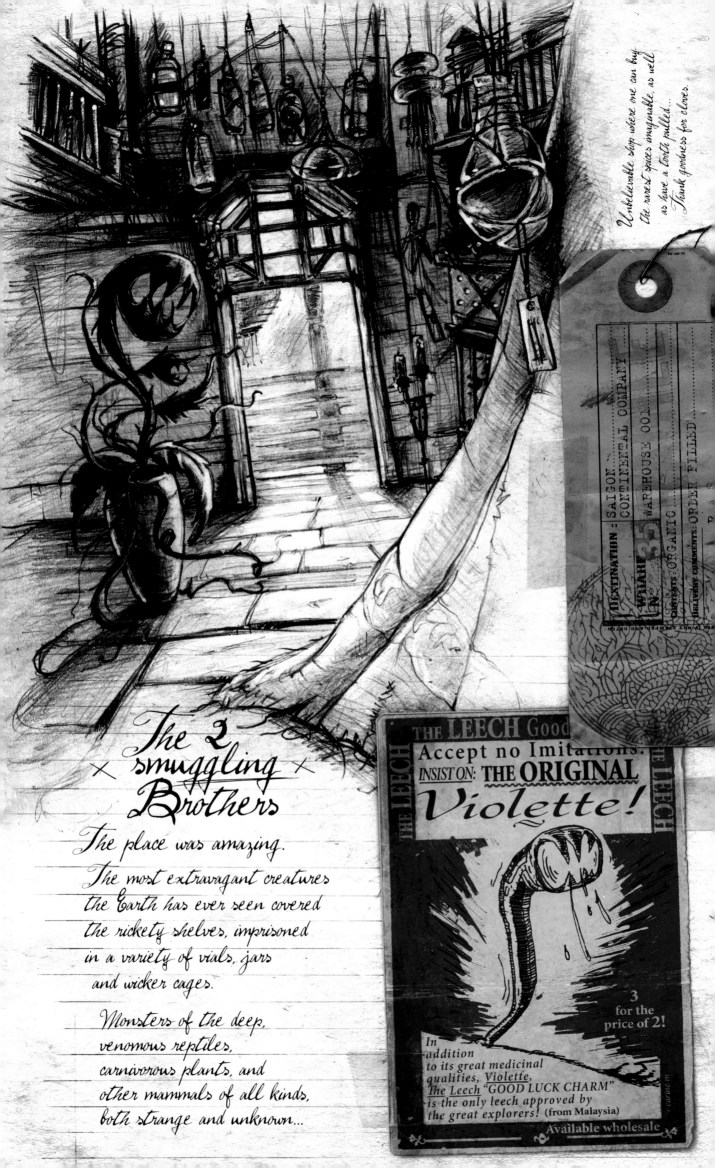

DESTINATION : SAIGON... CONTINENTAL COMPANY
WHAT?... WAREHOUSE 00...
N° 35
CONTENTS : ORGANIC...
DELIVERY COMMENTS : ORDER FILLED...

The 2 × smuggling × Brothers

The place was amazing.

The most extravagant creatures
the Earth has ever seen covered
the rickety shelves, imprisoned
in a variety of vials, jars
and wicker cages.

Monsters of the deep,
venomous reptiles,
carnivorous plants, and
other mammals of all kinds,
both strange and unknown...

Octopus from Shipwrecks

CATALOGUE FREE AND ANONYMOUSLY UPON DEMAND.

AUTHENTIC & ECONOMICAL

INQUIRE

HERE

There was no doubt about it; I was in a smuggler's den.

Be WARNED!

Once taken out of the jar — guaranteed unbreakable (patented) This exceptional creature will in 30 minutes Expand to 200 meters (at rest)

(import/export of all kinds)

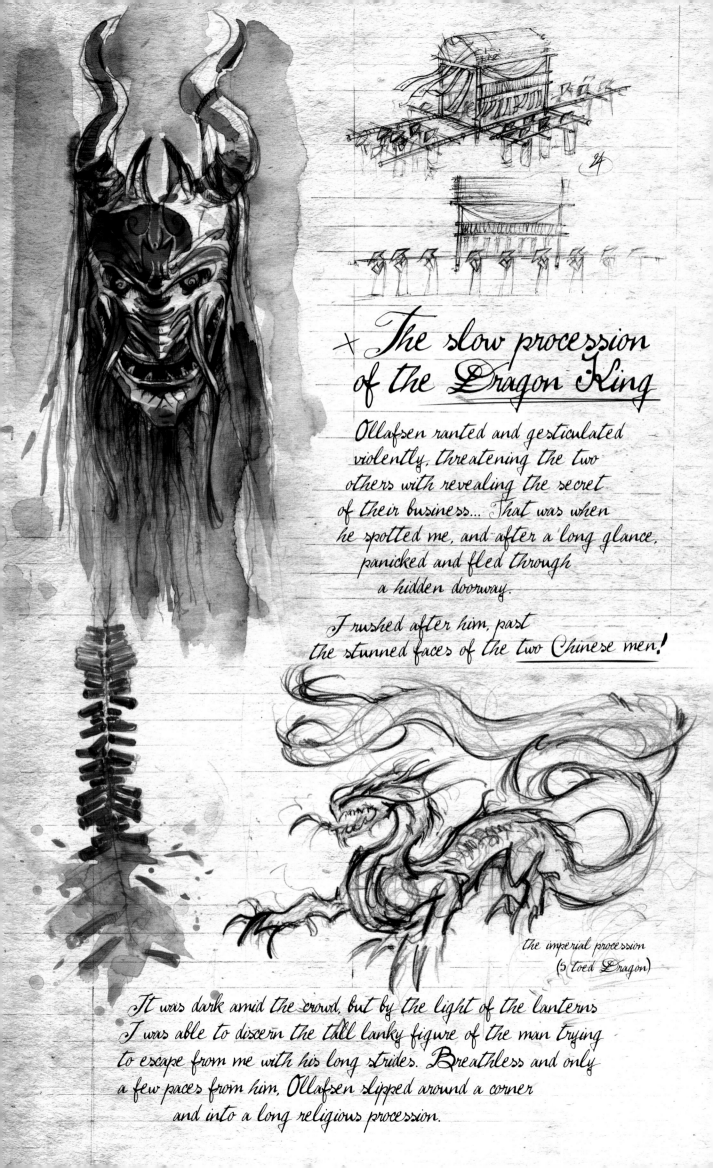

The slow procession of the Dragon King

Ollafsen ranted and gesticulated violently, threatening the two others with revealing the secret of their business... That was when he spotted me, and after a long glance, panicked and fled through a hidden doorway.

I rushed after him, past the stunned faces of the two Chinese men!

the imperial procession
(5 toed Dragon)

It was dark amid the crowd, but by the light of the lanterns I was able to discern the tall lanky figure of the man trying to escape from me with his long strides. Breathless and only a few paces from him, Ollafsen slipped around a corner and into a long religious procession.

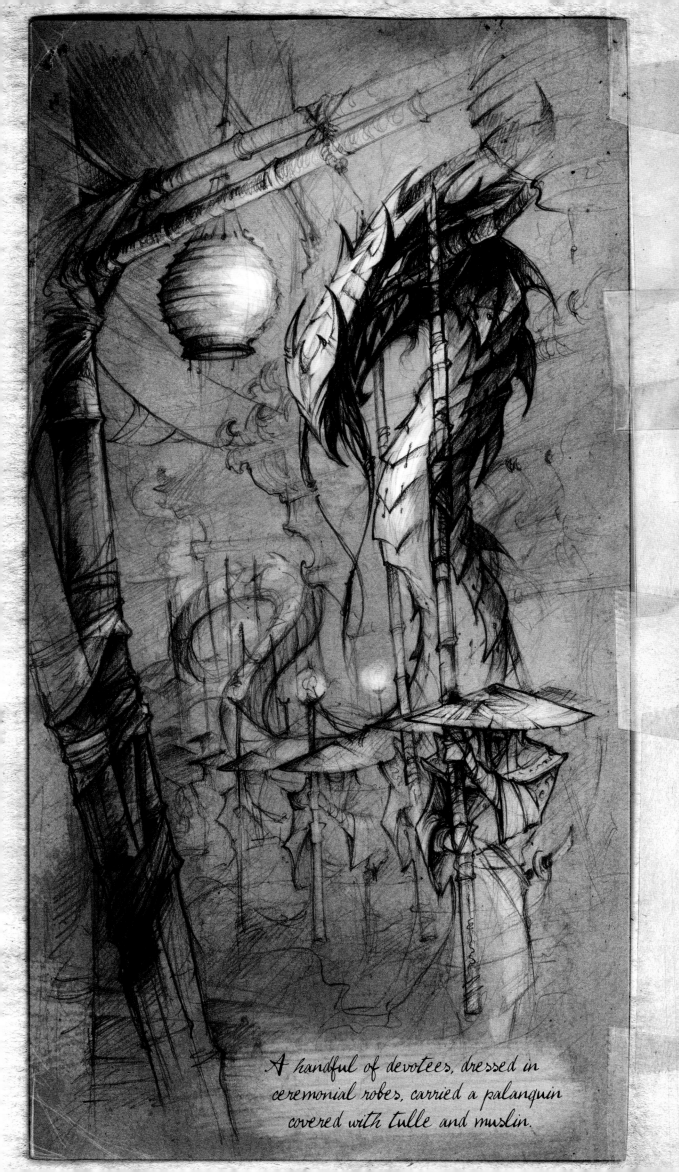

A handful of devotees, dressed in
ceremonial robes, carried a palanquin
covered with tulle and muslin.

The ancient route of the Dragon Kings

*I realize, surprisingly, that several weeks
have passed since my last entry.
My departure from Chengdu, my long
and interminable trip to Indochina,
and this morning, the terrible yet
necessary decision to leave Naomi
behind in the village of Man-Hao...
My heart is no longer in it...*

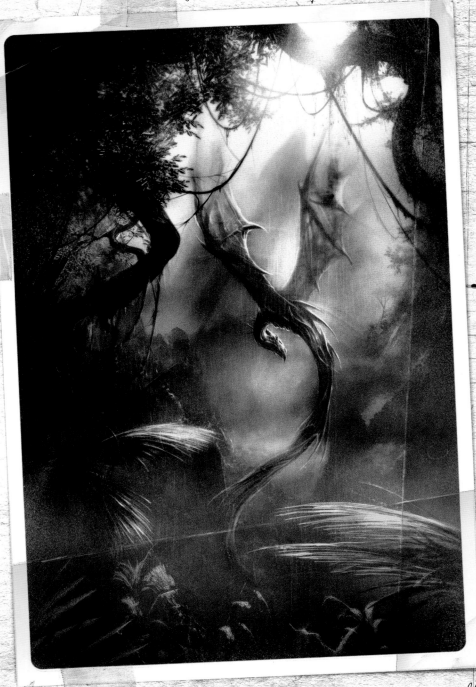

*It's pouring, it's monsoon season, the roads are impassable,
and I have to traverse a rainforest in order to reach
the Indochinese peninsula...*

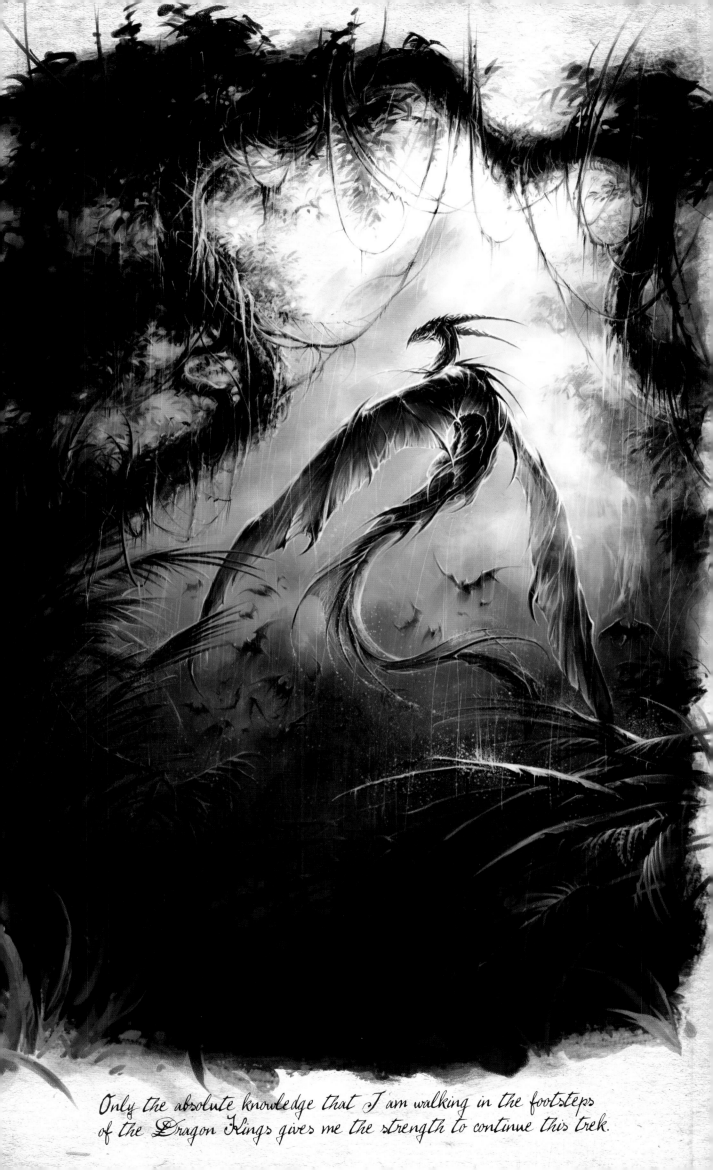

Only the absolute knowledge that I am walking in the footsteps of the Dragon Kings gives me the strength to continue this trek.

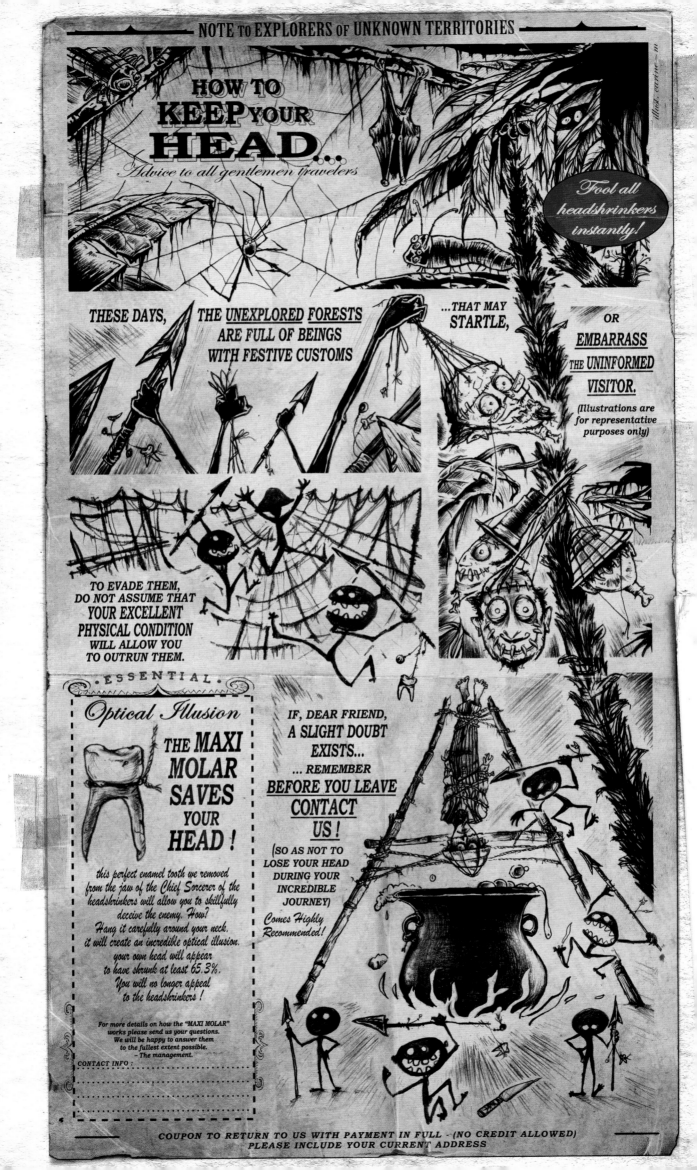

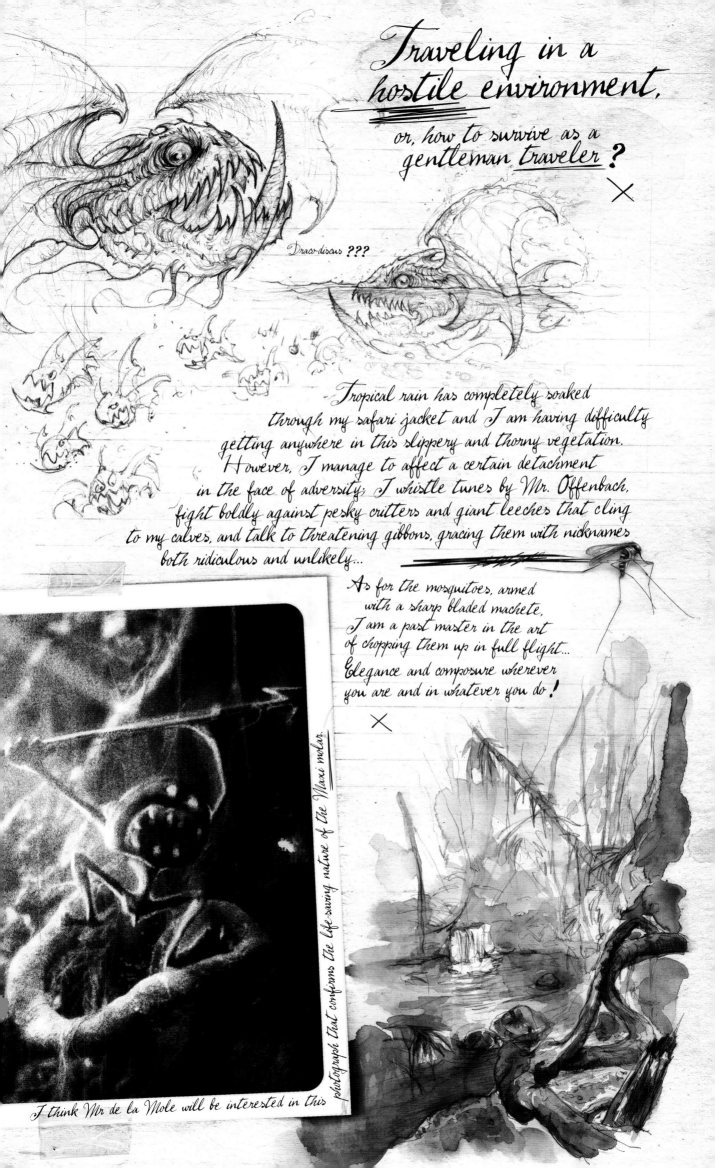

Traveling in a hostile environment,

or, how to survive as a gentleman *traveler* ?

Draco-discus ???

Tropical rain has completely soaked
through my safari jacket and I am having difficulty
getting anywhere in this slippery and thorny vegetation.
However, I manage to affect a certain detachment
in the face of adversity; I whistle tunes by Mr. Offenbach,
fight boldly against pesky critters and giant leeches that cling
to my calves, and talk to threatening gibbons, gracing them with nicknames
both ridiculous and unlikely...

As for the mosquitoes, armed
with a sharp bladed machete,
I am a past master in the art
of chopping them up in full flight...
Elegance and composure wherever
you are and in whatever you do !

I think Mr de la Mole will be interested in this photograph that confirms the life-saving nature of The Maxi motor.

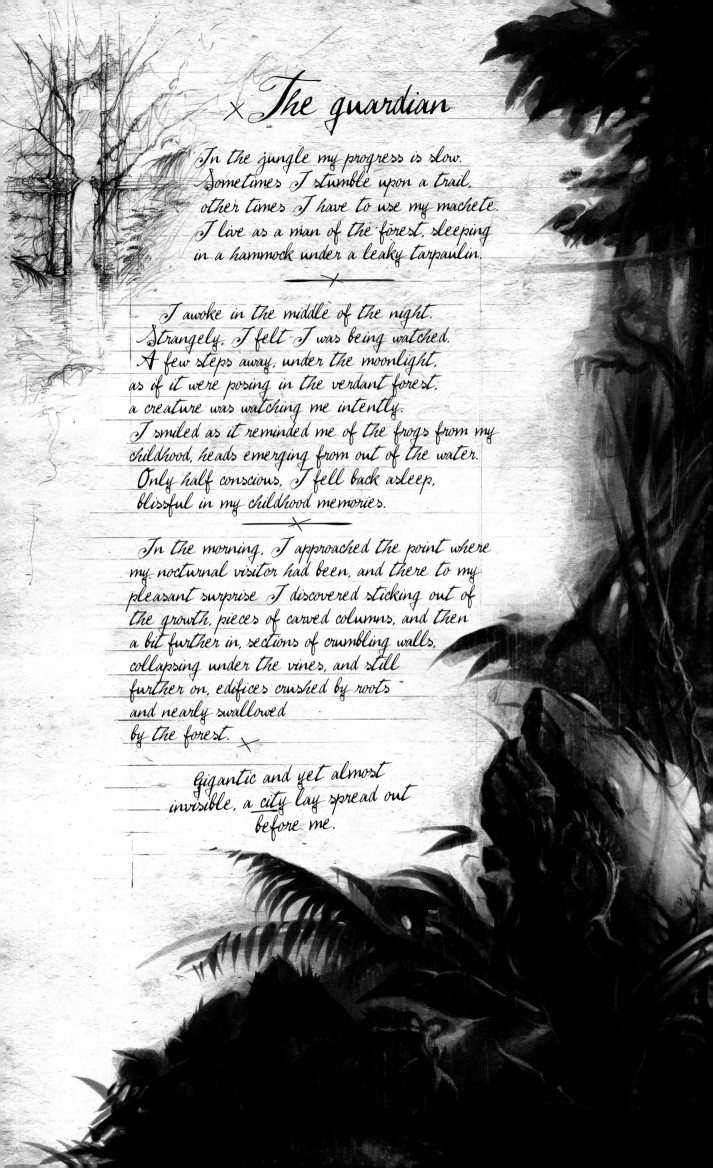

The guardian

In the jungle my progress is slow.
Sometimes I stumble upon a trail,
other times I have to use my machete.
I live as a man of the forest, sleeping
in a hammock under a leaky tarpaulin.

———×———

I awoke in the middle of the night.
Strangely, I felt I was being watched.
A few steps away, under the moonlight,
as if it were posing in the verdant forest,
a creature was watching me intently.
I smiled as it reminded me of the frogs from my
childhood, heads emerging from out of the water.
Only half conscious, I fell back asleep,
blissful in my childhood memories.

———×———

In the morning, I approached the point where
my nocturnal visitor had been, and there to my
pleasant surprise I discovered sticking out of
the growth, pieces of carved columns, and then
a bit further in, sections of crumbling walls,
collapsing under the vines, and still
further on, edifices crushed by roots
and nearly swallowed
by the forest. ×

Gigantic and yet almost
invisible, a _city_ lay spread out
before me.

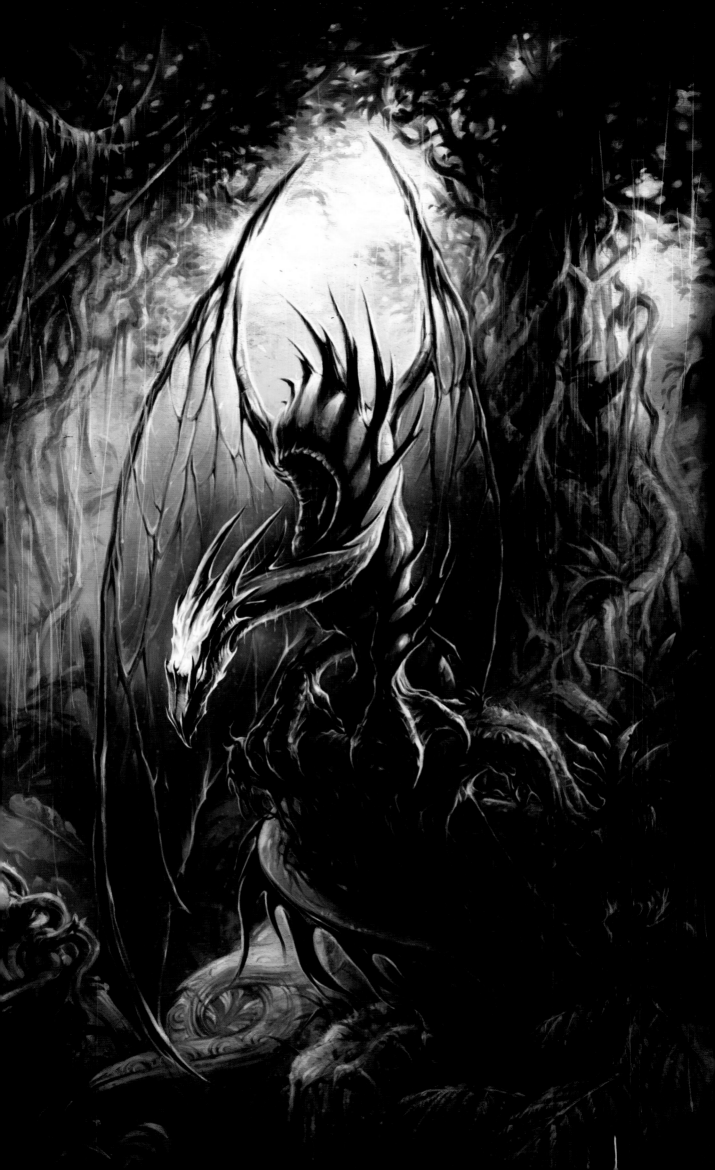

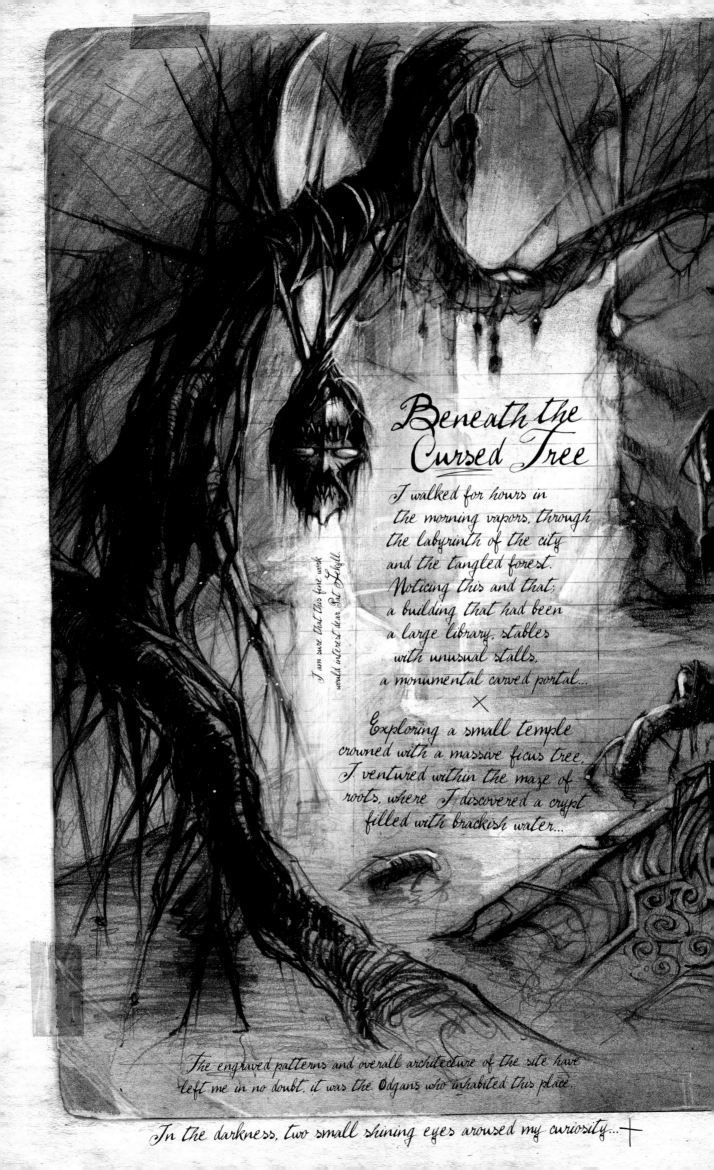

Beneath the Cursed Tree

I walked for hours in
the morning vapors, through
the labyrinth of the city
and the tangled forest.
Noticing this and that;
a building that had been
a large library, stables
with unusual stalls,
a monumental carved portal...

✕

Exploring a small temple
crowned with a massive ficus tree,
I ventured within the maze of
roots, where I discovered a crypt
filled with brackish water...

I am sure that this fine work would interest dear Pat Jekyll.

The engraved patterns and overall architecture of the site have
left me in no doubt, it was the Odgans who inhabited this place.

In the darkness, two small shining eyes aroused my curiosity...†

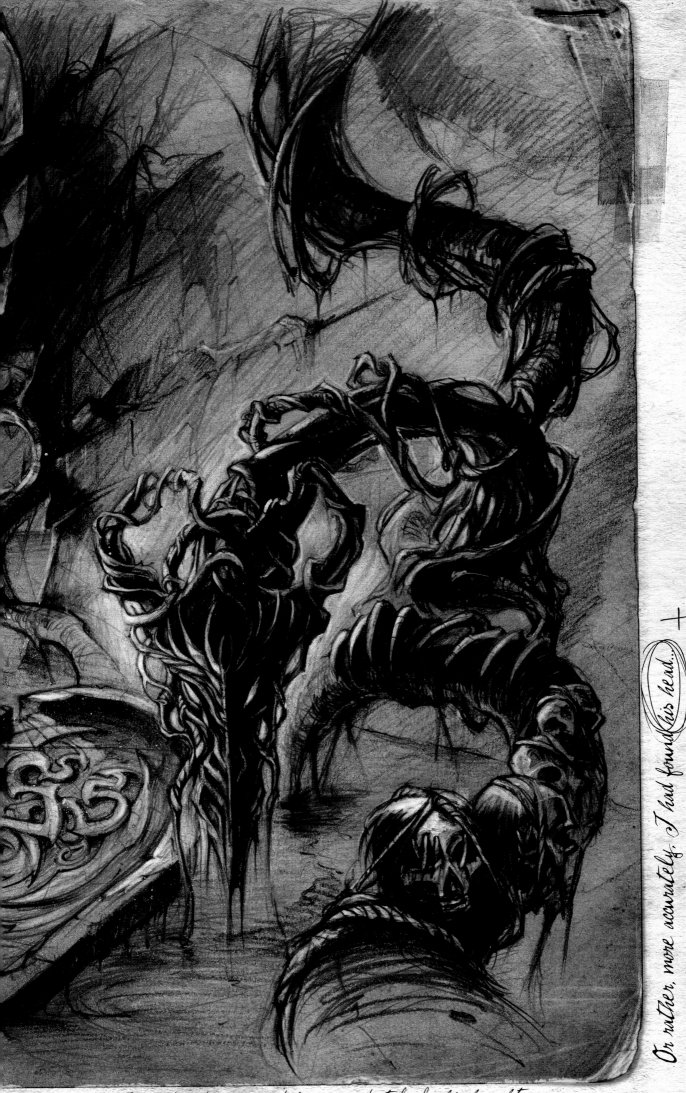

Or rather, more accurately, I had found his head... +

I approached and recognized him immediately by his haughty
and sullen expression. Finally, I had found Ollafsen!

Where the Dragon Dances ✕

Like a set and precise ritual,
the choreography lasted but only a brief moment.

Then the creature crept quietly into
the « Well of Dreams »...

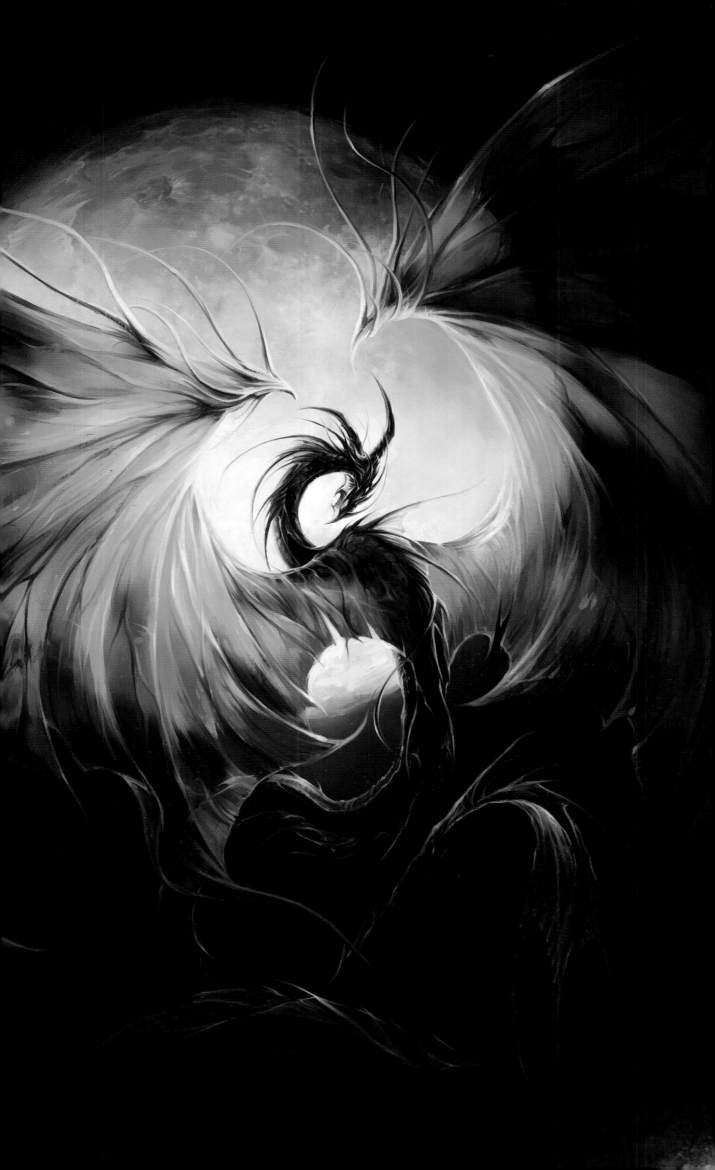

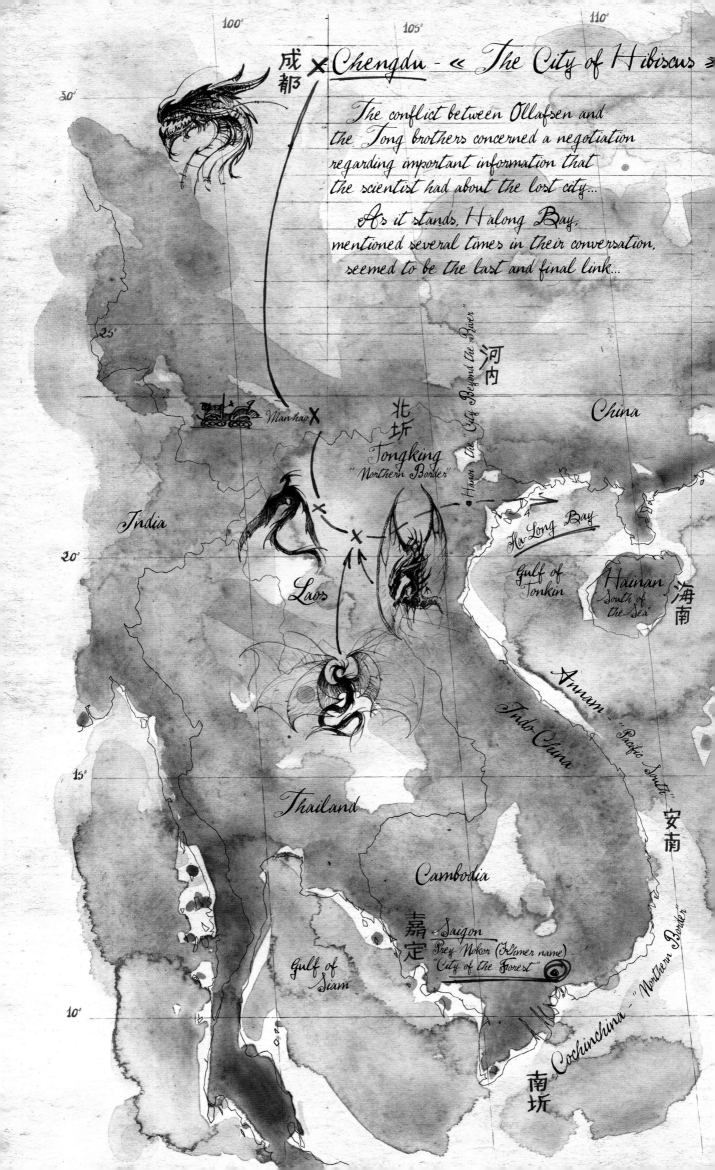

成都 ✕ Chengdu - « The City of Hibiscus »

The conflict between Ollafsen and
the Tong brothers concerned a negotiation
regarding important information that
the scientist had about the lost city...

As it stands, Halong Bay,
mentioned several times in their conversation,
seemed to be the last and final link...

100°
105°
110°
30°
25°
20°
15°
10°

河内

北圻
Tongking
"Northern Border"

Hanoi the "City Beyond the River"

China

Man-hao ✕

India

Laos

Ha-Long Bay

Gulf of
Tonkin

Hainan
South of
the Sea
海南

Annam — "Pacific South"

Indo-China

安南

Thailand

Cambodia

嘉定 Saigon
Prey Nokor (Khmer name)
"City of the Forest"

Gulf of
Siam

Cochinchina — "Northern Border"

南圻

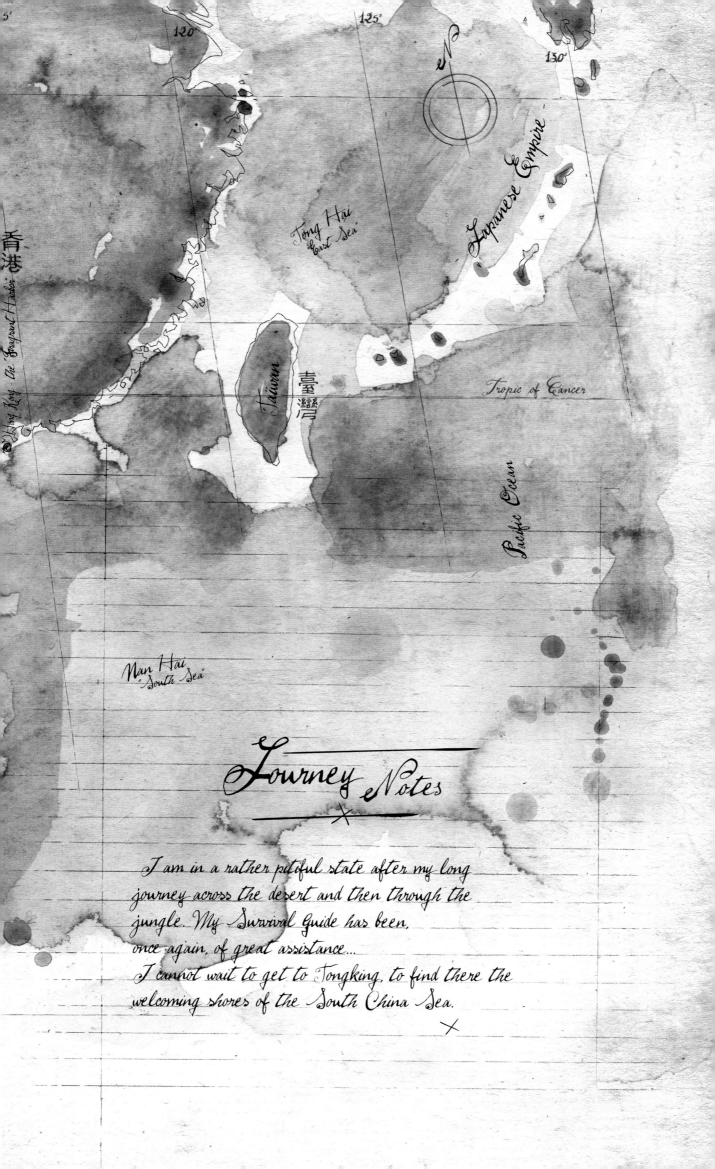

香港

© Hong Kong - The "Fragrant Harbor"

120° 125° 130°

N

Tong Hai
"East Sea"

Japanese Empire

Taiwan 臺灣

Tropic of Cancer

Pacific Ocean

Nan Hai
"South Sea"

Journey Notes

I am in a rather pitiful state after my long
journey across the desert and then through the
jungle. My Survival Guide has been,
once again, of great assistance...
I cannot wait to get to Tongking, to find there the
welcoming shores of the South China Sea.

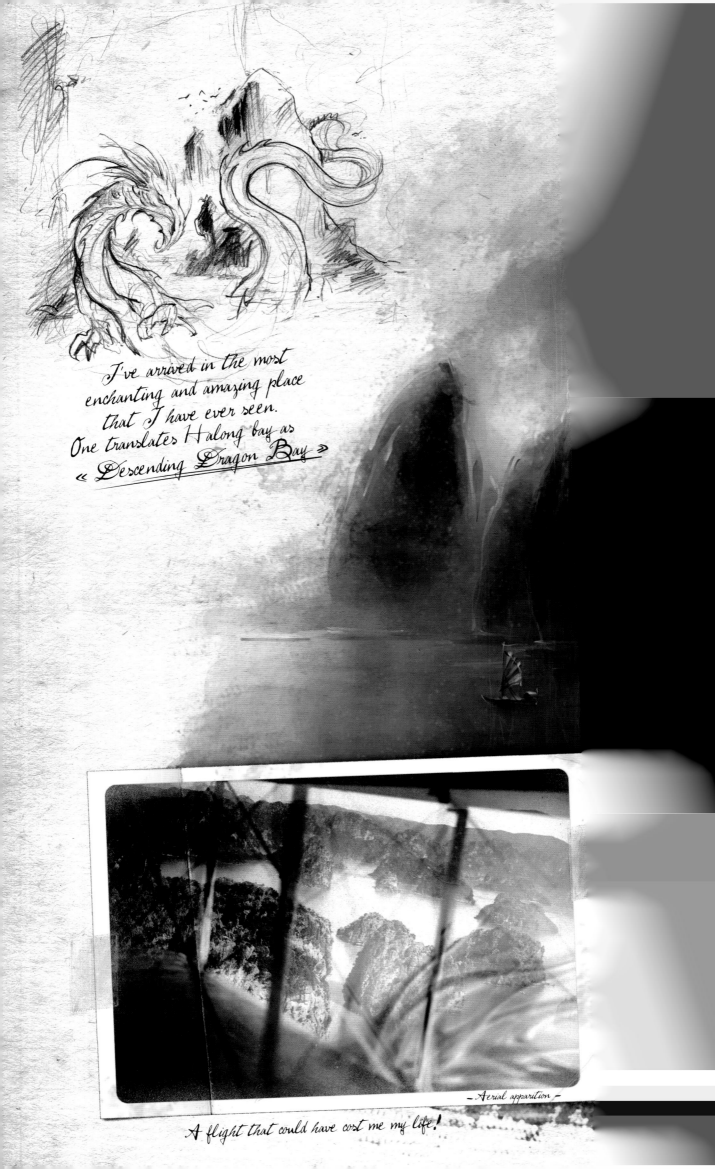

I've arrived in the most
enchanting and amazing place
that I have ever seen.
One translates Halong bay as
« Descending Dragon Bay »

– Aerial apparition –

A flight that could have cost me my life!

I cannot help but make a connection
between the Tonkinese traditions and
the Saga of the People of the Wind.
This memory, kept alive as a legend, seems to
confirm their voyages through these places during
the great migration to the City of Dreams...

The legend of Halong Bay

Fishermen report that a couple of unusually large
sea snakes appear at night during both the summer
solstice and the autumn equinox, driven by the sea currents
that draw close to the coast at those times of the year.

There are only a few, rare, sailors who can testify to
this sighting, but the old timers claim that on those
nights you can hear long sinister cries in the bay.
None of them will venture out to sea at those times, as
« crossing one is tantamount to crossing death. »

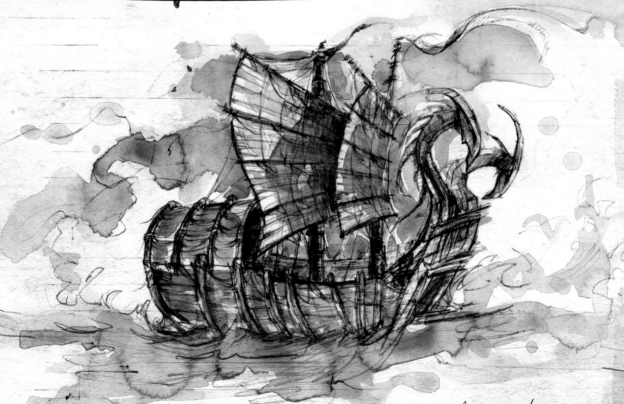

Other witnesses tell of the existence of a cursed
junk, a Dutch-Asian hybrid, which glides across
the China Seas. The stories I was told about it
made my blood run cold.

Saigon

I saw the shadow of the great Dragons haunt the mists of the Port of Saigon.

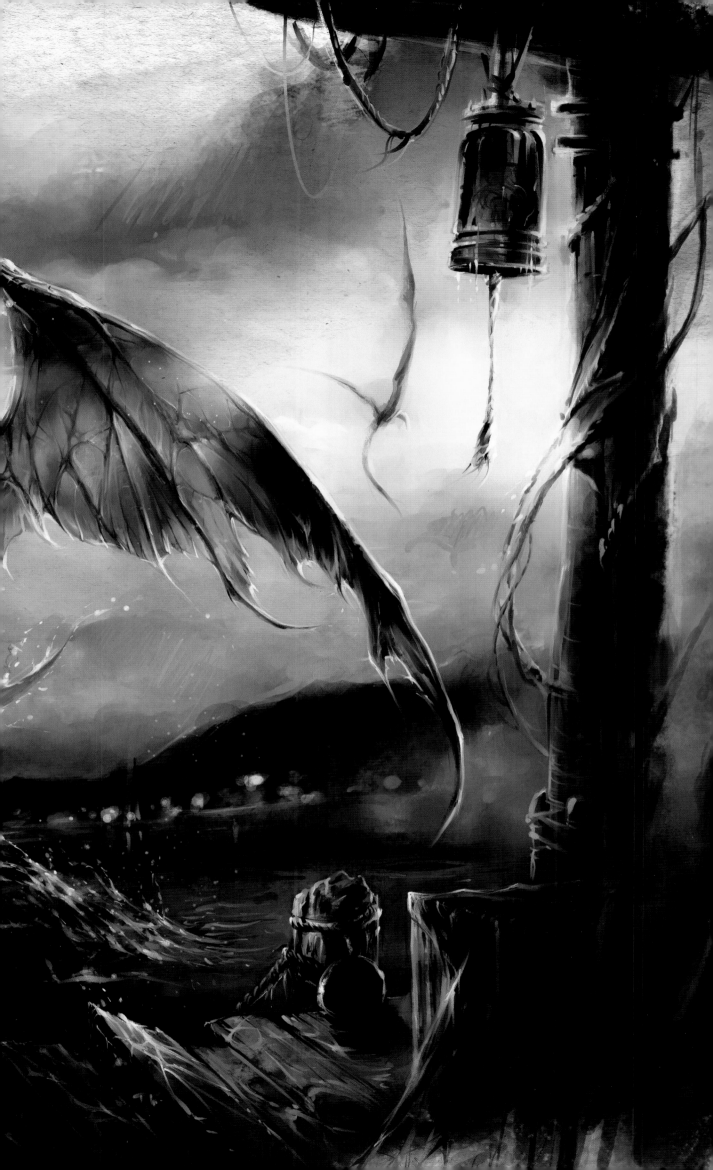

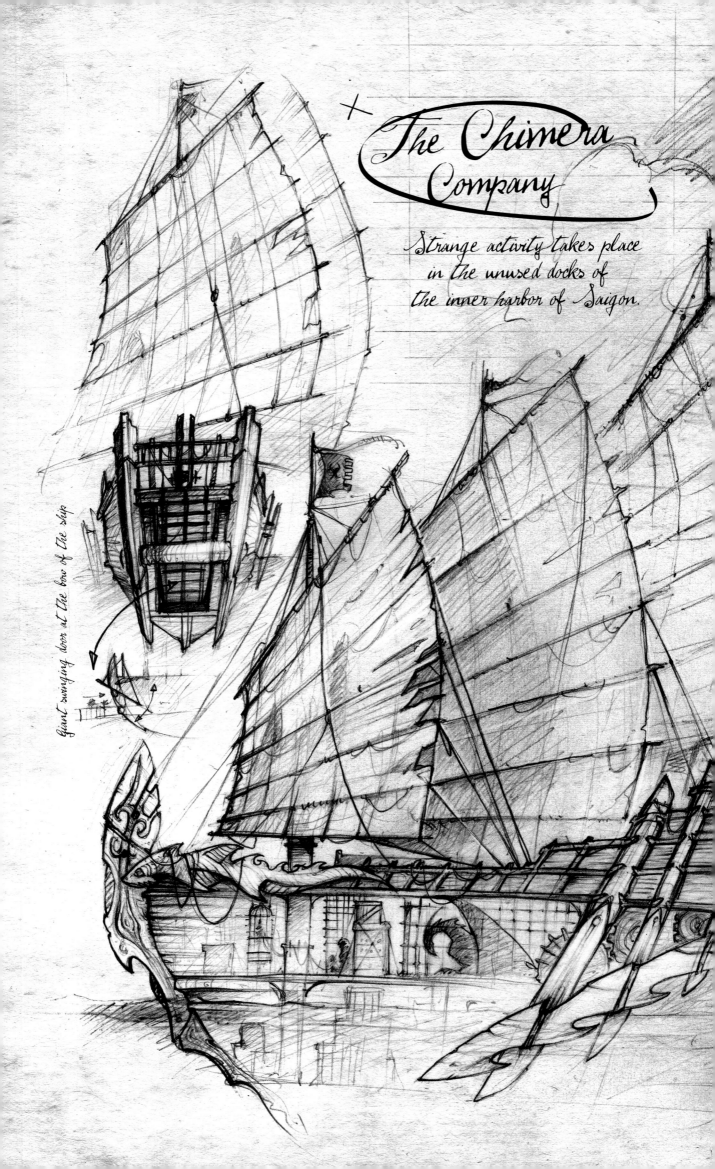

The Chimera Company

Strange activity takes place
in the unused docks of
the inner harbor of Saigon.

Giant swinging door at the bow of the ship

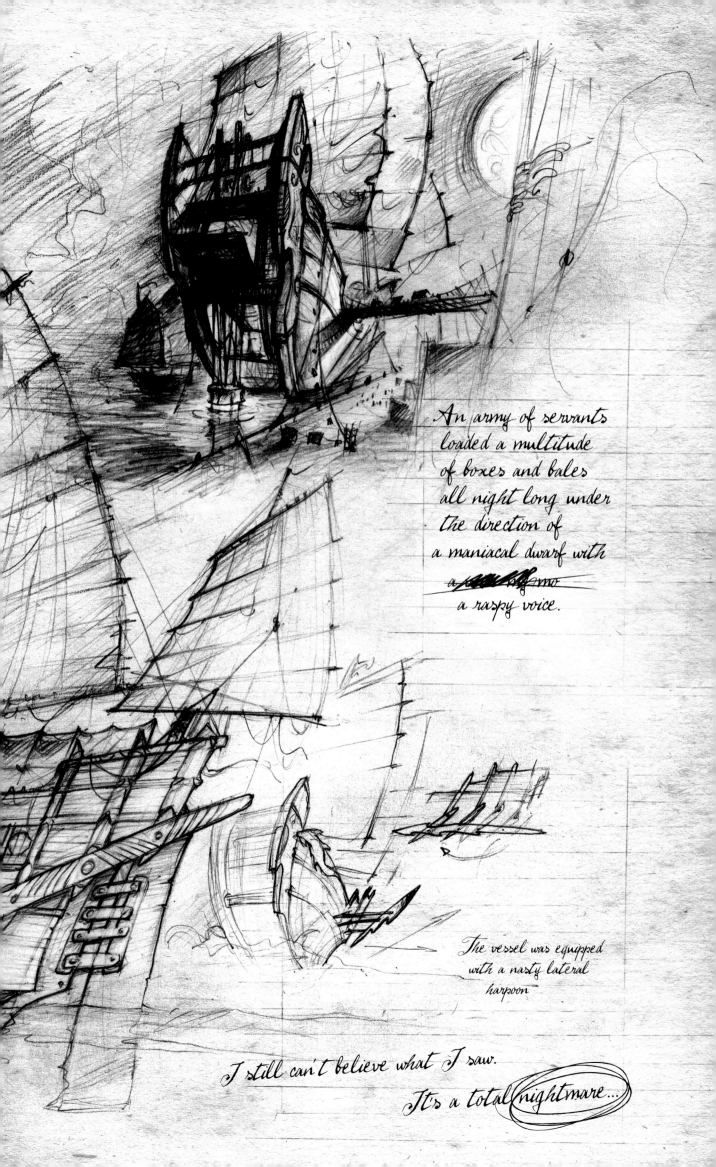

An army of servants
loaded a multitude
of boxes and bales
all night long under
the direction of
a maniacal dwarf with
a ~~piercing gaze mo~~
a raspy voice.

The vessel was equipped
with a nasty lateral
harpoon

I still can't believe what I saw.

It's a total nightmare...

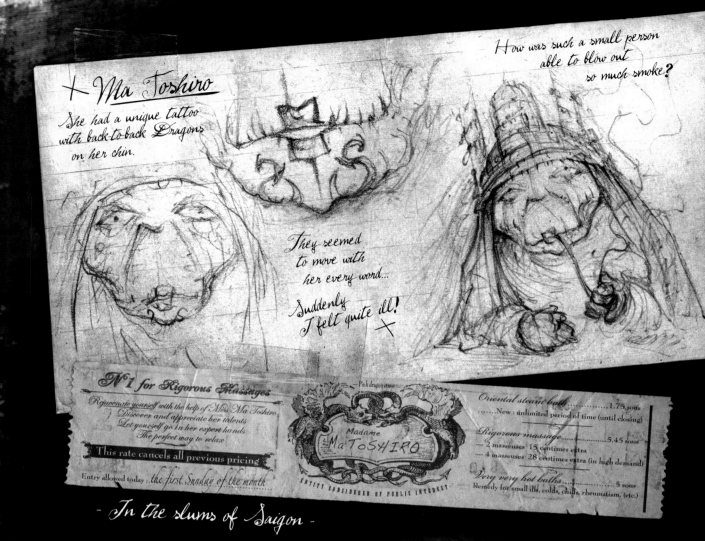

How was such a small person able to blow out so much smoke?

† Ma Toshiro

She had a unique tattoo with back-to-back Dragons on her chin.

They seemed to move with her every word...

Suddenly I felt quite ill! ✗

Nº1 for Rigorous Massages

Rejuvenate yourself with the help of Mrs. Ma Toshiro
Discover and appreciate her talents
Let yourself go in her expert hands
The perfect way to relax

This rate cancels all previous pricing

Entry allowed today ..the first Sunday of the month

Pink dragon street

Madame
Ma Toshiro

ENTITY CONSIDERED OF PUBLIC INTEREST

Oriental steam bath..............1.75 sous
...New : unlimited period of time (until closing)

Rigorous massage..............5.45 sous
— 2 masseuses 15 centimes extra
— 4 masseuses 28 centimes extra (in high demand)

Very very hot baths.............5 sous
Remedy for small ills, colds, chills, rheumatism, (etc.)

- In the slums of Saigon -

In The Opium Fumes of Ma Toshiro

✗

Ma Toshiro is the Madame of one of the largest opium dens in Saigon.

This tyrannical and cantankerous Japanese woman, just under 4 feet in height, appears to be the last of her kind.

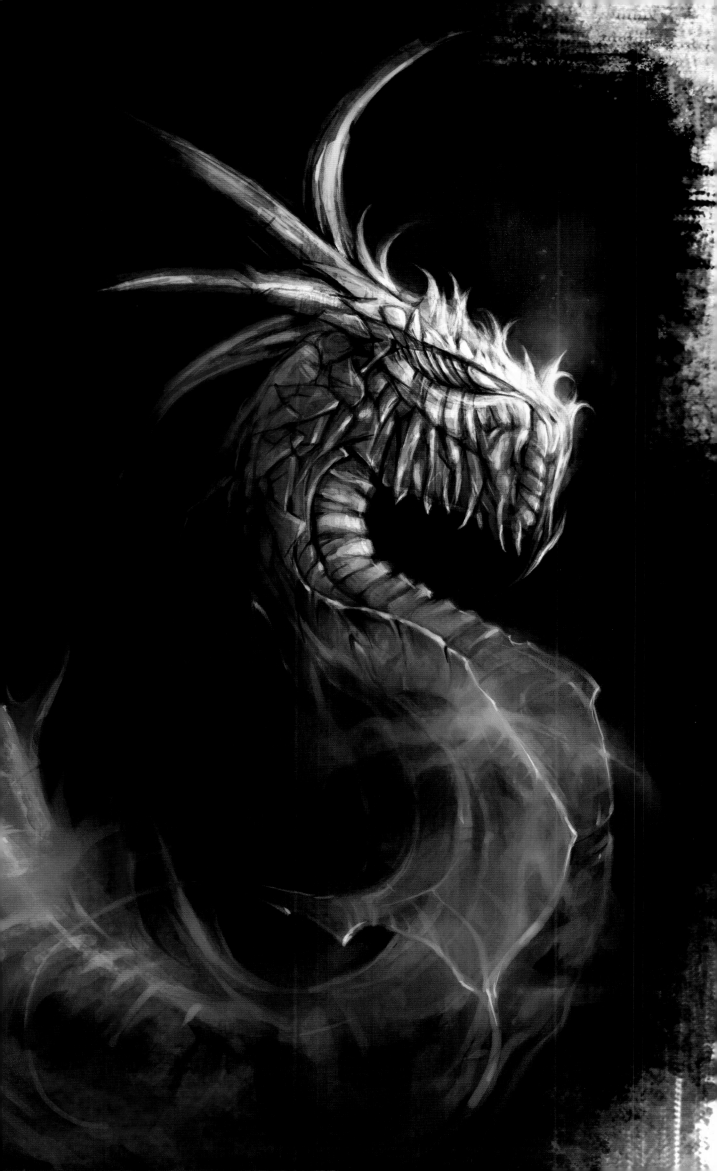

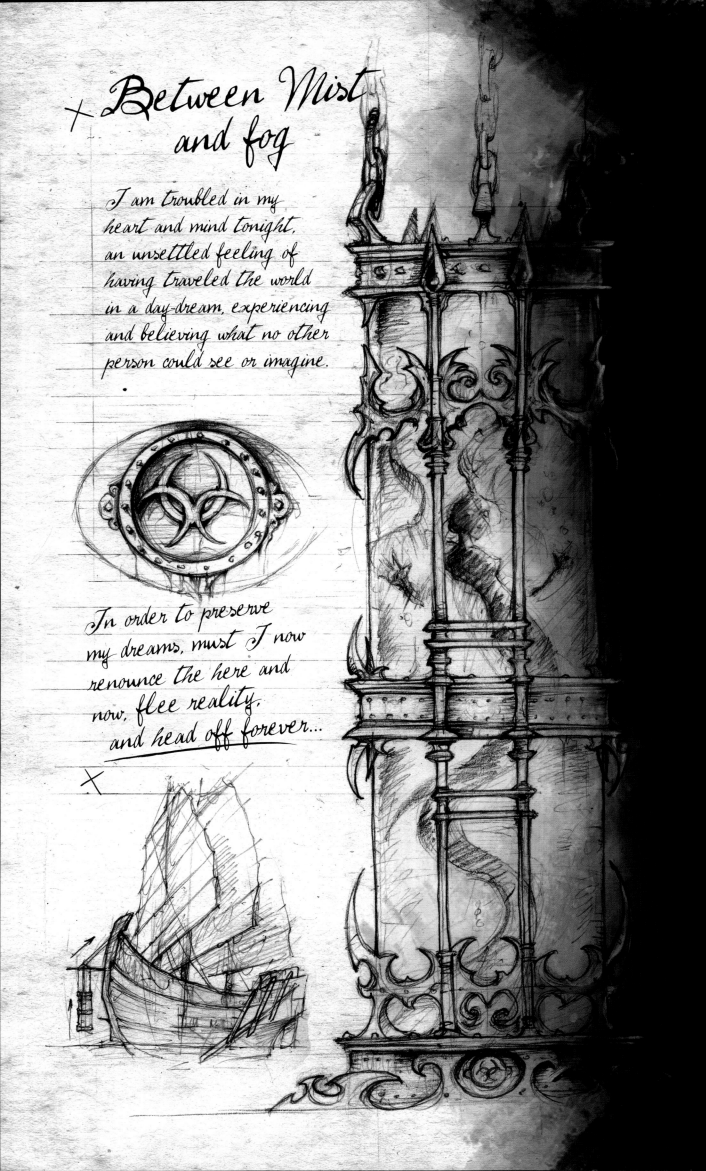

Between Mist and fog

I am troubled in my heart and mind tonight, an unsettled feeling of having traveled the world in a day-dream, experiencing and believing what no other person could see or imagine.

In order to preserve my dreams, must I now renounce the here and now, flee reality, and head off forever...

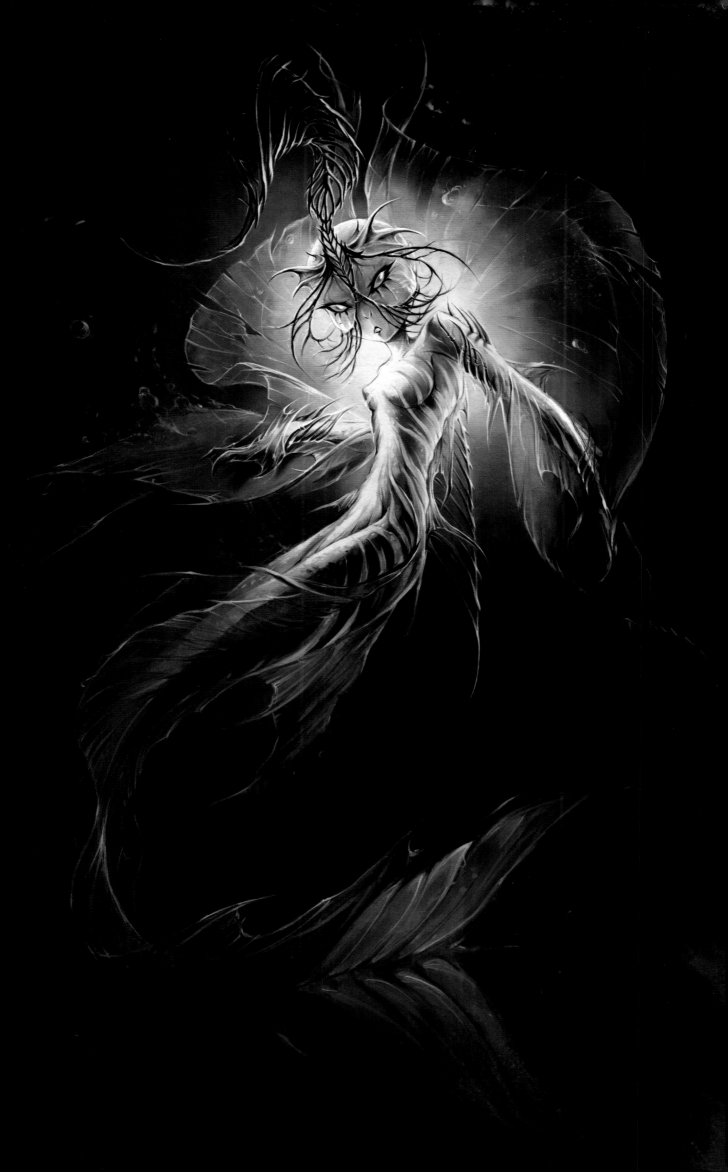

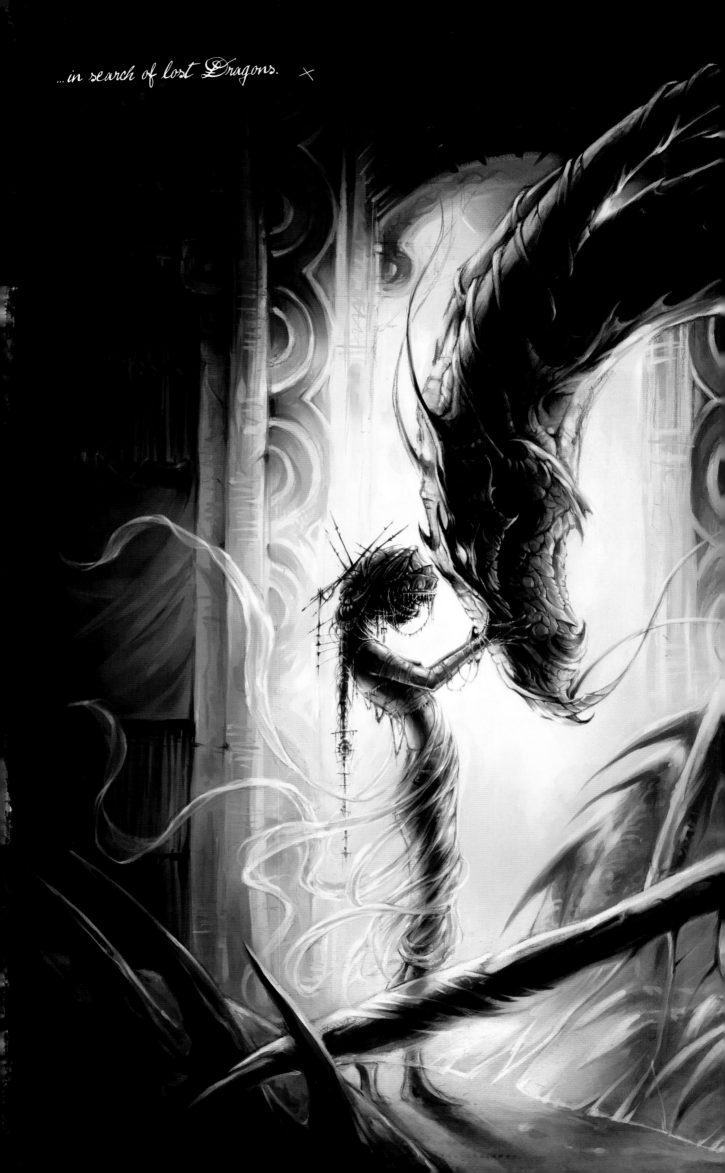

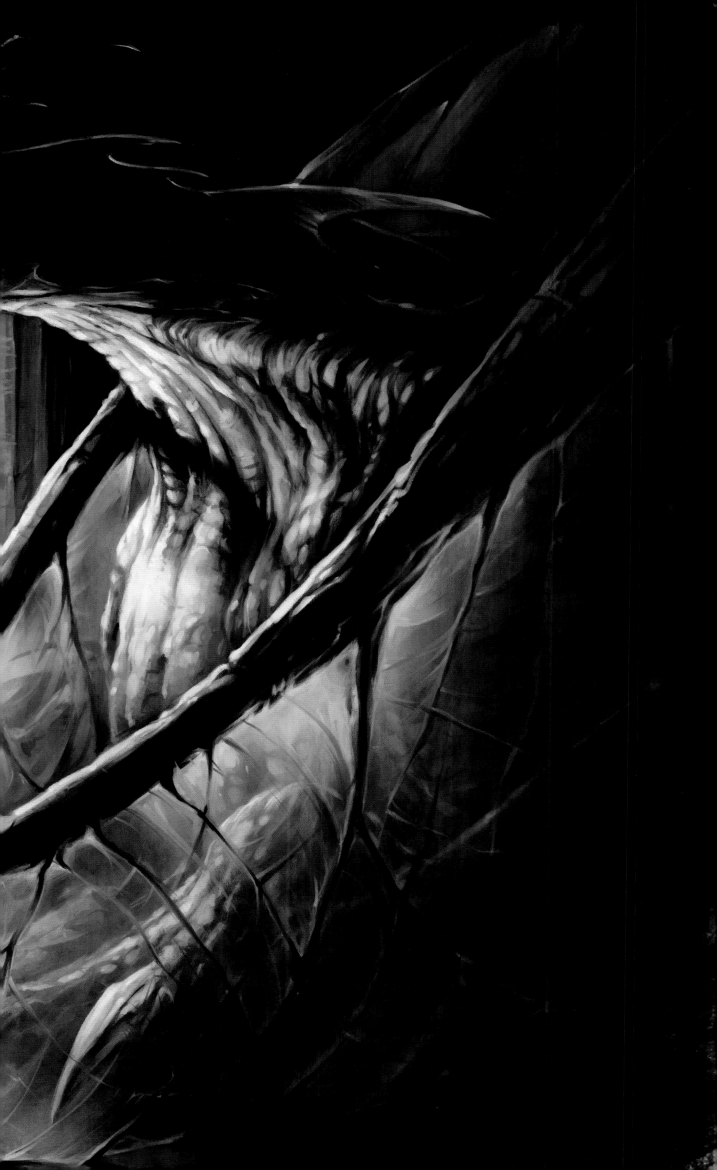

Travel log

Name	Address	Note
– Pat Jekyll	1, rue Gradlon Kemper	(Next to the cathedral)
– Inn at the Gates of Hell ✗	Toul an Ankou Brennilis Finistère (Morlaix train station)	not easy to find
– François – Marie Le Lagadec	Head mechanic Bourg de Pleyben	don't forget to pick up Naomi
– Leprechaun's Corner	O'Flaherty street Cleegan Connemara Ireland	Music and Guiness!
– Fairies Institute of Dublin	. Eden Quay Boardwalk Dublin Ireland	(ask for Mr. Korrigan)
– Mac Claymore Castle	Bain North Highlands Scotland	(bring back a few bottles of the excellent elixir)

THE WORLD OF DRAGONS
REAL AND ONLY ONE IN THE WORLD

WORLD'S FAIR

INCOMPARABLE

BEWARE, LADIES & GENTLEMEN
UNFORGETTABLE SHOW

INCOMPARABLE

TERRIFYING !
SENSITIVE SOULS ABSTAIN

$2 / $1 — 05·07·06 — 11 PM TO 3 AM — OPENING HOURS

HOWLING DRAGON

HOT FLASH !

$1 — EXCEPT IN A HEAT WAVE — 1ST TO 11TH · 7 PM

FIRE DRAGON

AQUATIC IMMERSION

$3 — POSSIBLE APPARITIONS — SUNDAYS AND HOLIDAYS

DRAGON OF THE ABYSS

• Irish Fairy Tales by W.B. Yeats, 1982.

• British Goblins by Wirt Sikes

Travel log

Name	Address	Note
- Anatole Batignolles	rue du Foin Paris (Seine)	PhD in Zoology specialist in mammalian hibernation
- Placide de la Mole	Avenue de Clamart ~~Vanves~~ Issy-les-Moulineaux	
- Timothy Burnott	Carrefour des eaux Port de Reykjavik	at the end of the docks
× Jenny Haniver	Fish Market 2550. 5th av. Ramberg Lofoten	(bring magnificent specimen back to P. J ?)
- Jan Mayen	71° Nord 8° W	
- Location of the Arctic Circle	66° N 33' 38' N	
- Bjørnøya	74.31° N 19.1° E	(I absolutely must go there some day)

- « *How many sailors and their captains...*
went blithely toward some distant continent
beyond this bleak horizon and were lost »

(*That's the*
rest of it!)

I have been trying for two weeks
but it's impossible for me to get it into my head

- *Night*
on the
Ocean
Victor Hugo

- *Voyage to the*
Center of the Earth
Jules Verne
Hetzel Edition

× *I imagine a city like an iceberg adrift*
in the middle of the Atlantic Ocean.

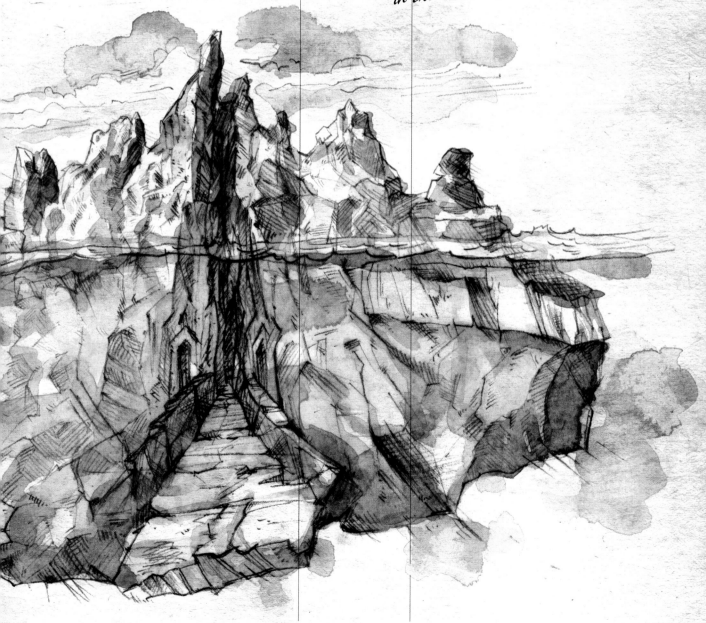

Travel log

Name	Address	Note
- Prince Gustav Hotel	Korkeavuorenkatu Helsinki	(Finland)
- Dragon Boutique (spices and antiquities... very very eclectic !)		
Tong Brothers Chengdu Central China (near the big lotus market)		

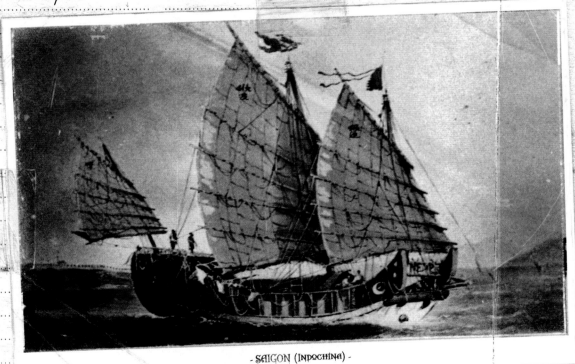

- SAIGON (INDOCHINA) -

| - Mister Wha Quoc | Man-Hao Village Yu Nan Indochina | (leave Naomi) teacher |

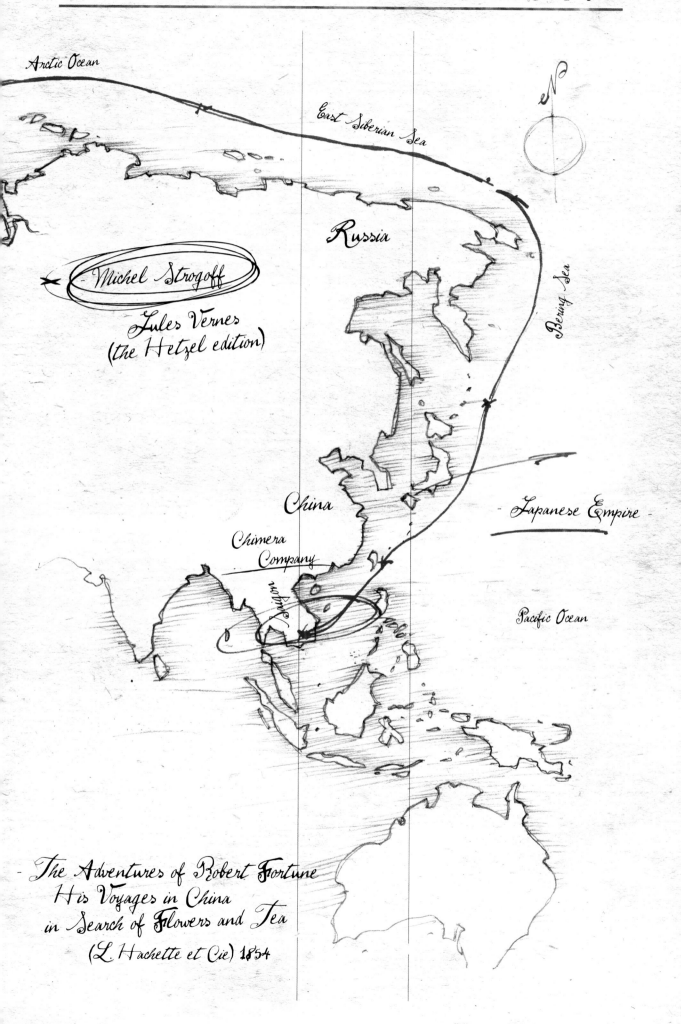

Arctic Ocean

East Siberian Sea

N

Russia

Bering Sea

Michel Strogoff

Jules Vernes
(the Hetzel edition)

China

Japanese Empire

Chimera
Company

Saïgon

Pacific Ocean

The Adventures of Robert Fortune
His Voyages in China
in Search of Flowers and Tea
(L. Hachette et Cie) 1854

to Carine M – without her I wouldn't exist (...).

 E. B.M X

to Elian, my Monster for all eternity !

 E. M

X With all our thanks to the whole Drugstore team !

And once again thank you... Patrick (...),
... to Cedric, a great photographer-traveler,
to Gerard, fan from the start and door guard,
to Huguette and Clementine- our faithful accomplices !
And also to grandma Dede and her Maxi Molar,
Laurette, for her good and valuable advice,
Zolbin Nokhai, keeper of the secret of the Odgans,
Treasa, traveler with the wind at her heels,
Sylvie C. from the library at the University of Nice,
Greenhouses of "Tete d'or" (an incredible park),
Caluire Caves (and their archives),
and again to Baldwilf chronicler of Noghaard
and Maryline, for her passion and her energy...

... and a special one to Anthony V., big tester of shrunken heads.

X Once upon a time in the West...

There were 3 desperados who managed to get our Dragons
to cross the ocean and end up in your hands.

We would never have believed it was but they did it.

These last thank yous are for them.

Thank you Etienne B. for your professionalism and your patience.

And Ivanka H. for having walked so closely
in the footsteps of our paper heros...

 E. & E.
 X X X

 # BIBLIOGRAPHY
AVAILABLE IN FRANCE

By the same authors · Jan '05 — Oct '14

Glenat Editions :

☑ Collection :: BLACK'MOR CHRONICLES ::

- 'IN SEARCH OF LOST DRAGONS' (FIRST Series).

- 'DEMONS' (SECOND series).

- 'WESTERN DRAGONS' (THIRD Series),

Anticipated Fall 2015 in France

☑ Collection :: ENCYCLOPEDIA OF GHOSTS ::

- 'Grisly Encyclopedia of Ghosts'

- 'Terrifying Encyclopedia of Apparitions'

☑ Collection :: TEA-TIME MONSTERS SHOW ::

- 'Everything you need to know about, and how to live with, MONSTERS'

In Search of Lost Dragons 'originally appeared in three books
published by *Au Bord des Continents* in 2005, 2006 and 2007

This work, adapted by the authors, consolidates them into a single volume,
thus divulging Elian Black'Mor's actual Journal from the FIRST series
of his Extraordinary Journeys.

Veritable Artifact from the BLACK'MOR CHRONICLES universe,
this journal was the springboard for the rest of his adventures!
It's up to you to discover them... E.B'M. & C.M.

COMMENTS :

Available in all good bookshops

certified BIBLIOGRAPHY responsable Placide de la Tanquietare
 Valvres Telegah. ©399

TELEGRAM

LAST MINUTE INFORMATION

ISBN						
978-0-0000-0000-0						
ILLUSTRATIONS						SPECIAL NOTE
E.B'M C-M						
FROM	VOLUME	NUMBER OF WORDS	REGISTRATION DATE	TIME OF REGISTRATION		NON-CENSORED
WEST	OMNIBUS	same	6/9/11	7:21 p.m.		

From an original idea created by Elian Black'Mor & Carine-M
Graphic conception & execution by : Élian Black'Mor & Carine-M
Text : Patrick Jézéquel – Élian Black'Mor & Carine-M

Illustrations : Élian Black'Mor & Carine-M

©2011, Editions Glénat
Couvent Sainte-Cécile – 37 rue Servan – 38000 GRENOBLE
www.glenat.com

SEE OTHER SIDE for confidential information that could shed some light on the key elements of creation.

AUTHORS' SITES :
www.elian-black-mor.com
www.carine-m.com

SITE OF AUTHORS WORKSHOP
www.arsenic-et-bouledegomme.com

English edition edited by *Hannah Elder*

Translated by *Ivanka Hahnenberger* and *Andrew Chappell*

Lettered by *Rodolfo Muraguchi* and *Bill Tortolini*

Publisher's Cataloging-in-Publication data

Black'Mor, Elian.
 In Search of Lost Dragons / Elian Black'Mor and Carine M.
 p. cm.
 ISBN 978-1-60690-464-0
 Series : Black'Mor Chronicles
 "Translated by Ivanka Hahnenberger and Andrew Chappell"

[1. Dragons --Fiction. 2. Fantasy fiction. 3. Voyages and travels --Fiction. 4. Adventures and adventurers --Fiction.] I. M., Carine. II.
Hahnenberger, Ivanka. III. Chappell, Andrew. IV. Series. V. Title.

PQ2622.L43 I5 2014
[Fic] --dc23

Nick Barrucci, CEO / Publisher
Juan Collado, President / COO
Rich Young, Director Business Development
Keith Davidsen, Marketing Manager

Joe Rybandt, Senior Editor
Hannah Elder, Associate Editor
Molly Mahan, Associate Editor

Jason Ullmeyer, Design Director
Katie Hidalgo, Graphic Designer
Chris Caniano, Production Assistant

Visit us online at **www.DYNAMITE.com** Follow us on Twitter **@dynamitecomics** Like us on Facebook **/Dynamitecomics** Watch us on YouTube **/Dynamitecomics**

ISBN-10: 1-60690-464-7 ISBN-13: 978-1-60690-464-0 First Printing 10 9 8 7 6 5 4 3 2 1

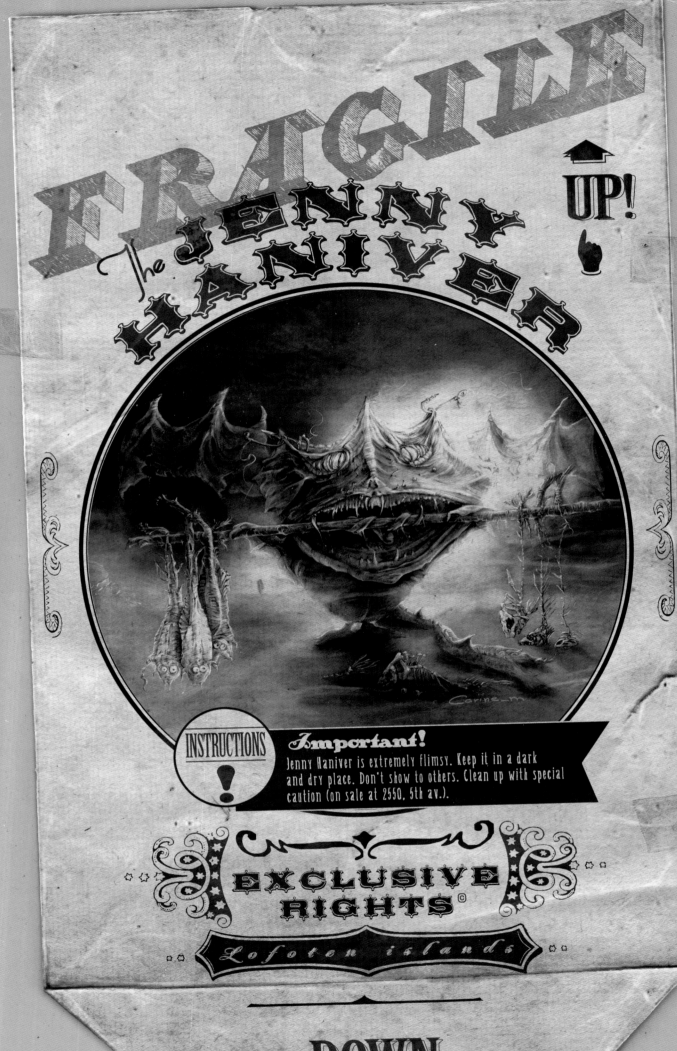